BIGGER THINGS

BIGGER THINGS

Copyright © 2014 Ev Bishop

Print Edition

Published by Winding Path Books

ISBN 978-0-9937617-1-3

Cover image: Kimberly Killion / The Killion Group Inc.

All rights reserved. Except for brief quotations used in critical articles or reviews, the reproduction or use of this work in whole or in part in any form, now known or hereafter invented, is forbidden without the written permission of the publisher, Winding Path Books, PO Box 82, Terrace, British Columbia, V8G 4A2 Canada.

Bigger Things is a work of fiction. Names, characters, places, and incidents are either the product of the author's imagination or are used fictitiously, and any resemblance to actual persons, living or dead, business establishments, events or locales is entirely coincidental.

*To all my sisters –
those by blood,
those by friendship,
those by shared experience*

AUTUMN
September

B5 – Mainstream; Your Entertainment & Lifestyle Weekly

DEAR FAT GIRL: I'm Desperate.

> Questions, Dreams, Raves, Rants and Fantasies?
>
> Express them and have them responded to by our experts!
>
> ## ASK MAINSTREAM

Dear Fat Girl,

I've tried every diet there is: Slimfast, the all liquid diet, high carb, low carb, the Zone, Cabbage Soup, the New Beverly Hills Diet, the Eat, Cheat & Melt Fat Diet, Sugar Busters, the Paleotech Diet, the Warrior Diet, the No Time to Diet diet, the Fat Flush Diet, a vegan diet, Richard Simmons—just to name a few. I've even tried God's diet!

 You name it, I've tried it, but I just can't seem to lose weight. My mother says that I shouldn't starve myself, that it'll backfire and hurt my metabolism . . . but what if I just don't eat until the weight comes off, then slowly re-introduce food until my system adjusts? Would that work?

 I work out for at least an hour a day, carry a full course load at UBC, and have a part-time job. I know I'm burning calories, but the scale won't go below 124. I'm desperate!

 Thanks in advance for any help you can give me.

Yours sincerely,
Desperate to Lose!

Dear Desperate, (I cringe calling you that.)

I was taking your dilemma, your urgency, seriously. Being overweight and seemingly unable to change is a health problem.

Then I read your weight. You don't need a diet; you need a head doctor! Unless you're under 4'5, you're not even remotely fat.

Get a life. Go have fun. Drink Crystal Lite or whatever it is that skinny people do and stop wasting my time.

Don't know if I helped, but you're welcome.

Sincerely,
Fat Girl

P.S. Readers, I'm tired of being swamped with letters from skinny girls who think they're fat. I am FAT GIRL. Get it?

If you're skinny and like to write, contact *Mainstream*. Maybe you could be a new columnist, "Skinny Girl with Body Dysmorphic Disorder." What do you think? Any takers?

1

JEN CLICKED THROUGH DOZENS OF beautiful faces matched to enthusiastic texts praising Soul Mates, an online dating service.

"Everyone gets a happily ever after, yeah right," she muttered.

Finally she came to what she was looking for: a personal ad with the heading, "Trapped in Tiny Town." She clicked to read more. "I'm a widowed, thirty-six-year-old white male. Current career and love of the outdoors keep me living in a small town."

Jen skimmed over his interests; books and cooking were the only ones they seemed to share. "I'm looking for someone who's able to see into the heart." *Corny weirdo,* Jen thought. "Someone who knows herself, her strengths and weaknesses and isn't afraid to say what she wants. Picture not necessary." Jen reread the last line three times.

"They were right. That is interesting," she said aloud. She took a mouthful of lukewarm coffee and hesitated over the "contact me" link, then shook her head slightly and clicked X. Tiny Town man disappeared.

They. Kyra Thomas and Chelsea Hamilton. Her friends. They were always hounding her about the great possibilities of Internet dating. Jen glanced toward a picture on the bookshelf

beside her. A girl with long cinnamon-colored hair smiled from her perch on a huge driftwood stump. She had a pretty face—small nose, full lips, nice teeth and large gray-green eyes that matched the ocean behind her. The girl was tired of hearing about her face, Jen knew. She smiled wistfully at the photo. It was pretty though. Great cheek bones, in spite of the fact that the girl weighed almost three hundred pounds. It was a cruel prompt for people who wanted the "best" for her, reminding them to nag, "You'd be so beautiful if you just lost weight. Look at your face."

In the past, Jen always managed to steer Kyra and Chelsea away from their favorite activity of trying to find her a man. Probably because they didn't have faith, even with their infamous matchmaking abilities, that they could find somebody who'd see past her girth. But now that fat Jenni Robertson had transformed into slim and slender Jen? Now it was a whole new game, and nothing Jen said convinced them of the truth: she didn't want to date right now.

Jen reached out and touched the girl in the photo. The glass was cold to her touch and the girl behind it kept smiling, unmoved.

She sighed and got to her feet. Twelve-thirty. She'd better move it, if she was going to get to her lunch appointment on time.

WARM AIR AND THE BUTTERY scent of fresh bread greeted Jen as she burst through the door to Yum, an aptly named restaurant from the smell of it. Gale force winds propelled the rain in after

her. A bright yellow plastic triangle showed a stick person falling onto his tailbone, and black lettering warned, "Caution, Floors Slippery When Wet."

You think? Jen thought.

The laminate flooring in front of the door was slick with water, the rust-colored floor mat sodden and useless.

"Brrrrrrrr," she said with a small shudder.

"Another bright, crisp fall day in Vancouver, eh?" someone said to her left. Jen looked up into the wry smile of a silver-haired woman, who was folding up an umbrella decorated with orange and blue cats.

"Yeah, no one gets liquid sunshine like us," Jen said. The woman chuckled.

Jen brushed rainwater off her navy coat sleeves, and scanned the blur of chatting customers. Finally, across the room by a foggy multipaned window, she spotted Kyra's trademark blond head bent close toward Chelsea's shining chestnut one. Jen waved, but they didn't look up.

"I'll have the spinach salad with mandarin oranges, no bread, please," Jen told the girl at the counter. "And an iced tea, no sugar."

She handed the girl fifteen dollars. "Have a nice day. Keep the change."

"You too. Thanks a lot." The cashier took a frazzled second to smile at Jen.

"Beautiful *and* generous? There's a combo a guy could grow to love," boomed a male voice from behind her. Jen's cheeks heated as people turned to look at her. She ignored the com-

ment and grabbed cutlery.

"Hey Red, don't leave. I was talking to you." The words followed her as she dodged briefcases and terracotta planters of bushy plants to her friends' table. It wasn't until she sat down that she glanced back at the counter. The yeller was her age, give or take, and good-looking in an "I know I'm attractive" way that Jen hated. He was still staring. She smiled sweetly and flipped her middle finger, then turned back to her friends.

"And how are you guys?" she asked, setting her food down and easing her heavy backpack off, shoving it under the table.

"You're so hostile," Kyra said, laughing. "You'll never meet a guy if you do that every time one talks to you."

"He's obviously a pig. He had it coming," Chelsea said.

"Yeah, if he's any indicator of the available guys out there, I'm staying single," Jen said.

There was a second's pause, and they all grinned.

"So what's new, you guys? I tried to get your attention a zillion times—"

Chelsea shrugged. "Nothing much." Then, as Jen hung her jacket on a nearby coat tree, she added, "That's a great sweater, Jen. You should bring in Irish sweaters, Kyra."

Kyra rolled a bit of the soft wool at Jen's cuff between her fingers.

"Well, they are warm and snug, but nah, I don't think so."

"Not enough cleavage showing?" Jen asked.

Kyra's green eyes laughed. "You know me well, but, hey, considering you're dressed like a logger, you look good."

"Gee, thanks. Not quite the look I was going for, but I

thought dressing warmly was weather appropriate. It's hideous out there. My hair's drenched. How come you're not soaked?"

"Just lucky. It was bone-dry when I left the shop, but speaking of hair..." Kyra flicked a honey-yellow wave over her shoulder and tilted her chin. "What do you think? Two shades lighter. Does it work?" She gave them the other side of her profile.

"It must. I can't see a difference. Isn't blond just blond?"

Chelsea scrutinized Kyra's sleek tresses. "Don't be silly, Jen. It's totally noticeable. It looks great."

"Well, thank you. I can always count on you. Jimmy and I were just discussing that."

Jen cringed. Why couldn't Kyra call him James like he himself did?

"He thinks it's amazing that I have friends that I've had since grade two."

"It is kind of amazing, and it means I should be used to our coincidences, but I'm not—nice bag." Chelsea motioned at Kyra's bag, then at her own tucked beneath the table. The two leather-paneled bags were identical. "Winners. Thirty bucks."

Kyra sniffed, indicating that she'd paid a lot more for hers somewhere else.

"Thankfully, I was left out of the matching clothes talk show you guys started in high school," Jen said. "I had my own sitcom, *Jen wears what fits,* with riveting episodes like, 'Gray sweatpants month,' 'Back in jeans finally week!' and, the classic, 'Oh no, I'm wearing a tent dress!'"

"You're not funny," Chelsea said, but she and Kyra laughed.

Jen raised an eyebrow. "So I see." She dug into her food, and Kyra did too, after removing the top bun from her sandwich. Jen reached for the discarded bread, then pulled her hand back before taking it.

Chelsea noticed her restraint and gave a thumbs-up that Jen pretended not to see.

"So what's keeping you so busy these days?" Jen asked Chelsea once her initial hunger abated.

"Same old, same old. Brianne's twelve-going-on-fifteen. Dina's Dina—I don't know. They just aren't toddlers anymore." Chelsea fiddled with her watchband.

The movement caught Jen's eye and made her smile. A watch on her wrist, a ladybug pendant around her neck that revealed a clock face if you opened its shining silver wings. Chelsea and her watch fetish. She probably had an alarm clock in her purse. Jen smiled broader and was about to make a joke, when something in Chelsea's face stopped her.

"And my mom and Richard—" Chelsea interrupted herself. "No, never mind, it's boring." She stabbed a piece of tomato.

"Are you okay?" Jen asked.

Chelsea started to shake her head, then nodded. "Yeah, yeah, fine. Just my crazy mother's stressing me out, as usual. And things are hectic for Ted. He's pouring every bit of himself into the business right now. I've actually told him he needs to start being there for me and the girls, or we won't be around for him."

"You said that?" Jen looked at Kyra's uneaten bread. She really should've ordered bread.

"I did." There was something like pride mingled with surprise in Chelsea's voice. "Not that it helped much. It's really not his fault that everyone and their dog is moving to the suburbs and building a house. I may razz you about being single, but honestly, sometimes I think I'm the lonelier one."

Jen frowned. "Yikes, Chels. Things are that bad?"

Chelsea started to reply, but Kyra interrupted.

"Oh, come on. Ted's a doll. He totally dotes on you. Men are different than us. They need more space."

"Well, I'm not interested in being the maid. And if it's space he wants, it can be arranged." Chelsea continued to rub her pendant's chain back and forth between her finger and thumb, and something in Jen's stomach clenched. She shot Kyra a look, but Kyra seemed oblivious.

"You don't mean it. You guys are great together. And speaking of Ted, he's that busy? Rats. I want to renovate again, and was hoping if I got quotes, he'd tell me if guys are trying to rip me off."

"Chels, is that a tear? Are you crying?" Jen asked.

"No," Chelsea said, rubbing a finger along the lower lid of her left eye with impatient speed. "Don't be silly. My eye's just irritated by an eyelash. And you're totally right, Kyra. Ted is great. The kids are great. *We're* great. I'm sure he'll give you feedback, no problem."

Which is real? wondered Jen. The bitter side she rarely saw in Chelsea or this cheery optimism about her and her prince? Maybe both, she decided.

"It's normal to have rough patches once in awhile. Ted's a

good guy, but you've been together forever. It only makes sense that you have to work things out occasionally," Jen said.

Chelsea nodded and relaxed her grip on her necklace.

"And how are you and James?" Jen asked, emphasizing *James*.

"Oh, great. But you know how the beginnings of relationships are. All romance and wine." Kyra took a big mouthful of grilled pepper salad. "Mmmmm, this stuff's to die for. Try?" She waved a forkful, offering. Jen and Chelsea shook their heads, and Kyra continued. "Actually, I think he's the one."

Jen and Chelsea laughed.

"At least one of us believes that all romantic love is not in vain, that true love lingers just around the corner," Jen said.

"And that men are worthy of our love," Chelsea finished.

"Of course it does. Of course they are." Kyra's mouth tightened and her eyebrows knit together for a moment, but then, just as quickly, she seemed mollified by a new thought. "Hey, speaking of true love just around the corner, did you look up the Tiny Town man? Doesn't he sound great?"

Truth or lie? "Right, speaking of that. Thanks for signing me up without my consent."

Kyra and Chelsea didn't even bother to feign remorse.

"But yes . . . I checked out his ad just before coming here."

"And?" asked Kyra.

"But?" asked Chelsea.

"And? And he sounds better than most of the idiots you think would suit me, I guess. His last line is intriguing, *if* he means it. But . . ." Jen smiled at Chelsea for knowing her so well. "*But* it's probably just a ploy to make women think 'Ah,

finally. A sensitive male free from our society's body and beauty myths—'" Jen crossed her eyes.

"Does that mean you're going to contact him?"

"Or not?"

"Definitely *not*," Jen said.

"Come on, what do you have to lose?"

"Gee, I don't know. My time? My sanity? Who knows?" Jen propped her elbows on the table, and grinned at Kyra's exasperated exhale.

"He could be the one."

"I don't believe in 'the one' anymore."

"Of course there's a one."

Jen rolled her eyes. "Give me a break. You've had a new 'the one' every year or two since we were fifteen. By my count, you've had at least ten soul mates."

Kyra's green eyes narrowed to slits. "At least I try. At least I don't hide behind a bunch of flab and resent it when men don't like me, then lose weight and resent it when they do."

"Kyra, stop..." Chelsea's soft reprimand was ignored. She twisted a strand of hair around her finger and watched her friends.

"Maybe I don't have to have a man every minute of the day."

"Yeah, that's what I was saying, that you need a man every minute of the day—once in five years might be nice though. Seriously, a man can't even say hello to you. Like that guy—" Kyra glanced around the restaurant until she laid her gaze on Jen's admirer. "He seemed nice enough, and he was cute."

As if sensing their glance, the man looked their way. Jen

shielded her face with her hand, and studied her food.

"Stop looking! I don't want him to think I'm remotely interested."

"You're pathetic."

"Let's consider the source on that one."

"Would you two please shut up? Everyone's staring."

A few heads had turned and two teenagers were laughing, possibly at them, it was hard to tell. Hardly *everyone*, Jen thought.

"I just don't see why you won't cut me some slack. Why the hell does it matter to you whether I'm with some guy or not?"

"It doesn't matter to me a bit. I couldn't care less if you—"

"Come on, you guys, come on. Don't fight. Kyra, it's fine for Jen to be single. Jen, it's nice that Kyra has someone to love. Be happy for each other."

"Good grief, Chels. You treat us like kids. 'Don't fight, guys. Be nice now,'" Jen mimicked lightly.

"Well, if you two wouldn't act like adolescents—"

"Jen, if you'd give people, including *men*, a chance, they would like you," Kyra said. "That was true before, it's true now."

"I'm sure." Jen dismissed the compliment with the shake of her head, her face warm. "I know you're just getting the last word in, but for what's it worth, I meant the comment about your soul mates to be funny, but it came out bitchy. I'm sorry."

Chelsea muttered something about crazy friends, and let go of the strand of hair she'd been mangling.

"Whatever." Kyra shrugged. "I didn't mean that thing about

you hiding behind your weight either. *I'm* sorry."

"Now, that's better." Chelsea patted Kyra's arm. When she was finally rewarded with a grudging smile, she added, "And stop pointing out how fabulous you think Ted is, or I'm going to let you live with him for a few months."

Jen and Kyra let out catcalls.

"Oh, be quiet. *Be quiet.*"

Kyra and Jen smirked, then Kyra disappeared to the lunch counter, returning shortly with a huge wedge of cheesecake topped with strawberries and chocolate.

"Dessert," Jen said in an exaggerated, dreamy voice.

"Yes, Jen, that's what they call this."

Jen laughed.

"And just for the record," Kyra said a few minutes later, licking a drop of chocolate from her finger, "any of the men I've loved could've been the one. Think about it. What if I chickened out, gave up, and missed out on the one who really was *the* one?"

Jen and Chelsea exchanged a look.

"What are we supposed to say to that logic?" Jen asked.

"Absolutely nothing," Chelsea agreed.

"See, I'm right."

"I wouldn't go that far—"

Jen was interrupted by a muffled beeping sound coming from one of the purses. She groaned.

"Is that you, Chels?"

Chelsea nodded a bit sheepishly.

"What is it this time? You need to have a drink? Go for a

pee?" Jen asked.

Chelsea shook her head. "You mock, but notice how I'm never the late one?" She silenced the alarm on her phone. "I've got to run and pick up the girls."

"Seriously? I thought Ted was going to get them today."

Chelsea tucked a wave of hair behind her ear and gave Jen an apologetic grimace. "Couldn't. The girls have a dance recital, so he can't work tonight. He asked if I'd grab them, so he can do a little more before he leaves for the evening."

Jen groaned. "That sucks. It's not like you get out that often. So what are we going to do without her, Kyra?"

"Well, actually . . ." Kyra studied her empty dessert plate.

"No, are you kidding? You have to go too?"

"I'm sorry. I thought Chelsea'd be staying longer. I accidentally made overlapping engagements."

"But we just got here! I turned down other plans because we were hanging out."

"I'm sorry, Jen. I just never get to see Jimmy during the day and since I was taking the whole afternoon off—"

"You're dumping me for *James*?" Jen picked up her napkin, scrunched it, then placed it on her dirty plate.

"What does '*James*' mean?"

"Nothing, nothing. Forget it," Jen paused. "Are we still on for Saturday though? Shopping for a whole new wardrobe? I can't believe it's my one-year anniversary. I'm going to own more than one pair of jeans again, imagine!"

Chelsea blushed. Kyra tapped her pointer fingers together.

"Volleyball tournament. And I said they could have friends

sleep over. Ted'll kill me if I desert him with them after harassing him to stay around more."

"Chamber of Commerce luncheon. Can we reschedule for Sunday?"

"Well, I was going to go to church—"

"Never mind, Jen. Sunday doesn't actually work for me either, I just remembered. How about Monday?"

"I have to work—"

"Come on, Jen, please? You build websites at odd hours all the time. It's not like Dave makes you punch a time clock. You work at home. Can't you work Sunday instead? Church doesn't last all day." Kyra smiled with dimples at Jen, then looked to Chelsea for reinforcement. "Would you be able to come if it was Monday instead, Chels?"

Chelsea fidgeted with her watchband. "I think so, I think so . . . but I feel bad about today. What are you going to do?"

"Read for a bit, I guess," Jen said, nudging her backpack with her foot. "Then hit the gym maybe."

Chelsea's eye rested on Jen's stuffed pack. "You brought your library with you as usual? Well, I don't feel quite so bad then."

"Yes, that settles it," Kyra said with finality. "Jen's at eleven, Monday. It'll be great, Jen. We'll celebrate. It'll be your day."

"Sure. Sounds good."

Chelsea squeezed Jen's shoulder, her face wrinkling in another wordless apology, and then she and Kyra hurried to the door.

Jen looked at her watch. A whole afternoon to kill, and then

a whole evening. She couldn't believe she'd turned down plans with Dave and Lana for... *this*. She tapped through some downloads on her e-reader. *Can Man Live Without God—* interesting question, but she wasn't in the mood. A book about sugar addiction—ugh, definitely not. The latest Jodi Picoult? Maybe—no. She finally settled on a graphic novel. Soon she, an elderly couple, and a group of women around her own age were the only ones left in the restaurant. She read for a while, but stopped when she realized she'd read the same page twice and still couldn't recall what it said.

On the way out of the restaurant, a display of chips caught her eye. *Corn chips.* Jen looked at them for a long moment, then reached into her bag and rummaged for change.

2

JEN DEAD-BOLTED THE DOOR AND made her way across her condo's tiny living room, shoes still on. Sighing with something a lot like relief, she sank into her chocolate-brown leather couch.

She lay there a few minutes, eyes closed, breathing deeply. Then she lifted her legs and pushed off each running shoe. They landed with dull thuds on the leopard-print rug. She ran her hands through her sweaty hair and shivered, chilled by the perspiration drying on her body.

"I should change," she said to the dark room, but didn't get up. Instead she pulled a fleece blanket out from where it was wedged into the back of the cushions, tucked it around herself, and reached for her phone.

"You have two messages," a robotic voice informed her. "To hear your messages—" Jen pressed 1-1. Her mother's voice replaced the robot's.

"Give me a call, Jen, will you? It's been too long." A pause. "Maybe we could have brunch on Sunday? Do you still eat brunch? Okay, never mind. We can have coffee. Okay, call me—bye." There was another pause, then dead air.

"Hey." Jen sat up abruptly, and sucked in a sharp breath. "Jen, it's Jay. I saw you the other day at Book Binge. Babe, you look great. I made my way toward you, but then you were gone. You must not've seen me." *Of course I saw you, idiot. That's why I was gone.* "So anyway, I've been thinking a lot lately. It's been almost a year. A lot has changed." *Yeah, like your wife finally dumped you. Kyra told me.* "We should get together and talk." *And there should be world peace. Too bad neither are going to happen.* "Sooooo, call me, number's the same or I'll call back later." *Thanks for the warning.* Jen punched the pillow beside her, hard. *Happy Anniversary, Jen. You have so much to celebrate*, she thought. Tears were coming, so she decided to take a shower. It might camouflage them.

IT WAS HARD TO BELIEVE that another weekend was over, another workweek begun. Jen dropped her heavy shopping bags inside the door and flexed her aching fingers. White lines marked her hands where the plastic bag handles had bit into her flesh. At least the four flights of stairs were good for her butt. She had a big glass of water and moved to start putting things away.

Midnight-blue silk shimmered in its tissue wrap at the top of one of the bags. Jen smiled at the memory of how the gown had clung in all the right places for once, and how her leg looked in the thigh high slit.

Shopping for clothes was strange now. It felt more like dressing a doll than dressing herself. Everything fit. Anything

she tried. She could just pick a size off the rack. That simple. That unembarrassing. A salesclerk even pooh-poohed the dress size Jen requested. "Goodness, dear. That would never fit you." For a moment, it was a flashback to BBT (bigger body times), then the woman continued and Jen's spine relaxed. "You're at least a size smaller than that." And, to Jen's amazement, she was. Two sizes smaller, in fact.

Jen closed her closet and looked at the shopping bags still sitting on her bed. They were stuffed full again, but now with clothes to give away. She moved them to the front door, so she wouldn't forget to drop them off at the Salvation Army and went into the kitchen. Light glowed off the soft orange walls.

"You look like a carrot in here," her mother had said when Jen showed off her handiwork during a phase of dieting that had her repainting every room in her condo to stave off munching. Jen smiled at the bright white border of daisies painted helter-skelter two feet down from the ceiling. She loved this room. Arming herself with a 64-ounce bottle of water, an apple and some cheese, Jen went into her office.

Originally, her office was the dining room, but she didn't need that kind of formality—the kitchen nook worked fine for her needs—so she'd laid maple laminate flooring and stuck her multiple desks and bookshelves in it.

Three monitors glowed at her. She settled into her well-worn chair, rolled to the newest computer, and clicked to open her mail. A chime sounded. She had four new messages.

Jen skimmed the first message and made a mental note to call Dave later and tell him the New To You franchise wanted

an online shopping site.

Uninterested in another credit card, Jen deleted the second message. Rolling her eyes, she trashed the third message as well. No, she didn't need a bigger penis.

The fourth subject heading looked like spam too, and she was about to hit delete again when she saw the sender's name.

She opened the e-mail. "Dear Red-haired Babe." *Red-haired babe?* She frowned at the e-mail and read it again.

From: InTinyTown
To: jar@yahoo.ca
Subject: Too Good To Be True?

Dear Red-haired Babe,

You sound too good to be true, but I am interested in going for coffee. It's actually doable because I'm only two hours away.

You might find I'm not your kind of guy though. I'm pretty laid-back, just your average Joe. I do like to do new things and I'm not afraid of a challenge, but I'm not really sure what you meant when you said that. If you want to e-mail back and forth for a bit first or make plans to meet right away, I'm open to either.

Thanks for making contact.

Cheers,
Greg Hart (That's my real name. What's yours?)

Feel free to e-mail again soon? What the hell? Jen leaned back in her chair, apple and cheese forgotten.

B5 – Mainstream; Your Entertainment & Lifestyle Weekly

DEAR FAT GIRL: I'm a concerned mom

> Questions, Dreams, Raves, Rants and Fantasies?
>
> Express them and have them responded to by our experts!
>
> ――――――――――――――
> **ASK MAINSTREAM**

Dear Fat Girl,

My ten-year-old daughter is a very big girl. We've been fighting her weight problem for years.

She's 5'3 and 110 lbs, but she resists all my attempts to help her. Her belly sticks out and so does her bottom. Even her legs are chunky. Everyone knows fat girls are miserable. I want her to be happy and healthy. What can I do?

Sincerely,
Very Concerned Mom

Dear Concerned Mom,

The number of people who write to me about someone else's problem when they're the ones with the problems, never fails to amaze me.

Have you heard of puberty? I'm assuming, yes, since you have a child. Apparently your brain was shortchanged of growth hormones during yours.

This is for all parents, not just you. The pot belly so

many of you are concerned about in your under ten-year-olds (What is wrong with you people?) is a normal developmental phenomenon. Children do not have the strong wall of abdominal muscles that adults do. Hence, the swaybacks and pot bellies.

Puberty, the onset of sexual maturity, usually occurs anywhere from 8-13 in girls, 10-16 in boys. Both genders grow rapidly, gain weight and experience changes in body composition, especially in the quantity and distribution of fat and muscle. Girls' bodies build up fat as they develop womanly contours; their hips get wider and breasts develop. Arms, legs, hands, and feet get bigger. Your child is 5'3; 110 pounds *is not* obese.

But enough, this isn't Sex Ed! Get yourself a book about child development and stop undermining your daughter's value and self-worth. Do you really want her to grow up believing that her whole identity is tied up in her body?

Do I sound harsh? I think I sound harsh. But love like yours creates eating disorders. Get help with your own body issues and stop hurting your kid.

Very Sincerely,
Fat Girl

P.S. Thanks for letting me in on everyone's secret. I had no idea I was miserable.

3

J<small>EN LAYERED TOMATO, CUCUMBER, SPROUTS</small> and hummus on nutty, whole grain bread and felt glad her back was turned to her mother.

"To tell you the truth, Jen, I'm sick of your attitude. You're a very pretty girl now. You have your own condo and a decent job. You come from a good family. . . . You're smart."

Nice, Mom. Put brains way down on the priority list.

"You need to stop moping, stop being so snooty, and stop playing hard to get."

In other words, grab the first man who'll have you.

Jen's mom stopped to take a breath just as Jen waggled her finger seriously at the pickle jar.

"What are you doing? You're a woman, Jennifer, not a teenager. You'd think for one minute, you could listen to me and stop imitating me like a child."

Jen moved toward the table, plates in hand, and stuck out her tongue. "Sorry, is that better? I've heard your patter my whole life. The replay gets old fast."

Marie waved her hand as if to brush away Jen's comment and squinted at her plate. "What is this? Surely you didn't find those ingredients in my fridge?"

"You make them sound like toxic sludge or something." Jen plunked down on a chair. "And no—I brought them with me."

Her mother sat down too. "When I said we'd have lunch, I assumed you'd know that meant I'd have food for you."

And should I have assumed you were going to cook it too? "I had a craving," Jen said aloud. *And I can't eat that processed garbage you call cheese and the white glue masquerading as bread.* It still boggled Jen's mind that with a mother like Marie, she'd ever managed to have a weight problem in the first place. Where had she learned that food could be good?

Marie snorted. "No wonder you're having cravings, you look half starved to death, like you're an-or-ex-ic or something." She picked up her sandwich, looking as if it might bite her, instead of the other way around.

The anorexic comments were newish, added when Jen first hit her goal weight, and was, for the first time since she was eleven, lighter than her mother. Jen didn't know what was more annoying—the accusation or the fact that Marie always enunciated each syllable of "anorexic" separately.

"God, Marie, it's not a competition," Jen's dad had muttered recently at a brunch where Marie spent fifteen minutes comparing and contrasting Jen's measurements with her own. His words made Jen blush, her mother livid.

"You think I don't know that? What are you talking about anyway, Ed? As if you know anything about mother/daughter relationships. You just sit in your chair, head in the sand—"

"Mom, you look great," Jen had intervened as usual. "You're gorgeous." Her mother raised her eyebrows, but finally let

herself be soothed.

"Well, I'm not bad for an old bag. Frankie still can't believe I have children Sam and Diane's age." Frankie was Marie's hairstylist. She tipped him well.

Jen grimaced at the memory of that brunch and forced it from her mind.

"I'm not anorexic, Mom. Not even close."

"Well..." Marie gave Jen a once over with her mascara-spiked eyes. "I guess you're not, but you've lost enough weight. You have to be careful. If you lose too much, your mood will suffer. You'll be one of those irritable skinny minis who never eat and can only talk about how many calories they've burned. No man likes that."

Jen almost choked on the bite of sandwich she'd just taken.

"What?"

"Nothing," Jen mumbled through her mouthful of sprouts. "It's just my whole life you've been saying I need to do something about my weight or I'll be miserable and alone; now you're telling me I should watch out or I'll end up a miserable skinny person, *alone*. Can I ever win with you?"

Marie opened her sandwich and studied its contents. Eventually she replaced the top piece of bread. "I just want you to be happy. And married."

"Ahhh, the catch!"

Marie took a small bite of her sandwich and chewed carefully.

"Actually, this isn't too bad," she said, surprised. She nibbled again.

"I am happy, Mom. Or close to it."

"I just don't want life to pass you by. Look at Diane and Sam. They love being married."

"Yeah, but I'm not them, remember?"

The phone rang and Marie jumped up from her bird-pecked sandwich. "Oh, Diane! Hello! Just a minute." She held her hand over the receiver. "It's Diane. I'm going to be a bit. Let yourself out, okay? I love you, sweetie. We'll get together again soon."

Jen nodded, but Marie had already disappeared into the next room.

It's not you, Jen reasoned with herself. *Diane's out in Surrey. If Mom saw as much of her as she does of you, she wouldn't always choose Diane.*

Jen finished her sandwich, brought her plate to the sink, and chugged two tumblers of tap water. She held her hand over her mouth, waiting for the waterlogged feeling to pass, then got her mom's plate and tipped its contents into the garbage. Her mother wouldn't care. In all the years she'd been alive, Jen had never seen her finish a whole sandwich.

※

"YOU NEVER RETURN MY CALLS," Chelsea's mother whined.

Chelsea winced at the volume, held the receiver away from her ear, and squeezed the dishcloth over the sink.

"Yes, I do, of course I do." Chelsea started to dust around the ceramic apple collectibles on the windowsill above her sink.

"What about last week, what about last night?"

Pale sunlight filtered in through the dying leaves on the birch tree outside the window, casting splotchy shadows on the wall.

Chelsea sighed. "That's two times, Mom. You call every day—and last week I was out with Jen and Kyra, you knew that. Anyway, I assume you weren't calling just to complain about me not calling?"

"Well, no . . ."

Chelsea waited. She waited some more. She finished the apples and moved to the china cabinet.

"*You* called me," Chelsea finally said. "What do you want?"

There was a long tortured sigh from her mother's end.

"He's got a girlfriend."

"So what? You knew he would."

"You don't understand. She's hardly older than you."

"So—"

"She has a ten-year-old daughter."

Chelsea dropped the dishrag, and then forced her hand, now a clenched fist, down to her side. Moving slowly, she stooped to retrieve the cloth. She looked at it for a long moment, then bit her lip, and proceeded to wipe the cabinet's golden oak face.

"Did you hear me? Did you hear what I said?"

Chelsea wiped harder.

"I heard you. Girlfriend. Ten-year-old."

Her mother fussed on.

A ten-year-old daughter. The words replayed in Chelsea's mind. She moved from the china cabinet to the Deacon's bench

sitting against the wall, across from the big dining room set. Her cloth slid over the maple back of the bench. *A ten-year-old daughter.* She pressed harder. Bit her lip harder. The pale hard wood shone. *A ten-year-old daughter . . .* When she finally let the cloth rest, her bottom lip hurt and she tasted blood.

"Why are you telling me this?"

"I don't know. It's just disgusting, that's all. He's almost sixty. What she sees in a man old enough to be her father is beyond me. And him? Well, it's—"

"Look Mom, I have to go. No . . . no, it's all right. I'm glad you told me. I just have to go—to the washroom. Yes, *all of a sudden.* I'll call you back. I don't know—*later.* K . . . okay . . . Bye." Chelsea hung up.

Her mouth formed the beginnings to a prayer, but it had been too long. She no longer knew how. She sank onto the bench.

It was hard and unyielding, but calming. Her finger traced the etched groove in the seat, a line as familiar to her as her own hand. She'd spent almost every morning of her childhood on this bench in Richard's hallway, right beside his kitchen where her prying-eyed mother cooked and cleaned and nagged. Comfortably close to her. Comfortably far from him. Away from any chance that Richard would come to her room, away from any excuse he could have to rouse her out of bed.

Chelsea pulled her knees up to her chest, and wrapped her arms around them. *A ten-year-old daughter.* She sat on the bench for a long time.

A shrill buzzing noise made her jump, and she looked

around, confused until she noticed the good, wholesome scent coming from her oven.

She walked on shaky legs to the stove, turned off the timer, and pulled two golden loaves out of the oven. As they cooled on racks, Chelsea bent over her reflection in the gleaming metal of the toaster. With a careful fingernail, she removed the eyeliner smudges that told of tears.

"The girls will be home soon," she whispered. "They'll be happy I made bread."

"DINA!" CHELSEA'S VOICE WAS SHARP. "What are you doing?"

"What?"

"What are you eating?"

"Oh—I just forgot. I'm sorry. Can't I please eat it? Just this one time, please?"

Chelsea let out an aggravated sigh. "Just this once, then no more. You're outgrowing everything in your closet. For the life of me, I don't know why your father buys that stuff."

At the oval-shaped oak table, Brianne sat silently through her mother's outburst, reading. She looked up and watched Dina wolfing down a jelly-filled donut and three Oreo cookies, one right after the other.

"I have an idea," she piped up suddenly. "Why don't Dina and me just stick our clothes together in the same closet? We could use mine for clothes and hers for games and stuff. Then it doesn't matter if she outgrows her clothes; she can wear mine."

"Why don't Dina and *I*," Chelsea corrected, looking up from

the counter she was wiping for the third time. "But what are you talking about?"

"Well, it's normal for kids to grow. Dina will grow a lot in the next year or two. I did when I was her age."

Chelsea smiled in spite of her irritation.

"When you were her age, hey? You're *twelve*. You sound like an old lady recalling herself at the tender age of nine."

Brianne shrugged. "I just don't see what's the big deal. We can share."

"Can we, Mom?" Dina asked, looking up from her empty plate like an eager puppy.

Chelsea suddenly flushed. Why was she putting her crap on her kids? She stared at them. They were so beautiful: Brianne with her lanky, coltish build and mass of curly dark hair, so like her own if she didn't straighten it. Dina with her daddy's fair round face, solid frame and flaxen hair, bobbed. She was a pixie. Chelsea frowned again for a moment. Dina *was* getting chubby though. She almost had breasts. And good grief, she was just a kid, practically a baby. She didn't need breasts and all that came with them. The girls returned her scrutiny, wide-eyed.

Chelsea felt tears form. They really were *so* beautiful.

"Are you losing your mind, Mom?" Brianne's voice was edgy now, sarcastic, more in keeping with her twelve-year-old self.

"Watch your mouth, Brianne—and the closet idea's out. You guys would just fight. Besides, Dina already wears your size. And bigger." Chelsea had no idea why she added the last words except that they were true. Dina's face went a dull red,

and the ever-present knot of guilt in Chelsea's stomach thickened and tightened.

"It's okay, kiddo," she amended, walking over to stand next to Dina. Stroking her cheek, she added, "Your sister's right. You are at the age where you grow a lot. You'll probably enter puberty soon."

They seemed to talk about puberty constantly these days yet still, without fail, the concept was hilarious to the girls. This time was no exception and at the mention of the "p word," both girls lost their solemn expressions and burst into giggles.

Their silliness relaxed the tension. Chelsea asked if they wanted some veggie sticks to chase down the sweets they'd just consumed. And after Brianne prodded her for the third time, "Aren't you going to eat too?" Chelsea munched on a carrot.

A few minutes later, Brianne disappeared to do her homework and Chelsea tried to shoo Dina. "You have spelling to do, hon."

Dina stayed put, though.

"Something on your mind, Deen?" Chelsea asked, moving from one cupboard to the next. What on earth should she make for dinner? It seemed like all she did all day was move from one type of food preparation to the next.

"Ummm..."

"Well, speak up. I've got work to do."

"Am I going to be pretty?"

"What?" Chelsea stepped down from the stool she'd hopped up onto to reach the cookbooks.

"Am I going to be pretty when I hit puberty?"

"Oh, honey, you're already pretty."

"No!" Dina's cornflower blue eyes were serious and her mouth, normally a smiling heart, was a thin line. "No. Will I be pretty like you and Brie when I hit *puberty?*" There was no hint of a giggle about the word puberty now. She stressed it as if it had some secret power, as if it were a magical place, not merely a phase of physical development.

"Sweetie, you're a beautiful little girl and you'll stay beautiful."

Dina's mouth opened to speak once more, and Chelsea heard the word "no" again before it was even formed. She was hit with inspiration. She knew how to help her youngest daughter.

"You are beautiful. A beautiful blonde," she reiterated. "And you'll be just as beautiful as Brianne when you hit puberty as long as you watch what you eat—healthy snacks and not too much. And exercise. Play, ride your bike, work hard at skating . . ."

Dina nodded.

"Do you have any other questions, beautiful girl?" Chelsea asked, hugging Dina, reveling in her warmth and softness. Dina shook her head against Chelsea's shoulder. Chelsea released her and added, "If you have any more questions, you always just ask me, okay? Anything at all . . ."

Dina nodded again and slipped away.

Chelsea smiled as she started dinner. Chicken breasts, spinach salad, rice pilaf . . . She'd have it all ready when Ted got home. He could eat with the kids while she went for a run. She needed to clear her head.

IN HER DREAM, CHELSEA WAS speaking Spanish and smoking on the veranda of a small restaurant. The twilight air was filled with the heady scent of cooking spices, and a hum of voices and laughter came from the bustling sidewalk. A nearby busker played the blues, open saxophone case at his feet. The sad notes somehow made Chelsea feel happy as she chatted with the man beside her. His seat was so close to her their knees touched. They held hands and every so often his grip tightened or loosened, as if even his hands were responding to what she was saying.

Staring into his face, Chelsea felt she knew him—but from where? From when?

The analytical part of her mind, active even in sleep, pulled her toward waking. *No,* she commanded groggily, *let me enjoy this.* It seemed to work. She felt herself relaxing.

The man said something, but Chelsea didn't catch what it was. An angry alarm was suddenly blaring, obliterating his words.

"Is this a fire drill?" she asked.

Her friend shook his head, smiling, and started to knead the back of her neck with his big hand. It made her want to purr. But there was the shrill noise again.

"I'm just really worried. What if there's a fire?"

"Don't worry," the man said. "Come a little closer and—"

"Get up, Chels. Hurry, will you? It's after seven." Ted's loud voice grated Chelsea awake. She tried to hold on to the dream's

happy peacefulness, but the scene was already fading fast, her brain muddling through its confusing elements. *You haven't smoked in years. Where the hell did you learn Spanish?* Suddenly she realized that her mind was speaking to her in the voice of Ted. She groaned. "Et tu, Brute?"

"What?" Ted asked from beside their king-sized bed where he was hunched over, searching for socks in a pile of clean but unfolded laundry.

"Nothing."

"Okay then . . . so get up. The kids are going to be late."

Chelsea nodded and grimaced, forcing herself out of the solace of her duvet. When Ted gave her a cheerful kiss goodbye later, his hair still damp from the shower, she kissed him back wishing she felt something other than exhaustion.

KYRA SLAMMED THE PHONE DOWN. "Stupid old bat!" she hissed and then remembered James. James! She breathed in deeply, twice. Air in, air out—and again—willing herself to calm down.

"Now where were we?" she said.

"What was that all about?" James seemed genuinely concerned, almost puzzled.

"Oh, you know family. Blah, blah, blah."

"No, I don't know. You never talk about your family. Enlighten me."

Kyra rubbed James' chest in a circular motion, then trailed her hand down, stopping just above his belt. "Weren't you telling me I was beautiful?"

"Well, actually," James relented, "yes, yes, I was." He lifted her chin and softly kissed a spot just below her jaw in a way that drove her mad. She leaned into him and relaxed. He was so good at this. At just the smallest thought of what might come next, she could feel her body getting ready. He reached up her shirt and ran his hands over her lace-covered breasts, stopping when her nipples rose. He traced the hardened nubs with gentle fingers, then suddenly tugged one. A shock line of heat coursed through her all the way to her knees.

"You smell good," he said in a matter-of-fact way that Kyra found very sexy. His hands didn't stop moving, but now they were out of her shirt and massaging her scalp—she loved how he did this, how he paid attention to her whole body. Unlike so many guys, he didn't have precursory target zones that he hit out of some perceived obligation before moving on to the "goods."

"Don't think," he commanded like he could read her mind. "Just feel."

It always surprised her how he managed to turn her whole body into an erotic spot, but she never knew if it was as good for him as it was for her. With other men, she did. They generally popped the question after the first time, yet James never had. *Not for my lack of trying . . .* She sighed.

"What?" His hands instantly stopped moving. He could even tell when her sighs weren't arousal based. He was amazing.

"Nothing."

"What?"

Kyra looked up at him and pressed her body against his. "Bad day at the store, Jimmy. Make me forget it?"

Using only one hand, she undid his belt buckle, leaving no doubt about what she had in mind.

He hesitated for a just second, and then replied in a pseudo-Texan drawl, "It'd be my pleasure, lil lady." He pushed her onto the bed. Kyra's stomach flipped and warmth swelled in her belly.

James leaned over her. "So how do you want to play this time?" His voice was more heat and breath than words. "Soft?" He touched her cheek, brushing her hair out of her eyes. "Or—" James grabbed her hips and pulled her against himself, hard. An electric current raced through her. "Or did you have something else in mind?"

Kyra bit her lip, as every part of her body below her waist simultaneously melted and tightened. By the time James actually entered her, she'd be aching with want and practically begging.

"Surprise me," she said in a breathless rasp that wasn't feigned at all.

"Oh, so it's like that, is it?" James grinned sexily, and looked her up and down. "Well, seeing as we have some time on our hands . . ."

Kyra smiled back and slid farther up on the bed. "I can take whatever you can give," she said and put a hand on his crotch. It rose to her challenge, and there was another sharp inhale—his this time.

Later, Kyra rolled lazily onto her side to look at him, only to

find him watching her. It was the one thing she didn't like about lights-on sex; there was no hiding. With James she always felt naked in a way that had nothing do with not having clothes on.

The way I respond to you is embarrassing, she thought. Out loud she said, "That was practically indecent," and stretched, showing her breasts off nicely. James grinned and ran a finger along her cheek line and jaw, but that was it. No talk of love, or where their relationship might be going. No sign that he felt similarly undone by what they did together. In fact, no indication that he felt anything other than finished.

Kyra turned away so that he wouldn't see her eyes, then got up, pulled a sheet around herself, and walked across the bedroom to the bathroom en suite. Halfway there, she turned and blew him a kiss. She could play it casual too. She returned, washed and dressed. At her vanity, she smoothed her hair, checked her makeup, and slid on a pair of amber drop earrings, carefully nonchalant.

"Something wrong?" he asked.

Kyra picked up her compact, bent toward the mirror and dusted her face. "Not a thing. I just didn't realize how late it was."

She caught him watching her again as he lounged on the bed, and she lowered her eyes to avoid meeting his gaze in the big mirror over her dresser.

"We're good like we are. Why wreck it?" he asked.

She nodded. "I know." Maybe she was wasting her time. Maybe he wasn't marriage material. But he seemed happy to be

monogamous, and she knew she could be—he definitely matched her sex drive. And when they'd first met, he'd said he wanted to get married one day.... So why not to her? James smiled again and his eyes crinkled up at the corners. Dammit, he was just so appealing.

It didn't matter how she simpered over the previous men in her life, she'd never had any problem cutting them loose. She didn't even mind letting them save face by saying they dumped her. In fact, she preferred it. Now here she was, stuck on a guy she couldn't read at all. It would be funny, except that it pissed her off so much.

Kyra went back to the bathroom and peed. "I'm going to be a minute," she called. "Will you confirm our reservation? Just tell them we're running half an hour behind." She heard the bed creak as James got up. "Brochure's on the fridge." He took himself out of the room and Kyra used the acquired time to power think.

Good job. Check.

Good with kids. Check.

Not a cheating scumbag. Check.

Nice looking by himself; good looking with me. Check.

Good conversationalist, witty and diverse at parties. Check.

Good and kind, but not stupid. . . . Check.

She'd give him another month or two, she decided, but then if things were still the same, they'd have a serious chat.

Kyra felt herself calm down. Men couldn't help themselves; they'd disappoint you constantly if you let them. He obviously didn't realize that being good the way they were was exactly the

reason they should get married. Their kind of chemistry didn't just fade away.

She smiled at herself in the mirror. Some people didn't know what they wanted. Once you recognized that, you could them help figure it out in a way that also helped yourself.

Downstairs, James helped her into her coat and held the door open for her. She beamed at him. Upstairs, she'd forgotten to list "charming and polite." Check!

James returned her smile, but studied her face. "You're an enigma, aren't you?"

"Cripes, what's that supposed to mean? Most people say I'm an open book." He shook his head, shut the door behind them firmly, and keyed in the alarm code. "Nope. That's just what you want them to think. It's a carefully constructed ruse."

"I *wish* I could be so mysterious," she said and winked, but inside something tightened in a very nonsexual way. She threw him the keys. "You can drive, but only if you're fast."

"You're the boss." James caught the keys and made a low noise like a racecar revving.

The strange sensation in Kyra's stomach intensified as she got into the passenger seat, buckled up, and realized he was still watching her.

OCTOBER

4

JEN'S NOSE WAS COLD AND her arm, sticking out of the blankets above her head, was even colder. Ugh. She burrowed deeper into her bedding, but then peeked a look at the clock. Almost ten. She thought about getting up, but why bother? She'd worked late. Plus, it was *cold.* Relishing the warm, smooth cotton against her bare legs and the luxury of not having to be anywhere, she sighed heavily and dropped back into sleep.

She didn't enjoy her peace for long. The phone shrieked beside her ear.

"Hello?" she groaned.

"Jen? It's Sheila from Lady's Fit."

"Hey Sheila. Say, would you mind calling back later, I'm sleeping in and my membership's—"

"It's nothing to do with your membership." Sheila paused and seemed to search for words.

"Oh. What is it then?" Jen looked at the clock again. Just after ten now. Not so early that she could resent the call. Hip-hop music blared in the background.

"I'm sorry, it's just kind of... well, we don't want to have to call the police, and her husband isn't home. Then Karen re-

membered she signed up—"

"I'm sorry, Sheila, but what on earth are you talking about?"

"It's Chelsea, your friend, the one who joined under your name at the bring-a-friend promotion last month? We can't get her to leave."

"What?"

"She got here at six and she's been going like a maniac. Normally we don't care, and we get bodybuilders who do long stints, but she's... not right. When I suggested that maybe she'd done enough on the stair climber, she lost it. Clients think she's going to pass out. She keeps saying it's her right to be here."

"I'm on my way."

"Be fast. I'm almost ready to call the cops. I don't know what else to do."

"No, wait. Please. I'll be fifteen minutes, tops." Jen sprang out of bed and pulled on sweats and a T-shirt. Chelsea could be a bit over the top about working out, sure, but she'd never be stupid about it. Apprehension swirled in Jen's belly, making her nauseous. This wasn't just over the top, it was...

"Crazy... You're being crazy, Chels. Come on," Jen begged. She didn't like the color of Chelsea's skin: gray parchment splashed with purple. "Have you checked your heartbeat lately? It's practically jumping out of your throat."

Chelsea turned her head, finally acknowledging Jen's presence. Her legs kept pumping, not furiously, but in a slowed step that barely moved the machine's pedals up and down. Jen

stepped back at the sight of Chelsea's eyes. The whites were red and painful-looking. Her pupils so dilated, the irises looked almost black. But it was their gleam that was all wrong—not just unhappy or stressed out—something darker. Jen shuddered.

"I don't see what the big deal is. I'm just working out. If I'd known this fucking hellhole had time limits, I never would've signed up."

Jen tried to hide her shock at Chelsea's language and took another step back. Chelsea didn't seem to notice. "And it's not in their fine print. I read it carefully. You should've told me. It's complete misrepresentation."

Jen looked at Sheila who stood a machine away, pretending to be resetting it. Sheila returned her look with a helpless shrug. Jen took a deep breath and forced herself to retake the two steps to Chelsea's side.

"I can see why you're angry," Jen said. *Because you're losing your mind, that's why.* She fought to keep her voice mellow, conversational. "And I'll talk to them about their policy—but you aren't being kicked out, just being asked to switch to something less intense. Maybe take a break to stretch?" Jen couldn't help but notice that although the gym was busy and all the treadmills and ellipticals were full, the platform of stair climbers was empty except for Chelsea. She'd scared everyone away?

And she did look scary. She was drenched with sweat. Knotted muscles protruded from her calves, and the hollows behind her knees were cave-like, the tendons stood out so prominently. A sulphur-mixed-with-cooking-egg odor emanated from her. Jen bit her lip, trying to quell the panic rising in

her throat. Her eyes teared. She bit her lip harder. *No crying. Act like everything's normal.*

"Come on, Chels. We have a coffee date, remember? You're not shafting me, are you?"

Chelsea's angry expression morphed into confusion. "We didn't have plans today, did we?"

Jen nodded, but couldn't meet Chelsea's eyes. "Yeah. Maybe we can have lunch too? I'm starved. How about you? When did you last eat?"

"Don't you start up too!" Chelsea's voice was almost a scream. "I eat plenty—*plenty.*"

"I know you do."

Sheila started to fidget and Jen knew she'd better speed up the process.

"Look, it's not fair, but it's the way it is. Sheila"—Jen cast a dirty look the woman's way—"has made it clear your time is up. If you don't come, she's going to call the police."

"Don't get me wrong," Sheila said, sensing Jen's game and striding over. "I don't want to, but management has strict rules. I can't afford to lose my job."

Chelsea's jaw tightened. Glaring, she hit the stop button on the machine. The steps fell from mid-motion with a clunk. Chelsea tried to bounce off, but didn't have the strength in her fatigued legs. She swayed. Jen managed to catch her and Chelsea sagged against her for a few seconds. Then, pulling herself up tall, Chelsea limped toward the change room. Jen hung back a moment.

"I'm really sorry," she said to Shelia.

"It's not your fault. I'm just glad you managed to get her to

stop—and don't worry, Jen. She's not the first to go a little exercise bonkers. She'll come around. Some women hit three gyms in a day. They're insane. This one time—"

"I'd love to chat," Jen lied, "but I should go check on her." She bobbed her head in the direction Chelsea had disappeared. "Then we'll get out of your hair. No hard feelings or future awkwardness, I hope?"

"Oh no, of course not," Sheila said. Jen left her nodding, and went to find Chelsea.

Jen pulled the blanket up over Chelsea's warmly dressed body, and looked down at her friend. She seemed completely normal now—or as completely normal as any adult could seem when her other adult friend was tucking her into bed for a nap. The promise Chelsea had forced Jen to make on the drive home chewed at her and Chelsea knew it.

"Don't worry so much, Jen. I told you, I was just in a shitty mood because of some stuff that's going on. I was trying to distract myself." Chelsea's voice was sleepy, but there was still a strained note in it. Annoyance? Anger? What?

"I *am* worried though. That was bad—"

"I know, I know. It was just low blood sugar. I've eaten now. I'll be fine."

A skeptical snort escaped from Jen before she could stifle it. "Broth and crackers are hardly—"

"I'll eat a good dinner with Ted and the kids, I promise. You know it's gross to eat something heavy after working out."

Jen thought about it. It was true. And when she helped

Chelsea get dressed, she'd been relieved. Chelsea wasn't totally skeletal. She must eat sometime.

"And please, Jen. Don't worry Ted or Kyra. You promised," Chelsea mumbled, eyes closed. "You're a good friend."

"I don't know about that. I'd feel better if you'd at least tell me what's bothering you—"

"Can't I have a bad day once in a while? It was just a very bad day. It won't happen again."

Jen stared at Chelsea and didn't reply. How could she? Over the years, she'd had her own stints in bed with a stash of books and munchies. Maybe this was just a different kind of coping. Not healthy either, but maybe not the worst thing in the world?

"Actually, Jen, I want to ask you one more thing . . ." Chelsea's voice was reedy, on the verge of sleep. Her eyes stayed closed.

"Okay. What?"

"Your faith. Does it comfort you?"

Whatever Jen had been expecting, it wasn't this. She nodded slowly. "Mostly, yes, I guess. Why?"

"Huh," Chelsea said. "Funny."

"Sorry, I don't understand—"

Chelsea's eyelids flashed open and for a second the creepy look from the gym was back, but then her eyes closed again. When she finally muttered an answer, there was no heat to her words. "Believing in God wouldn't comfort me. It would piss me off."

"Oh . . ." Jen faltered, then realized she didn't have to come up with a response. Chelsea had crashed into sleep.

B5 – Mainstream; Your Entertainment & Lifestyle Weekly

DEAR FAT GIRL: I'M A YOUNG FAN

> Questions, Dreams, Raves, Rants and Fantasies?
>
> Express them and have them responded to by our experts!
>
> **ASK MAINSTREAM**

Dear Fat Girl,

You make me feel okay to be me. I'm not fat, but I'm not skinny either. My grandma says I have to watch it. My mom says that's stupid and that I'm beautiful. (But she's my mom. She has to say that.)

My question is, why do you only write once a week?

Love you!
From 13inmay@ . . .

Dear 13 in May,

May I call you sweetie? Let me call you sweetie! Your mom sounds very wise and from your letter, I can tell she's right. (And remember, I'm an expert!)

I only write once a week because *Mainstream* is only a weekly. If you need advice, or someone to talk to about this kind of stuff more often, try to talk to a counselor at school, one of your teachers, or even your doctor.

Listen to your mom!

Love to you,
Fat Girl

P.S. All you great teens-to-be, please don't give your e-mail addresses to anyone you don't know personally and that your parent/guardian hasn't approved. There are lots of nice people out there, but there are some really bad ones too.

5

"Jen. Diane again. I've called twice this week. Is three times the charm? Hope so. I want to talk about Mom. But you know that. Is *that* why you haven't called me back? Call me!" Jen listened to the message with a small twinge of guilt. She really should call her sister back. She hit delete, and listened to the next message.

"Jen, me again. I forgot to mention that Rainey wants some auntie/niece time. Would it work for her to stay over Friday night? I'm visiting Mom. Rainey could SkyTrain in to meet you. Call me back."

Jen dialed Diane's number.

Granville Station was crowded and had a bad smell—too many bodies, too close together. Not for the first time, Jen thought about how it was easiest to feel alone when you were surrounded by hundreds of people. She pushed the thought from her mind, mumbled an apology when someone jostled her, and looked around for her niece.

Suddenly, cold hands grabbed her from behind and covered

her eyes.

"Guess who?" said a mock-gruff voice. "Hey, that sucks! You didn't even jump."

Jen laughed. "You'll have to do better than that to scare me. And anyway, I'd know your watermelon body spray anywhere."

Rainey fell into step beside Jen. "Hey, I'm almost as tall as you."

"You really are—now slow down will you?" Forgoing the mall, at least for the time being, they exited onto the street and ambled along Granville. An ice cream shop caught Rainey's eye.

"You want ice cream? Don't you think it's more of a hot chocolate kind of day?"

"Any day is a good ice cream day. Besides, I have gloves. I believe in being prepared." Rainey waved small stretchy turquoise gloves at Jen, and Jen laughed.

They got cones and walked on, chatting and people watching. After a bit, Jen asked, "So kiddo, what do you want to do today?"

"Can we shop?"

"Shop? Really? Since when do you like shopping?" Jen licked her almost gone strawberry ice cream and tugged Rainey's braids with her free hand. Rainey shook her head of auburn cornrows free, and their beaded ends pattered on Jen's watch.

"I'm thirteen. It's what we do." She crunched an edge of her waffle cone.

"*We*, huh? Like you and all thirteen-year-old girls everywhere are a collective, not individuals?"

"Pretty much." Rainey munched down the rest of her cone.

"Shopping it is then." Jen tossed the remainder of her ice cream into a nearby garbage can. "Are we looking for anything specific?"

"Jeans. How come you didn't eat your cone?"

"Don't like them."

"Yes, you do." Rainey's brow creased. "You're still watching your weight."

"Sort of. But I also really don't like cones that much."

They headed back the way they'd come, toward Pacific Centre.

"Speaking of weight," Jen said as they entered through heavy glass doors and stood surveying shopping choices on either side of them, "your mom says that Grandma's riding your case lately. How do you feel about that?"

Rainey looked past Jen and pointed at a bright sign. "There's *Legs.* Let's check there."

"Their clothes don't fit my pinky," Jen said.

Rainey looked at her with a raised eyebrow, and again Jen noted their family resemblance. It took a millisecond for her to comprehend her niece's criticism. "Oh, duh," Jen said, blushing a bit. "Of course, I fit their clothes now."

"Their sizes are stupid anyway. I'm almost in their largest size and I'm practically still a kid."

"Practically, eh?"

"Is it hard to remember that you're not fat anymore?"

"That's what I love about you," Jen said and gave Rainey a one-armed hug. "You call things like they really are."

"Oh, sorry."

"No, I meant it. It's refreshing. I'm not offended at all."

Rainey scanned the sea of shoppers for witnesses from school and seeing none, returned Jen's squeeze. "And I like that you don't get totally pissy about everything."

Jen didn't think it was a good time to tell her niece that perhaps "pissy" wasn't a word her mother or grandma would appreciate hearing out of her mouth.

They entered the store. Impossibly thin mannequins bared boyish midriffs and posed, staring, in eternally bored positions.

"So do you forget you're not fat anymore?" Rainey asked again.

"Yeah, sometimes. It's strange. I guess I was just the other way for so long," Jen said. Rainey nodded.

The grasshopper-bodied salesclerk seemed obsessed with outfitting Jen, but eventually realized that Jen wasn't buying for herself and somewhat grudgingly turned her attention to Rainey, who unselfconsciously ordered four styles of pants, each in three different sizes.

"Your sizes are wonked," Rainey said in explanation, disappearing into a camouflage green stall. The salesclerk rolled her eyes. Catching her, Jen raised her eyebrow.

The clerk had the decency to turn red and she ran to get the next size up in the black skinny jeans.

Waiting to see Rainey's first pick, Jen couldn't help but marvel at her niece's attitude. Rainey wasn't fat, but she wasn't rail thin either. Jen cringed, remembering herself at thirteen and the agony of shopping with her mom—the humiliation of not fitting any "junior" sizes. Thank God, no self-respecting

stores had Junior Miss *anythings* anymore! It had never occurred to her to claim the sizing was ridiculous and to demand a size up.

A stall over, some mother was battling with her daughter. "No, absolutely not. Your belly is hanging right over the top of those and I can see your butt crack when you move! Where'd you get that filthy little g-string anyway?"

Jen tried to stifle a giggle, but a small sound escaped. The mother looked over and cast Jen a weary smile. Rainey opened the door and strutted out in a little powder-blue hoodie and jeggings with silver flecks.

"Ta-da!" she said, giving a little turn.

"Now see!" exclaimed the mother. "That's a cute outfit. Why can't you choose something like that?"

Rainey turned fuchsia but didn't miss a beat. "Hey Janelle," she said, sounding apologetic.

Janelle nodded. "Nice hoodie."

"Yeah, but check this out." Rainey pulled the hooded sweatshirt over her head, tossing it at Jen. "I'm getting this for the dance."

Jen and the mother gasped.

"Cool," Janelle affirmed.

"I don't know about that one, kiddo," said Jen, trying to think how she could veto the slinky black spaghetti-strapped tank that barely covered Rainey's stomach and left her perky adolescent breasts popping out the top. "Your mom will kill me if I let you go home with that. Besides—"

"Tell her that her butt crack's sticking out," suggested the

mother.

It was Janelle's turn to be fuchsia. "Shut up Mom!" she hissed. "It looks really good—really good," she repeated, then disappeared into her own cell again.

Rainey turned a few times in the mirror, craning her head over her shoulder to check out the rear view.

"Nah, not really me," she finally decided.

Jen said a silent thank-you.

"But let me show you the silver one. Just a sec."

Jen was left alone in the mirror-walled waiting area with the mother who gave a sympathetic grunt. "It's a nightmare what kids want to wear these days."

Jen nodded.

"They don't seem to care a bit if their love handles show. In my day, we'd have died before letting anyone see our fat jiggling all over the place."

Jen wasn't aware of the look that must've crossed her face, until the woman turned pink and moved away to nag her daughter to hurry up.

"They're just normal, nice-looking girls," Jen said, trying to be conciliatory. The mother ignored her and tapped the dressing room door more earnestly.

Okay, so we're not going to be kindred spirits, Jen thought.

"How you doing in there, Rainey?"

"I'm almost done." Rainey popped into view again, this time wearing a blue cap-sleeved shirt and silver skinny jeans.

"Super cute—and that color makes your eyes really green."

"Is Mom gonna spaz about my butt?" Rainey turned around

so Jen could take a look.

"No, I think it's okay. An inch of flesh all around, but not a crack to be seen," Jen said, straight-faced. They both looked over at Janelle's now deserted stall and smirked.

Rainey hopped into the changing room. "The silver is going to look soooo cool under the black lights!"

On the way out of the store, they passed a tall, lanky teenager being dragged out by her wrist. "I look like a cow in those. I won't wear them. You can't make me!"

The woman with the skinny teen in tow kept her eyes focused on some unseen point ahead and ignored her.

Rainey mumbled something under her breath that Jen couldn't quite catch. It sounded like "retarded."

"What did you say?" Jen asked.

"Oh, nothing—but do you ever get sick of every stupid female in the world hating their weight?"

Jen stopped walking and gawked at Rainey. She was for real. A bolt of happiness zipped through her. She smiled and touched Rainey's cheek. "Yeah, I really do. It's stupid." She made a mental note to tell Diane that Rainey was fine. That she was great, actually.

It was strange to hear someone else's night-breathing in her condo, since Jay—Jen shut that line of thought off, just as a voice in the darkness made her jump.

She started, then smiled, as another completely unintelligible gurgled phrase came from the couch where Rainey slept. The movies had finished hours ago and they'd chatted for a while and then, just like when she was much younger, Rainey

had fallen asleep almost midsentence.

Diane was right. It was good for her to have Rainey over. She was skeptical about whether it was really that important for Rainey's well being, but it was definitely good for her own. As Jen's mind wandered over her relationship with her sister, she finally realized that lying in bed was useless. She wouldn't be sleeping anytime soon. She got up, slipped into a flannel housecoat, and padded on silent feet to her computer room. She left the lights off so she wouldn't disturb Rainey and, checking that her speaker was off first, moved her mouse. Her desktop came to life in bright greens and blues as tropical fish swam across her screen. She smiled at what was waiting in her inbox.

From: InTinyTown
To: jar@yahoo.ca
Subject: Home alone too

Hey Red-haired,

I like the babe part but if you insist, I guess I'll drop it.

Yeah, it's another exciting Saturday night for me. Although, and I'm not too proud to admit it, since you've started e-mailing, nights are more interesting. I'll know if you don't write back before tomorrow morning that you're luckier than me, and your night got filled.

So to answer your latest questions . . . (And seriously, you could've asked these immediately, first e-mail, I would've understood.)

1. I don't need to see a picture of you to find out if I'm interested in potentially dating you because our writing back and forth will let me know that. I'm looking for personality and intelligence. You've got both in spades, so I'm in.

2. I'm not a 550 lb, two-headed, snake-haired monster with acne who would therefore find any humanoid girlfriend satisfying no matter what. I AM a 300 lb, sumo wrestling, three-eyed, worm-haired alien, but some human women find that attractive and I'm insulted that you suggest that the only reason I wouldn't request a photo is because I'm so ugly that I'd consider *anyone* a step up.

3. I'm not a serial killer. I appreciate your friends' concerns, but if they were seriously worried, why'd they send your e-mail address pretending to be you in the first place? That's a bit hypocritical.

4. No, I'm not worried that you're a serial killer. Okay, actually I am *slightly worried*, but only because you bring up the topic so much.

5. I'm totally willing to have a criminal record check done, and to meet your parents (although that's my idea of hell too), or do whatever else it takes for you to feel safe.

6. My job is really boring. Okay, I'm lying. I don't find it boring. I love it. I just hope that fact doesn't make me boring. I'm still going to wait to tell you what my job is until we meet. For now, just pick an interesting career and insert it here _____. Make sure, however, that it's one that binds me, for the time being, to small town life. (Small towns are kinder to worm-haired aliens.)

Well, that wasn't actually twenty questions, it was only six and like I said, you don't need to apologize for asking questions. I've thought up a few more myself. Here goes.

Jen read his questions, then reread the whole letter, trying not to laugh out loud because she didn't want to wake up Rainey. Finally, still grinning, she hit reply.

From: jar@yahoo.com
To: InTinyTown
Subject: NOT Home alone! ;)

Hey Greg,

Did my subject catch your attention? LOL. My niece is staying over. We had a great day.

 Your answers made me howl. And I apologize. I was being shallow. You're absolutely right to say that my interpretation of why you wouldn't demand a picture was ignorant.

 Also, you're kind of whacko about the subject of your career. As long as it's not illegal (and *I'm* starting to worry along *that* line), I swear it won't prejudice me against you. What do you do? No matter what "interesting career" I think of, I'm sure it's way off base. Everything I can think of that would warrant such secrecy is illegal, and you've said before that it's "most assuredly not." You're probably just an accountant trying to spike my interest with all your evasiveness (and hey, evasiveness is a dubious quality in an accountant!). But I guess it's okay for you to have a secret, since I do. But when/if we meet, you have to fess up or I walk.

 Now, to answer *your* questions...

 1. I still don't know when I'll give you my real name. Patience m'boy, patience!

 2. I'm so curious and intensely suspicious about you not requesting a picture because I may have, at some time in my life, experienced the two-headed, snake-haired monster syndrome. I know how shallow people can be.

 3. Yeah, I love web design. It's creative and I'm learning something new all the time, but I don't know... Sometimes I think I'd like to do something that helped

people. Do you think that's dumb? There's probably not a lot of money in it. . . .

Jen typed for another twenty minutes and finally, yawning, hit send.

B5 – Mainstream; Your Entertainment & Lifestyle Weekly

DEAR FAT GIRL: LOSE WEIGHT!

> Questions, Dreams, Raves, Rants and Fantasies?
>
> Express them and have them responded to by our experts!
>
> **ASK MAINSTREAM**

Dear Fat Girl,

Darling, I should have your job! You get paid big bucks to dispense advice and really, what do you say? All your softy, side-stepping the real issues does no one any real service.

Want guys? Lose weight! Want a date? Lose weight! The secret to a happy life is to lose weight!

So how do you do it, you want to know? It's simple. There are many great diets out there that help take off fat quickly and for some people, surgery may be an excellent solution. If you want to know more, or if Mainstream wants me to write a column too, just contact me.

Sincerely,
Thin Sister

Dear Thin Sister,

We're not related. It has never occurred to me to answer any letter or questions in the manner you suggested.

Most questions to Fat Girl (to *me*) have to do with finding happiness in the place where the writer is at now, dealing with emotional or physical health, or (and you may

find this hard to believe) with finding permission to love and respect themselves as individuals, fat or not.

Your advice, "There's this diet," will help no one. Fat people are North America's diet experts. There's nothing new on the diet front to tell them. They know all the techniques, all the food values, all the pros and cons of each new trendy plan. Whatever fat people need, it's definitely NOT a new diet.

Mainstream isn't hiring as far as I know. (And besides, their fat columnist can be a real bitch. You'd hate working with her.) Why don't you query women's magazines? Most of them seem to have an unquenchable appetite for stupid, body-wrecking fad diets that they can stick on their covers to attract readers like you.

Sincerely,
Fat Girl

P.S. I'm thrilled to know I'm paid big bucks. Can someone please let my editor know? (I'll take retroactive checks, Stan!)

6

THE DAY WAS GRAY WITH an unfriendly damp chill that promised rain, so as Jen approached Quentin's she was surprised to see Chelsea sitting on the patio. All the other customers were tucked away inside.

"Hey, Chelsea, good to see you," Jen called as she climbed the wide stairs and made her way over to where Chelsea sat. "To what do I owe the honor of your company on a Saturday of all days? Getting a sitter for the kids on a weekend, just for me? I'm privileged!" Jen punctuated with a laugh and continued, "Sorry. Too much coffee. It really hits me now. I won't be having what you're having." She waved at the green, ceramic fishbowl of half-finished coffee perched beside Chelsea, pulled out a chair, and plunked down beside her friend. Finally, she stopped babbling and looked, really looked, at Chelsea. "Man, you look awful. Are you okay?"

Chelsea pushed a hand through her already rumpled hair and frowned.

"Thanks a lot, Jen. That's just what a person wants to hear—how awful they look."

"No problem. What else are best friends for? But seriously,

are you all right?" Jen chewed the edge of her thumb and studied Chelsea. For normal people, looking bad occasionally was, well, *normal.* But Chelsea? Chelsea wasn't normal. She was superwoman, and given her behavior at the gym and now this? An itchy blanket of worry slid over Jen. Should she have told Ted about the gym thing? She'd believed Chelsea that it was an isolated episode, but maybe . . .

"Are you okay?" Jen repeated. Chelsea didn't seem to hear Jen's question.

Her gaze had shifted to a nearly leafless tree growing out of a small, cutout square in the pavement, and she shivered.

"Do you want to move inside?" Jen asked.

"Poor tree," Chelsea said suddenly. "I guess fall is really here."

It was a bizarre thing to say, especially in response to a direct question. Jen opened her mouth to ask, again, how Chelsea was, but Chelsea went on.

"No, let's stay outside. We'll be stuck indoors soon enough. Let's try to pretend that winter's not coming." Chelsea's voice was thin and distant, and she rubbed her hand along the table as she spoke. "I had a dream where I was sitting outside on a restaurant patio and it had tables just like this . . . only I've never seen these until today." Chelsea lifted the tablecloth and studied the table closely. A few leaves scuttled by, making a rasping sound as they tumbled along the ground. Chelsea flinched at the light noise.

Jen had no idea what to say. "Uh, yeah. That's weird all right. Maybe you saw them uncovered before and just don't

remember? Or maybe you're psychic and foresaw this coffee date?" She chuckled a bit.

"Good one. If I were psychic, I would've known what this day was going to be like and stayed in bed."

"You're in a lovely mood, I see. I've already asked this, but what on earth is wrong?"

Chelsea glanced around quickly, as if surprised by where she was. Suddenly she was herself again. "Not much, Jen, sorry. It's just not been the best day. Ted and I had a fight. I yelled at the girls all the way to skating—and they're mad because they had to go to my mom's. They wanted friends over." Chelsea's jaw clenched. "But it's not always about them. I wanted to see my friends for once."

"Hear, hear," Jen said. "I tried to get Kyra to come too, but you know her."

"Yep, she's in deep with James. We'll be mud for awhile." Usually a comment like this would trigger a laugh or reminiscence about one of Kyra's past romantic escapades, but today it just sat there. Finally Chelsea announced, "You know, I don't really feel like another coffee. Are you done too? Want to just hit the gym already?"

"Sure." Jen didn't bother to point out that she'd just gotten there and hadn't ordered anything yet. She wasn't thirsty anyway. "So your mom has the girls? How's she doing these days?" Jen asked a block or so later, as they waited for the walk light.

"As good as you'd expect someone traded in for a younger model to be. Just great. She cries all the time—one of the reasons the girls don't want to hang out with her—and she's gained

thirty pounds. She needs a job because"—Chelsea practically spat, making Jen step away in surprise—"because the dick managed to hide all his assets. Who's going to hire a fifty-five-year-old crying housewife, who's never worked outside the home before?"

The music from the gym hit them like a wave as they opened the heavy glass doors. Jen practically jumped up and down with relief when the noise halted Chelsea's rant.

B5 – Mainstream; Your Entertainment & Lifestyle Weekly

DEAR FAT GIRL: My Weight Controls Me

> Questions, Dreams, Raves, Rants and Fantasies? Express them and have them responded to by our experts!
>
> **ASK MAINSTREAM**

Dear Fat Girl,

I rarely, if ever, allow myself to eat more calories in a day than I burn.

I'm a slave to eating the right things and monitoring my exercise. I can't even eat in front of other people!

I want to get married—and I've met some real sweeties, but I always bail when they propose.

My shrink figures that when my dad left my mom, I made a mental parallel between staying thin and fit and being able to keep a man. Ironically, it's that connection that keeps me unable to commit, like I'm afraid that if I do, I suddenly won't be able to stay thin and then I won't be able to keep my mate.

It affects the few friendships I have with women too. They totally don't understand, and think I'm bragging about being thin when I try to explain what I mean.

Sorry to go on and on. I just wanted some feedback. My shrink is great but it's taking too long. Do you have any words that will help me put the body thing into perspective

and help me form relationships? Quickly?!? There's this great guy at work that I'm interested in.

Sincerely,
Controlled by what I don't eat.

Dear Controlled,

Your problem with obsessively controlling what you consume/burn is a lot of people's wish-come-true. Or so they think. Good for you for seeing it's a problem.

Here's food for thought. Have you ever considered telling any of the so-called "sweeties" you meet how you feel? You sound like you might be the type to keep "unpleasantries" from the menfolk. Maybe it ties in with your "if I'm unsatisfactory in any way, he'll leave" way of thinking?

Also, is it possible that you go through the men, not because of your disordered eating, but because blaming yourself (your selfishness, your eating/exercising demands, etc.) is easier than facing the fact that sometimes relationships die and it's not the woman's fault? Or perhaps your ego craves the continual boost that attracting a new guy provides?

Just a few thoughts. You asked.

Good luck,
Fat Girl

P.S. You asked for advice; I asked questions. Oops! Here's a tangible "to do." Stop dating for a while (maybe a long while) and figure out who you are without a man in tow. Start eating in front of people. You may feel self-conscious at first, but it will get easier. Little steps first.

7

"WHAT?" KYRA ASKED IN LIEU of a greeting, appearing beside the small coffee shop table where Jen sat. She collapsed her silver umbrella and water droplets spattered the huge Marilyn Monroe portrait hanging nearby. "Oops," she said, then grabbed a napkin and carefully blotted Marilyn's glossy face.

Jen folded the issue of *Mainstream* she'd been perusing. "Well, hi to you too. What do you mean, *what?*"

Kyra laughed and flicked her newly strawberry blonde hair over her shoulders. "I'm just surprised to see you alone. Chelsea's van is right outside."

"Maybe she stopped at the drugstore?"

Kyra nodded. Mini-mystery solved in their minds, they started discussing what type of movie they were in the mood for. Kyra ordered a skinny latte with real whipped cream.

The coffee arrived at the same time Chelsea did, both hot and steaming. Chelsea waited for the waitress to collect the money for the coffee before she sat down. She was wearing running pants and a T-shirt. Jen and Kyra stared at her sweaty face.

"Don't worry," she said, slipping off a backpack. "I brought

clothes to change into. I got here early and decided to run, get some exercise in."

"But you already did the gym today. I saw your name on the register," Jen said.

Chelsea shrugged. "I was feeling energetic, sue me. Are we staying for a bit?" Jen and Kyra nodded. "Okay, order me a double espresso—black. I'll go change."

"Yuck, but okay," Jen said to Chelsea's already departing back.

Jen and Kyra looked at each other. "Have you seen her lately?" they asked in unison and then nodded simultaneously as well.

Jen motioned at Kyra to go first.

"Well, I don't know. I've always seen her a bit more than you."

Jen nodded.

"She just seems really intense or something. You know how she's always been super mellow with the girls? Earth mother incarnate? Lately she complains nonstop about them, and when I was there the other day, she flipped out. Over nothing. The worst part though? The kids weren't even shocked. They just got out of her way."

"She's been going to my gym. *A lot,*" Jen whispered.

Kyra's eyebrows scrunched together. "She's too thin already."

"Yeah. It's more than the scrawniness though. She's sounds, I don't know, wrong, not like herself, when we talk."

"I know what you mean. Too vague or something. I'm really

worried."

"Me too. But what am I supposed to say? 'Hey, Chels... I know I've always hounded you about giving me moral support and joining my gym but now that you have, I think you're having a breakdown?'"

Despite the mugginess of the shop, Jen shivered. She zipped her gray hooded sweatshirt, then sat hugging herself.

Kyra leaned over the table. "See! I think she's having a breakdown too."

"I meant that more as a figure of speech."

"No, she's not right. It has something to do with her mother."

"Yeah, maybe. The other day—"

Chelsea's reappearance interrupted them. She looked immaculate in an ivory twin set and pencil thin black pants, her face a soft glowing alabaster.

"Only you can emerge from a public washroom looking like you came from a salon," Jen said. Chelsea smiled, dipped her chin and raised her arms slightly, imitating a curtsey.

"You don't think these pants make me look fat?"

Jen and Kyra exchanged the quickest of glances. "Are you out of your mind?" Jen asked. Chelsea looked at Kyra for comment. Ex-fat girls can't be trusted to give reliable body size opinions, Jen thought wryly.

"You wouldn't look fat in pink velour. We were just saying you look the skinny side of healthy these days actually."

Jen sucked in her breath. Would they get blasted for Kyra's honesty or would Chelsea write it off? Women had told Chel-

sea she was too thin her whole life.

"Oh no," she said, with a little chuckle. "My body's just adjusting to my new workout schedule. You didn't seriously think I was going to join the gym at the expense of my running, did you?" she directed the last sentence to Jen. "And this outfit must be slimming. I've been battling a bit of extra lately. The scale won't move."

And yet another surreal conversation with Chelsea. "You can't afford to lose another ounce," Jen said. "You need your skin to hold your organs in. *That's* why the scale won't move." She hoped the finality of her tone would break through to Chelsea.

Chelsea shrugged and Jen knew she hadn't convinced her of anything. Chelsea's eye caught the copy of *Mainstream* resting under Jen's elbow. "Have you read that rag lately?" she asked.

"Yeah, all the time. I was just checking showtimes for tonight."

"No," Chelsea said impatiently, reaching for the magazine. Jen lifted her elbow. Chelsea moved her freshly delivered espresso in front of Kyra, then thumbed through a few pages, looking for something. "I meant, do you read the columns? Like the one by that imbecile, Fat Girl?"

"All the time. I love her!" Kyra said, bobbing her chin.

Jen nodded too, but not quite as zealously as Kyra.

"Well, I was at the doctor's yesterday, and—"

"Doctor?" Jen pounced on the word. Chelsea ignored her.

"And I read her latest advice. It was ridiculous. Ridiculous!"

Kyra grabbed *Mainstream* from Chelsea. "All of them or just this one?" she asked, her tone puzzled.

"Well, naturally, I don't read them all the time. I'm not fat. Well, not like the women who write those letters." Chelsea looked apologetically at Jen. "I don't have weight issues."

Uh huh. I'm the only one here with weight issues.

"But sometimes they're amusing," Chelsea continued. "She's too hard on slim women though, and she acts like everyone has an eating disorder, like in this last one."

Kyra skimmed the article. "I don't see anything wrong with this. I think it's good." She pushed a wave of hair out of her face and turned toward Jen. "Can I take your copy home? The booth's out."

Jen nodded.

"You can't be serious!" Chelsea's voice was shrill. "She tells that poor woman to talk to the men she's dating about her weight issues. Men don't want to hear that. It's all supposed to be effortless. Looking good, being sexy, being a good mother, volunteering for worthy causes, and, if you can, earning some money too. If that woman takes Fat Girl's advice, who's assuredly single, let me tell you, she'll end up alone too. And that's what the letter writer's afraid of. Fat Girl should've told her to suck it up. Do what women have done for centuries before her and quit whining. Get married to the guy at work and get on with it. And that mother/father split thing was pitiful. She should get over it. Everyone blames their parents for their problems. Take a bit of personal responsibility. *That's* what Fat Freak should've told her!"

Kyra stared at Chelsea, wordless. Jen, stunned by the monologue, looked down at the table. She knew it wasn't personal.

How could it be? But it felt personal.

"I think she's kick-ass," she said. A bit weakly though.

"I just read her column for fun," Kyra said finally. "But she usually has good points. And I think she's right. That woman should find out who she is on her own first, before she gets married. Who wants to be a mere extension of someone else? Too many people marry and expect their spouse to fulfill them. It doesn't work that way."

Jen stared at Kyra. *You think you know someone, and then they totally blow you away.*

"How do you know she's single?" she asked.

Chelsea looked at her like she was an idiot. "You read her column. She's way too opinionated."

"Sheesh, it's the 21st century. We're allowed to talk. Freedom of speech and all that. Last I heard we could even vote and were actually recognized as people," Kyra mocked lightly.

Jen looked at her friend again, feeling like she'd never quite viewed Kyra accurately before. It was like their roles were reversed. She was the one who was supposed to champion women's rights, be politically aware and vocal. Kyra was supposed to be shallow and men-obsessed.

"Besides, she's fat," Chelsea said.

"*What?*" exclaimed both Jen and Kyra.

"Oh, come on, Kyra, pretend anything you like but everyone knows that in reality, men are repulsed by fat women. Jen knows." Chelsea winked at Jen like they were on the same side.

Jen felt like she'd been kicked in the face. Kyra looked like she was going to cry.

"I can't believe you just said that. You're so insensitive.

What is wrong with you lately? You're not yourself at all!" Kyra sputtered and reached under the table and squeezed Jen's knee. Jen realized then that she wasn't even that offended. She just felt like she'd been dropped into the Twilight Zone. Who was this skinny alien and what had it done with peacemaking, loving, *kind* Chelsea?

"I'm just speaking my mind. I thought you Fat Girl fans would approve." Chelsea took a dainty sip of her coffee. "Anyhow, Jen's not overweight anymore, so what does she care?"

Jen's face flamed. She had to give a dig. Just a little one. "So Chels, what did you say that doctor's appointment was for? Prozac?"

Chelsea gave her a dead-eyed look. Jen felt about an inch high. She'd just told Kyra that she thought there was something wrong with Chelsea, and now, minutes later, she was using the possibility as a weapon. Maybe Chelsea really was seeking medical help for depression or anxiety or something. She was a terrible friend.

The rest of the night didn't get better, though Jen supposed one could argue that the absence of conversation on the way to the theater and their quick good-byes later were good things considering their earlier "bonding" at the coffee shop. However, the tension in their silence was almost a physical presence, and her stomach continued to hurt long after they parted.

Feeling both sad and edgy, she skipped the elevator and did the stairs, two at a time. When she reached her floor, she was calmer, distracted by legs that felt like sore jelly. Inside her

condo, Jen headed straight for the fridge. She rummaged through it and grunted in disappointment, but then rallied. The stuff she'd found wasn't that bad. Deli meat and pickles, cheese . . . Yummy. Did she have crackers? She caught a glimpse of her face—overeager and guilt-ridden—in the black glass door of the microwave and looked down at the Havarti in her hand. She sighed. Then slowly, regretfully, put all the food away. It was tomorrow's lunch. She stalked into her computer room, collapsed into her chair, opened her e-mail, and typed in a flurry.

From: jar@yahoo.ca
To: InTinyTown
Subject: I've decided

Greg,

Okay, okay. You might be right. Maybe we should meet. Even if you are a serial killer. Much more of hanging out with my friends, and I'll be hoping that you are. Do you ever get the feeling that maybe you've never really known a person at all?

Well, e-mail me back or message me and . . . Oh, rats. I just changed my mind. (Again!) I'm sorry. Why risk a good thing? We talk so openly, get along so well . . . I'm sure actually being real to each other will change all that. Sucks but true. (I do hope we chat tonight though.)

Anyway, talk to you soon then.

~Red-haired. I mean, JEN! ☺

Jen hesitated for a second, and then clicked "send." Almost simultaneously, a small chime sounded and a blue box popped

onto the screen announcing, "InTinyTown has just signed in." Seconds later, bold purple font greeted her. "Hey Jen! I was hoping we'd talk tonight."

Jen smiled. "Yay," she whispered and started to type a reply.

B5 – Mainstream; Your Entertainment & Lifestyle Weekly

DEAR FAT GIRL: I'm Fat Too!

> Questions, Dreams, Raves, Rants and Fantasies?
>
> Express them and have them responded to by our experts!
>
> **ASK MAINSTREAM**

Dear Fat Girl,

Hi! I actually am a fat girl! LOL! I've been reading your latest rants and omigod, aren't skinny people who whine and bitch (Oops, am I allowed to say that?) about being fat, when you actually ARE fat, the rudest?

Anyhow, my problem is this: I know I should lose weight for my health, blah, blah, blah, but I actually *like* being fat. It has pluses. (No pun intended, lol!) I like weeding out creeps by seeing how they respond to my weight. When people try to encourage me with that pretty face bullshit (Am I allowed to say that?), I just get pissed. Who are they to say what I should look like, be like, act like?

Anyway, I don't know exactly why I'm writing this. Maybe to say thank-you? And maybe to ask, is it normal to feel this way?

So yeah. Cheers to you.
Fat Girls Unite!

Dear United,

I hear you about the pretty face thing. Can't they just say,

"I find your body repulsive," and be done with it? (A little honesty, people, please!)

You wanted to hear that you're normal? You are. (But what's the barometer for normalcy anyway?)

Most heavy people have emotional reasons for being so. Rebellion is one of them. Scientifically, losing weight is simple: consume less energy than you burn. Emotionally/philosophically? That's a whole other ball of wax.

In his book, *Fattitudes*, Dr. Jeffrey R. Wilbert looks at the myriad of reasons that fat people stay fat. It's an easy read with good insights. However, he writes from the perspective that all fat people should discover their "hidden psychological payoffs" for staying fat, work through them and lose weight. Whether I agree with that opinion is beside the point, *Fattitudes* is a beneficial read, something I find most books about weight are not. Actually, I recommend this book to anyone with body issues. (Skinny chicks, you too!)

Keep sticking up for yourself. Be well.
Fat Girl

P.S. *Mainstream's* pretty liberal about profanity. Have you read the Love/Lust column? They even use the F-word, but I think that's just bloody-damn rude.

8

"Mmmmm, chowtime!" Lana announced, eyeing Jen's plate of assorted deep-fried seafood morsels and Long Island iced tea. She exchanged the chair in front of her for one at another table that didn't have arms, and settled across from Jen.

"I don't eat like this very often anymore," Jen confessed.

"Well, better enjoy it then. So does Dave show up on time, ten or fifteen minutes late, or not at all?"

Jen laughed. "He just called. He'll be here, or so he says. I vote for five minutes late."

"If you're right, we'll have to buy you a reward. By the way, I agree, getting together once a week, face-to-face, is a great idea."

"I've been feeling isolated lately. I like working from home, and it's not like we need to see each other, not really, but we always have a good time when we do."

"Yep, I hear you," Lana agreed. She let the waitress know they'd wait for their third party before they ordered meals, but put in a request for the same appy Jen was eating. "So what's new with you anyway? Your last few e-mails sounded down."

"I don't know. Adjusting to a new phase of life, I guess. It,

well . . . I don't know," Jen repeated again. "What about you?"

"Same old, same old. Eddie's away again. Maybe for a month this time. The bed gets cold without him—Bastard!" Lana's voice was filled with laughter and affection that turned into exaggerated horror. "Besides, four weeks without sex!"

Jen stopped fiddling with a scallop and grinned. "Sex? What's that again? I've totally forgotten."

"But I'm a sentimental suck too. I wish I could say it was all about bed, but I get lonely. I actually came this close"—Lana pinched her thumb and forefinger together—"to calling you up and seeing if you wanted to hang out."

"You should've," Jen said, popping a crispy, garlic-buttery prawn into her mouth.

"Like you're doing nothing on weekends."

"Absolutely, I am. Doing nothing, that is."

"Get real."

"I'm serious."

Lana gave her a look that Jen couldn't quite decipher. "I thought you'd be out tearing up the town with your new look and all."

"It was pounds, that's all," Jen said, embarrassed. "It didn't change my life."

"Really? You mean all the infomercials lie? Good golly, I can't believe it!" Lana's laugh didn't soften her sarcasm, but it did make her massive cleavage shake.

"What crimes are you two scheming about now?" Dave's radio-announcer voice filled the pub.

"Two minutes after one! Write it down, Jen. And Dave, let

me buy you a drink. It's a miracle!"

"I'm confused but grateful," Dave joked back. "And I never turn down a free drink. Nice cleavage by the way," he added, admiring the low neckline of Lana's purple shirt.

Jen couldn't believe it; Lana blushed.

"Watch it, buddy. That's sexual harassment." Lana's tone was not harassed.

"Is there something going on with you two that I should know about?" Jen asked, only half in jest. "If there is, I'm going to feel terribly left out." She slid over on the bench to accommodate Dave's bulk.

"Don't worry, Jen. Lana's too much woman for me. I can only dream."

Lana laughed out loud.

The waitress appeared as soon as Dave's butt hit the bench, as if she'd taken Lana's "we'll wait to order until our third party arrives" literally and thought she'd meant instantaneously. Dave already knew what he wanted though, a Baron of Beef with fries and onion rings. Lana was ready too: a Monterey Jack Burger with zucchini sticks.

Jen hesitated. She'd thought she was ready. She'd allowed herself to splurge on a deep-fried appy, knowing that she'd have the garden medley soup, skipping the roll.... She took in Lana's sexy, glowing face and her ample, fleshy chest and arms. She looked at Dave, who carried at least 360 pounds on his six-foot frame. He looked happy and comfortable, cute even, in a navy sweatshirt and cargos. *What the hell,* she thought. *I'm with friends.*

"I'll have a bacon mushroom cheese burger with peppercorn sauce, and mayo for my fries, please." *You were never planning to have the soup, were you?* her inner critic accused. *Look how quickly that order flew out.* Jen pushed the nagging voice away. Fries! She was going to have fries. It had been way too long.

"You bet," said her waitress, without looking up from her pad. "Anything else?"

"Can you bring us another round of Long Islands?" Lana asked.

"Absolutely," the waitress called, already moving away from their table.

Jen was already buzzing from just one drink. Alcohol really hit now that she was slimmer. "Two's my limit or I'll never get any work done this afternoon. Cut me off!"

"Like any of us are going to work this afternoon. Have naps is more like it." Dave shrugged off her request. "It's time off. Enjoy."

"Speaking of work, if you two have time, you should stop by my place and see what I'm doing with the virtual model thing for Clothes For You. It's hilarious," Lana said. "Really cool. You can plug in your own head, or just for fun, use animal heads. You should see the long-horned cow I came up with."

Jen looked at Dave.

"You said you didn't want it," he reminded her.

"I thought they wanted a plain Jane, click to select the item you want, shopping buggy basic." Jen tried not to sound petulant.

"They did until I talked to them," Lana said simply, but

sounding a bit wary.

"Well, good for you." Jen suddenly changed her mind and became happy for Lana. "I'm in a bit of a creative slump," she admitted. "You sound pumped. I'm jealous, I guess."

"Yeah, what's up with you? I was surprised when Dave said you didn't want it. I thought we had an unspoken rule, whoever gets contacted about a project gets first dibs."

"I don't know. . . ." Jen was saved from having to try to explain anything by the arrival of their food.

"That was fast," approved Dave.

"Mmmm, that looks great, Jen. I should've ordered it too."

They ate in silence for a few minutes. Finally, halfway through his sandwich, Dave said, "So am I right in assuming that this working on our own thing really sucks?"

Jen hardly heard what he was saying. She was lost in the sensual delight of her meal. "I'd forgotten," she mumbled, "how good these things are." She let out a low moan of pleasure.

"I love a fellow food moaner," Lana agreed. "Some people just don't seem to get how *good* food is."

Dave shook his head at them.

"Oh, sorry, were you saying something, Dave?" Jen asked, grinning. She felt so happy all of a sudden. Good friends. Good food. Good life.

"I was just commenting on our growing collection of e-mail complaints and how it sucks to be totally cut off from the world and each other. I think our initial idea to meet occasionally to discuss work, but to correspond primarily through e-mail and IM was a good start-up strategy, but now I almost think we'd

benefit from office space. Clients could come by, instead of us always arranging dinner or coffee meets. We wouldn't have to wait for feedback on ideas because we'd be in the same room—"

Lana held up her hand. "Don't say another word. I'm in."

"Me too!" Jen forgot her burger momentarily. "I was even thinking of taking a part-time job somewhere just to have regular contact with people."

"Official office space will make us more visible, too. We'll pull in even more clients." Lana nodded her head vehemently, as if to agree with her own words. Jen and Dave nodded too.

"We'll keep flexible hours as usual, but aim to always have a body in the place, say 8:30 to 5:00?" Dave suggested.

"Sounds good," Jen said.

"I can do the early hours, no problem," Lana said. "But are we going to hire a secretary?"

A long list of costs started to run through Jen's head. "Why don't we wait on that, see how bad we find the interruptions. Overhead will be new to us, so let's try to keep it small."

Dave agreed with Jen. Lana shrugged and picked at the tidbits remaining on her plate.

"So," Jen queried after they'd spent a few minutes digesting this new business leap. "Do you actually have a space in mind?"

Dave's grin was huge, and his blue eyes shone. "Do I! We'll check it out after we hit Lana's."

Back home, stretched out on her couch, Jen wished she felt bloated or sick after stuffing herself, but she didn't. She only felt drugged. Peaceful and worry free, she was too tired, too full, for

anything to penetrate her food fog. She'd begged off the trip to the potential new office, and to Lana's, on the pretence that she still had errands to run and it was already after 4:00. Really she just wanted to enjoy her food stupor. She felt too lazy to trek all over the place.

Neither Dave nor Lana seemed disappointed. Jen suspected they wanted siestas too. They'd talked themselves out, discussing the new office, oddities of clients, and bits of their social lives... Jen hoped she hadn't ended the conversation Lana started about Jay too vehemently.

The phone rang. Jen picked it up, forgetting to check the caller ID first.

"Hello?" she said in a scratchy, tired voice.

"Babe. You're home. Wow."

Speak of the devil. Jen put a hand over her eye. *Jay.*

Jay's voice rumbled on. "You sound like you're in bed. I wish I was there."

Jen couldn't help it. Her stomach tightened and a small but unmistakable flare of heat surged in the center of her pelvis and radiated out at the suggestiveness of his tone.

The mind wants to forget but the body remembers.

"Hello Jay," she said.

"Hello Jen..." He echoed her, his voice a sad-sounding purr.

Jen frowned. "Why are you calling me?"

Silence. Jen slowly smoothed her hand over the leather of her couch, still warm where she'd lain on it. It felt like skin. "Look Jay, I'm sick. My sinuses are running all over the place."

She kept her voice groggy on purpose, even though her mind was rapidly clearing. *That's it, make him regret losing you, create a vision of phlegm and fever.* "I need to run. I need cold medicine before the shop downstairs closes. I don't want to have to go down the block."

"I just miss you, Jen." Jay's voice as ragged as hers, and something twisted around Jen's heart. "I miss touching you. I miss kissing you. I miss making you laugh—"

A small sound escaped from Jen before she could clamp it down—the surprised gasp of pain a person lets out when she's just cut herself badly, the sound that comes before the real hurting starts.

Jay's tone changed. For a moment it was almost satisfied. "I knew you felt it too—" He paused. "But most of all, I just miss talking with you. I miss *you*."

"Jay . . ." Jen pressed her free hand against her forehead and cheek as hard as she could. *C'mon brain, don't fail me now.*

"I know I don't deserve to get to talk to you anymore. I lost you and it's all my fault. I get that." Jay's voice went even lower, became the purr of a cat with a full belly. "But we were so good together. You don't know how I beat myself up. I—"

"Jay—" Jen's voice broke off. *He beat himself up after you found him out, Jen. After.*

"I just want to see you in person one more time, to say good-bye face-to-face. Don't you think, because of what we had, we should?"

"No, Jay, it's been so long. Let's just let the pain end, okay? It was bad, bad for both of us."

"Not for me." His voice was soft to the point of being almost

inaudible. "It was always good for me." Jay sighed then, and it was suddenly like he was there in the room. Jen knew how his hair would look—tousled from his hand pushing through it. She saw him studying her, a half smile on his mouth, heat in his eyes as if he liked what he saw. She felt his mouth tentative on hers, asking permission. She felt his hands, demanding and possessive.

"Just one coffee?" Jay's voice coming from the phone almost startled her. "On me—I've got my wallet, promise," he said, a touch of laughter in his voice.

Jen smiled in spite of herself, then bit her lip. The first time they'd gone out, she'd made a big deal about paying her own way. He'd insisted with equal fervor that she let him treat. When she finally caved, he reached into his jacket only to find he'd left his wallet somewhere. From then on, he always bought, claiming to forget that he'd paid her back.

"I don't know...."

"Please? I really need to see you."

"I guess—but it's the last time, Jay. I mean it. Call it a final farewell for two people who once cared for each other."

"Gag," she said out loud after hanging up. "You fool no one, Jennifer. I can't believe you bought his line again." *It's not like I'm really going to go,* she defended herself in her mind. *I just won't go.* But another part whispered back, *You could just meet him one more time, just to give him back his DVDs and his sweatshirt....*

Now that the call was over and Jen was temporarily done berating herself, she realized she'd lost her lovely soporific feeling. She was cold and cranky. And almost... hungry? How was that possible?

How on earth could she feel hungry? But she knew: some stupid psychological upset, grief, loneliness, boredom, some unmet inner need, no doubt—blah, blah, blah.

So I'm hungry for something other than food. I eat for emotional reasons. Big fucking deal. Jen pushed those thoughts into the far recesses of her mind.

Sometimes people are just hungry, she reasoned. *I've been working out pretty hard. I probably just need the calories.*

She snorted. *Oh yes, Jen. You being a twelve-foot-tall pro wrestler and all.*

The phone rang again, interrupting her inner argument.

"Hey Lana, what's up?"

"I feel bad about the comment I made about Jay when we were leaving the restaurant. I'm sorry. It was stupid and insensitive."

Jen started to laugh uncontrollably. Silence that sounded like a question came from Lana's end.

Okay, hyena girl, tone it down. "I wasn't offended at all."

"Oh good. That's a relief."

"Yeah . . ." Jen paused a moment, deliberating how much she should reveal of herself and her loser problems, then bit the bullet. "And speaking of Jay. Here's an uncanny coincidence. Guess who just called?"

By the end of the conversation, Jen had upbraided herself several times for being an idiot, Lana had agreed she was one (nicely, in a "cheer up, it'll be fine" sort of way), and Jen had invited Lana over for pizza and movies.

Jen hung up and stared at the phone. She looked at her gym bag, packed and ready to go, by the door. She picked up the

phone again and punched in a number. A machine greeted her. She sighed with relief and spoke her message in a rush. "Oh, Chelsea, hi. Jen here. I was hoping to talk to you in person but hopefully you'll get this message. About the gym ... I'm done in, and I'm going to ditch tonight's workout. Sorry! Talk to you soon."

Jen moved the gym bag out of her sight and flicked on a corner lamp. "It's just one day. *One day!*" she whispered as she lit the cinnamon pillar candle on her coffee table. "I've been so good for so long."

KYRA WALKED AT A GOOD pace, desperately hoping that Jen would, in fact, be home this Friday night, as she always half-jokingly/half-bitterly claimed she was *every* Friday night.

"She has a level head. She'll tell me what I should do," she muttered under her breath. It felt a bit strange to be turning to Jen for help. Normally Chelsea would've been her first choice but that was changing—something else she didn't want to think about right now. "Focus on yourself, girl. Focus!" Kyra almost laughed out loud when she realized what she'd just murmured.

"Gee, that's a new one for me, hey, James? Having to *try* to think of myself!" Though James was nowhere near, it felt good to snipe at him. *Asshole.* She was still muttering to herself when she arrived at Jen's building. Head down, Kyra almost bumped into a large, glossy-haired brunette coming from the opposite direction, but looked up at the last second, just in time to stop. She stared at the woman, startled by her presence at first, then

jolted by the look of happiness on her face. Was everyone happy but her?

Realizing that she was gaping at a total stranger, Kyra mumbled an apology. "I almost crashed into you."

The woman laughed a deep, throaty laugh. "You seemed pretty lost in thought there. Are you okay?"

"Fine, fine . . ." Kyra's voice trailed off as she recognized the buzzer number the woman keyed. When she heard Jen's cheery, "Come on up, Lana," Kyra turned on her heel, and strode away into the night.

B5 – Mainstream; Your Entertainment & Lifestyle Weekly

DEAR FAT GIRL: I Eat All the Time!

> Questions, Dreams, Raves, Rants and Fantasies?
>
> Express them and have them responded to by our experts!
>
> ## ASK MAINSTREAM

To: Dear Mrs. Fat Girl,

My cousin and me read your advice a lot. Please don't tell Myrna. I eat all the time and it makes her mad but I try not to. But I am hungry, not thirsty, a lot.

My little sister is dead and my Daddy left me with Myrna. It is bad now. Sometimes I eat so much that I throw up. My cousin said that I should ask you. I get scared or sad but when I eat a lot, I don't feel anything.

Am I bad?

From: Carli R.

Dear Carli,

You are not bad, not bad at all. Food does make us feel better when we are sad and lonely or scared. Your cousin sounds nice. Have you told your auntie about this? If she is nice, please tell her.

You write a very good letter. You must be in school. Some schools have people to talk to called counselors. Ask your teacher if you can visit yours and then tell her exactly what you told me, okay?

Myrna probably doesn't think you're bad. Sometimes grown-ups get sad or scared too. It makes them worry about everything but they can't say it very well and it just comes out sounding mad.

Also, here is a phone number for a nice doctor who knows a lot more than I do. If you can, please call 1-777-789-4591.

I'm very sorry about your sister. Please write me again if you want.

Love,
Fat Girl

9

CHELSEA WAS WALKING DOWN A busy sidewalk. The storefronts were familiar and it seemed to be a street she knew. Only, somehow, it wasn't. She paused in front of Perfect Pairs to admire the knee-high red leather boots in the window. Suddenly, large hands slipped around her waist from behind. Fingers rested on her hipbones.

"Hi, beautiful."

Chelsea started slightly and turned around. "You!" she exclaimed happily, embracing her dream friend. "I didn't know if I'd see you again."

"But we see each other lots—of course, you'll see me again. Again and again. I love you."

Chelsea looked deep into the man's eyes, eyes like slate-blue water. *You know him,* her brain insisted. *Who is he?*

"Penny for your thoughts?" he asked.

"It's just that I know you. I'm sure I know you."

"Of course you know me!" He laughed and then Chelsea laughed too, thinking how much she loved the smell of him.

"What do you say we go in and buy you those boots?" he asked.

"Let's," Chelsea said, enjoying the warmth of his hand on the small of her back. "But only if you'll speak Spanish to me."

"Oh, I'll speak Spanish to you, all right." He winked and held her gaze. Heat flashed low in her belly and spread . . .

But then he interrupted the moment. "You should get that. Get the phone."

"No . . . wait!" she pleaded, but it was too late. The rough tweed fabric of the couch's arm prickled her cheek. He was gone and the dream with him.

Chelsea shook herself to consciousness. Beside her on the cushion, the phone really was ringing. She picked it up. "Hello?"

Brianne's voice shrilled in reply.

"Yes, I know," answered Chelsea, more alert now. "Look, I'm your mother, not your slave," she paused while more shrilling ensued. "I was just on my way when the phone rang. I'll be right there . . . Yeah, okay . . . OK! I have *not* been like this for months. I did not forget you . . . I was not sleeping—enough already. I'll see you soon."

Chelsea threw the phone at the couch, grabbed her keys from the coffee table and headed to the boot room. She stared at her beige clogs for a moment before slipping them on over her wool socks and hurrying out.

Opening the garage door, she was greeted by sheets of pounding rain. *Perfect.*

Chelsea was tight-lipped and silent, as she stood on one side of the large oak table and slapped dishes down in front of Brianne, Dina, and Ted. The three of them sat mutely as she heaped

mashed potatoes, then green beans, then pork chops on each blue plate.

"There. Are you happy now? There's the stinking dinner you wanted cooked so badly." She slopped applesauce on top of each of the chops.

Brianne's mouth opened, then clamped shut again. Her dark eyes filled with tears, and she tipped her head back and stared at the ceiling as if willing them back into her head.

Dina stared at her plate and popped a thumb into her mouth.

"Get your thumb out of your mouth. You're not a baby anymore. You quit that years ago. Don't even think of starting up again!"

Dina took her thumb out.

"Eat your stinking food, all of you! You bitch and moan and bitch and moan about how I never cook anymore. 'You never do this, you never do that,'" Chelsea mocked. "Now I've done what you wanted, so eat your damn food!"

Brianne bolted from the table and ran to her room. Ted stared at Chelsea. "For crying out loud, Chels..." his voice trailed off. He sounded more weary than angry.

"What?" Chelsea demanded. "Oh, I suppose you think it's my fault that little Miss Princess upped and left the table?"

Ted shrugged and started to say something, then sighed heavily. "Just forget it," he said and left the room too, Brianne's plate in hand.

Chelsea stared at Ted's back, then down at her own plate, then over at Dina obediently shoveling in mashed potatoes.

Dina's eyes, fixed on some unseen focus point in the middle of the table, made Chelsea want to shake her and scream. Anything to make her stop looking like that.

Fury throbbed through her. She knew her anger was irrational and that just made her angrier. Something inside her keened, *What are you doing? What are you doing?* A cauldron of tears boiled in the back of her throat. She fought for control. Struggled to sweeten her voice.

"I'm going to the gym. Make sure you finish your dinner and get your homework done."

If anything her attempt at calm seemed to disturb Dina even more. Her eyes lost their dullness, looked pained. She nodded, and then whispered, "Thank you for making dinner, Mommy."

Chelsea felt like her throat ripped open. She rubbed it and stared at her hands, almost expecting to see blood. Wordless, she returned Dina's nod, then fled from the kitchen, from those damning eyes. She threw her gym shoes into a duffel bag and escaped.

B5 – Mainstream; Your Entertainment & Lifestyle Weekly

DEAR FAT GIRL: Why'd I Get Dumped?

> Questions, Dreams, Raves, Rants and Fantasies?
>
> Express them and have them responded to by our experts!
>
> ## ASK MAINSTREAM

Dear Fat Girl,

I'm sixteen and was (*am*) totally in love. For real. But my boyfriend broke up with me.

I'm really confused, and I want him back. I cry all the time. Even my mom is being nice to me, it's that obvious there's something wrong.

The reason I'm so confused is that my mind keeps screaming (I know this is stupid but I can't help it) that he can't have broken up with me because I'm really skinny now. I used to be almost chubby but now I'm about five pounds under what my lowest weight should be for my height range and I really DO have big bones so maybe I'm even ten pounds lighter?

I just thought I really looked good. He told me he loved me. In fact, he says he still loves me, just wants to see some other people first and then we'll get back together after we graduate and we'll get married... but I think, forget that. Even though I love him, he can't really love me or wouldn't I be enough for him?

Sorry . . . I got off track. I'm used to my journal where I just blab. My question is why did he break up with me? I'm skinny. I look good. (At least, not totally ugly or anything.) I LOVE him. Sometimes I think I'll never eat again, just to punish him.

Sincerely,
Confused

Dear Confused,

First things first, I'm sorry that you're so sad lately. Your ex-boyfriend sounds like a real jerk and I wish older women would read your observation, "He doesn't really love me or I would be enough for him." It's both true and wise. Good for you. Keep thinking that way. Your heart will heal.

I'm also happy that you know that you are skinny, perhaps even too skinny, for your height. Some people never can see that and it's dangerous to their health. My concern is that you equate thinness with power. Skinny people and fat people are EQUALLY at risk for problems in relationships. Starving yourself to thinness will never equal power or protection from pain. Do not give into your feelings to stop eating to "punish" him. It will only hurt you. He won't even notice. (Sorry if that hurts.)

The best revenge? Eat well. Live well. Have fun! When he realizes that you aren't withering away without him, he might even come scurrying back. But please, don't be conned. Smile sweetly and tell him you're really sorry but it's too late. Hang out with your friends, girls and guys. You're young. You have lots of time for romance later.

Wishing you well,
Fat Girl

10

KYRA TOOK A DEEP BREATH and stepped into the lounge. It wasn't too bad. She'd been in worse. But still... she'd always promised herself she'd never be one of *those* women, the desperate kind that haunted bars and pubs looking for love. It was a personal rule that she only went drinking with girlfriends or with a date, never to get a date. *I'm not breaking my rule,* she defended herself, *I'm looking for James. I've already dated him.*

A few leeches leered and made lame come-ons, but again, she'd been ogled by worse. She sat down at a small, battered table for two and drummed her fingers to the mindless eighties' tune playing. The band must be on a break, she thought.

The bartender moved out from behind the counter and made his way over. "What'll it be?" he asked.

"Can I get a Tom Collins?" He nodded. "Great. Keep them coming—and not too weak, please." He nodded again.

"Sure thing, honey. You want anything to eat tonight?"

Kyra scanned the grease-stained menu in front of her. "Ummm, no. No thanks."

"You drinking alone, or should I leave the menu for a friend?"

Kyra glared at him. "I'm not *drinking alone*. I'm just having a few drinks, alone."

"Sure honey, it's all the same to me," he said. "No need to be defensive, unless you've got a problem, that is."

"Stupid bartenders," Kyra muttered when she thought he was out of earshot. "You all think you're shrinks."

"We're cheaper, that's one thing—and I bet we hear the same stories."

Kyra blushed.

He was back seconds later, swishing a coaster, then a tall green drink, onto the scarred table. "I made it a double on the house. Maybe it'll help you relax," he said and moved to his left to pour shots for some college kids.

Kyra misted up at the unexpected gesture, then realized he probably meant it as an insult. She jumped when the bartender yelled, "Alfred, you fucking screwup, put that cue down, or I'll toss your ass outta here. I won't tell you again."

So much for shrinks.

Later, woozy with five double gins sitting in her belly, Kyra looked at her watch. The band was almost finished their last set. She sighed and realized her head was pounding to the same beat as the bass blaring from the half-shot amp. James hadn't shown up. She was disappointed, but not particularly surprised. This really wasn't his scene. He only came for his kid brother, Brian's, sake.

"You want another?" The bartender asked with a raised eyebrow.

"No, I'm done."

"Probably good thinking. For a little thing, you sure put 'em away."

"Family inheritance." Kyra laughed a little.

The bartender smiled at her joke and accepted his tip. "Have a good night, honey."

It was time to leave. She headed toward the door, mildly amused by how crappy everyone looked under the blue and green strobe lights. Why bars continually did that to a bunch of drunks, she'd never figure out. Like they didn't look terrible enough on their own? Brian saw her just before she escaped and motioned her over, guitar still in hand. She shook her head, pointed to her watch, and shrugged in apology.

He nodded his shaggy head in return and grinned, but then looked around and gave a questioning look. She read his lips through the haze of smoke, "Where's Jimmy?"

She shrugged again, waved good-bye, and walked out before he changed his mind and made his way over to talk to her.

The night air was sharp and dry, a shocking contrast from the beer-scented mugginess of inside. Waiting for a cab, the irony of her situation hit her. She'd always thought the way men behaved after she ended relationships with one of her polite variations of "I'll never forget you, but . . ." was pathetic.

They always seemed to think they'd manage to change her mind, or that she'd be impressed by their inability to let go. Frankly, they just disgusted her. She wanted them to get angry and say, "You're treating me like garbage, like a disposable person," but they never did.

If one had, it would've made her respect him, would've

made her think that just maybe there was a chance he could understand her. A guy who wouldn't put up with her shit would've made her consider going through with the marriage deal. But whining, stalking, won't-take-no-for-an-answer weakness? It turned her passion cold. Immediately.

But what was she? Someone who showed up at her ex-boyfriend's brother's dumpy band gig, hoping to "casually" run into him, that's what. No wonder James couldn't stand her. Men liked fun and vivacious women. Where had she slipped up? How had he known about this needy desperation in her? No one else had ever seen through her.

Two men came out of the bar and stumbled over to where she stood.

"Hey baby, you smell pretty," one slurred. The other giggled.

Kyra took a cigarette out of her purse and lit it slowly. "And you smell like shit. Fuck off." She inhaled deeply and stared at them through narrowed slits that said she'd happily grind the glowing cherry of her smoke into one of their eyes.

They scuttled off. "She's a cold bitch, man. A cold bitch," the giggly one said nervously. Kyra nodded and a bitter smile tugged her mouth. *What's not to love about a stalking, trash-mouthed dye-job, James? What?*

Kyra waited until the men rounded the corner, then threw the cigarette onto the gum-blotched, butt-riddled cement and ground it into oblivion with the heel of her boot. It was a disgusting habit. How could people stand it? She riffled through her purse for gum.

Kyra's stomach hurt and her head wasn't far behind. "Oh,

hurry up." Her words were more a command than a whine. As if cued, a taxi rounded the corner and pulled to a stop.

She opened the rear door and hopped in.

"Just you?" the driver asked, half-turned in his seat to look at her.

"Yeah. Don't sound so disappointed. Bar's not closed yet. Give it half an hour and you'll get a cab full going every which way you're hoping for."

The guy ignored the last half of her comment, and pushed a button to start the meter. "Where to?"

Kyra gave her address and settled in for the ride, sighing deeply. The lights they sped past were nothing but a blur of constant color to her gin-muddled mind, and she felt a little queasy. "Another wasted night," she mumbled, "no pun intended."

She leaned back against the seat, closing her eyes. She opened them seconds later to escape the mental picture of her drinking alone in that dive, watching for James. "I should have stayed home and gone on the treadmill—I would've felt better, and at least I could've had my pride."

"What? You gotta speak up, I can't hear you," the cabbie said, not impolitely.

"Oh, nothing. Just yammering to myself." Kyra sank back against the seat again and watched the world passing by.

B5 – Mainstream; Your Entertainment & Lifestyle Weekly

DEAR FAT GIRL: I'm a Butt Guy!

> Questions, Dreams, Raves, Rants and Fantasies?
>
> Express them and have them responded to by our experts!
>
> ## ASK MAINSTREAM

Dear Fat Girl,

I have to confess that I'm not your average guy. I love big women, the heavier, the better. My friends think that skinny chicks are the bomb but what can I say? More cushion for the——(*Mainstream* has edited for intelligence).

 I love everything about abundant flesh, big breasts, soft thighs. Half my female friends don't believe me, the other half love me.

 Anyway, I'm writing to say you shouldn't feel bitter about men, in case you do. Chances are you'll find the right guy for you. Actually, if you want to give me a dingle, call me at (number omitted by *Mainstream* to protect author from Fat Girl's wrath).

Chow for now,
Like Big Butts and I Cannot Lie

Butt Boy,

I have to confess that I hear your cheesy line all the time, so thanks but no thanks for the "compliment."

 Men (and I use the term loosely) like you seem to think

that fat women should feel flattered by their reversal of society's misogyny. "I like fat women. I'm sooo enlightened."

Any man that can't see past a woman's body, who describes what he likes in a woman in terms of body parts is an idiot in my books.

And aren't you being just a tad self-deceptive? Yes, I'm curvy but is that really going to make sarcastic ol' me more attractive to you than a thin bimbo who thinks she's fat and adores you because you tell her you like buxom women? Give me a break.

Unfortunately, so many women are conditioned to being seen as physical shells first, they won't even hear your line as the insult it is. Your bullshit might actually fly with them. They have my condolences.

Ciao—**very sincerely,**
Fat Girl.

11

JEN TRIED TO IGNORE THE fact that she'd put on the sexiest bra and panties she owned—and what that meant she was considering. Instead she studied her third pair of jeans, turning slowly in the mirror, looking at herself from all angles. She'd already decided on her top, a snug white business shirt with darts that emphasized her breasts and a shape that hugged her rib cage and now small waist. It was totally hot, but looked like she was trying not to be. It was perfect. She was furious with herself, knowing what she was doing, but unable to stop.

Lana was supportive. "You've already shown him that he's not controlling you anymore. You blew off the last coffee date you promised him. Show that fool what he be missing," she said in a mock gangster slur.

"You watch too much daytime TV," Jen said, laughing. "And I only canceled coffee because something came up that I couldn't put off."

"Yes, but he doesn't know that—and you know and I know that you're not getting back with him, so why not give a little in-the-face, 'this is what you're missing out on, buddy'? It'll do your ego good."

Jen groaned. She wished she felt as sure about what she and Lana both supposedly knew as Lana did.

"I'm serious. You've spent your whole life hiding, why not come out and play for a bit? You aren't going to look pathetic, if that's what you're afraid of. You're going to look fabulous, confident and over him."

"What do you mean, *hiding?*"

Lana shrugged. "You just aren't very comfortable in your own skin."

"Maybe that was true before but it's not now."

"No?" Lana didn't wait for an answer, just shooed Jen to her room. "Get dressed. You'll be late. Besides, my show's on again."

Canned laughter blared from the living room, and Jen finally settled on low riding, slim fit flares. She smiled. Lana was hilarious. And right.

She strutted out. "What do you think?"

"Looking good, looking good. And now, if you don't need my fairy godmother services anymore, I'm out of here. Thanks for letting me crash last night. It was fun."

"It really was. Do you want to take home the leftover ribs and chicken?"

"Will you eat it?"

Jen shook her head ruefully. "I've been eating too much these days as it is."

"Oh, don't go all skinny on me. It's just food, not the root of all evil."

Jen retrieved the take-out boxes and handed them to Lana with a slight gnawing of regret.

"I'll call and let you know how it goes," Jen promised. Lana nodded and waved as the elevator's doors shut. Jen took the stairs, two at a time, as usual, but this time she felt winded at the bottom. She resolved to start eating better again.

Jen walked into Quentin's and looked around the semi-crowded restaurant, then spotted Jay at a small table near the back. His head was down, but she'd recognize those dark curls anywhere. She got closer and noticed what he was so engrossed in: *Total*, a trendy new men's magazine. It carried articles like, "Is a Penile Implant Right For You?" and "Eight Ways to Get Laid Tonight." Jen had flipped through the magazine a few times at her doctor's office and hated it.

She cleared her throat. "That rag treats women like candy. 'How to pick up a chick every time,'" she read from the cover. "Sexist drivel."

"Hey, it worked on you," Jay said.

"Yeah, apparently, it worked on your wife too." Jen pulled out a chair and sat. She didn't move in closer to the table.

"Touché," Jay said and smiled. A dimple appeared in his left cheek. "I took the liberty of ordering you a Chai Latté. Still like those?"

"Not much. Too fattening," Jen said, but she accepted it when the girl working brought it over.

"I told her to make it fresh when you walked in."

"It smells delicious," she admitted grudgingly. "Thanks."

"You *look* delicious."

Jen smiled. She couldn't help it. She was a sucker for his flattering tongue. He made her feel beautiful. She longed to ask

which was true? That he thought she looked delicious now, or that he'd considered her beautiful then? *Then.* That time in her life when his words, his compliments meant everything to her self-esteem, meant so much that she'd loved him in spite of his lies, his two-facedness, his *wife.*

Like he read her mind, he said, "But then again, you've always been gorgeous. Roman goddess to Greek nymph. I crave you, Jen." His last words were a sultry growl.

"Jay..." Jen was suddenly hyper aware of her tiny cheeky panties and the seam of her tight jeans, as her mind, her heart—and her thighs—responded to his words. She'd been alone for almost a year. She was always so sure that slenderness would solve that issue for her but here she was, finally skinny... or slim, at least, and still alone. Why couldn't she be like Kyra for once? Just have sex for fun. It didn't have to mean anything.

That's not you, her brain muttered. *Are you nuts?* Jen shuffled her chair closer to the table, so she could reach her latté better.

"So..." Jay's voice trailed off in an open-ended question. He looked at Jen's hand resting on the table and Jen knew it felt wrong for him too, to be together and not touching. "You're still sure?" he asked softly.

Jen's heart hurt. Crazily, she remembered how little aches and pains worried her when she was heavy. She'd always thought she was having a heart attack. Maybe that's what was happening. Maybe she was having one now? *No, the timing would be too perfect.*

She looked at Jay, at the memorized crinkles around his eyes and the slightly crooked line of his nose (He'd broken it

falling off monkey bars, drunk in grade nine.) and nodded. "You were *married*. Married the whole time we were together."

"I told you I was going to leave her—"

"Yeah, once I found out about her. Found out by running into you two together, once we'd already been together for three friggin years!" Jen's face burned. She felt sick. The words were repetitive now, just echoes of every conversation she and Jay had at the end. But the pain? The pain of the redundant conversations always felt new.

How could you not know for three years? Idiot! You expect to me to believe there weren't signs? Jen chewed the inside of her lip, and blinked hard. It was like a lame soap opera.

"But I was never *happily* married," Jay said. "You met Paige. She's cold. Unstable."

Don't listen to him. It's a line. He's playing you. Jen shifted in her seat; it was too warm in Quentin's. She slid her blazer off and hung it over the chair beside her. *But Paige really is a bitch. He's not lying about that—and if we get together this time, it's eyes wide open,* a different part of her mind noted. The other part snorted in disgust. *Don't be stupid. Please.*

Jay's eyes pierced hers, and he kept talking. "I couldn't leave her. She always said she'd kill herself . . . but still, I was going to tell you, I swear, but the time was never right. And I knew that I would lose you, and the longer I put it off, the more sure I was of that, and the more I couldn't handle the thought." He took one of Jen's hands and traced a line on her palm. The gesture was so familiar that Jen wasn't even aware that he was doing it until he sang in a barely audible whisper, "I'm lost without you, baby."

"That's playing dirty and you know it," she said. Their song. The words played through Jen's head all too often and whenever she heard it on the radio, she had to change the station. It hurt too much. But now he was remembering it too. She tilted her head to one side, appraising him. It did take two to have a bad marriage. And it wasn't like he was still with Paige.

Are you kidding me? her brain screamed. *If he's charming to you, imagine how charming he was to his wife to keep her all those years.* Jen turned off those thoughts and forced new ones. *Everyone changes. Maybe we could have something. Maybe he does love me.*

A waitress clearing a nearby table made a clanking sound that brought Jen out of her thoughts and back to Jay's skirted around question. He watched her, with just enough of a smile to be endearing but still look worried.

"I like to make you happy," he said, stressing "happy" in a suggestive way and winking. Jen's stomach flipped. *Happy!* Her hormones cheered, drowning out any squeak of reason that tried to pipe up in the back of her mind.

"I like happy," Jen said, haltingly. His hand still held hers, one finger hypnotically moving over and down, back and across each crease of her palm. She shivered, and hesitated some more. Finally she let it out. "I've missed you too."

Later, lying in her bed with Jay tracing a line from her chin to her breast and back again, Jen wondered why she didn't feel better, cozier, comforted? Sated? Where was the afterglow? She tried to enjoy the moment and snuggled into the crook of Jay's arm, but it felt exactly like it was: contrived.

This was what she wanted, wasn't it? A casual romp in the hay—that may or may not lead to being back with Jay? Her mind didn't throw any barbs now. In fact, the part of her brain that usually ran a constant dialogue, weighing pros and cons, was silent. She felt lost. Let down. Jay hadn't said he loved her. For some reason, she'd assumed he would. He always did before. But it wasn't really what Jay had or hadn't done, or had or hadn't said, that was bugging her. She'd known going in this was a bad idea, but she'd chosen it anyway. Again.

Jay slid his arm out from under her and slipped out of bed. Jen groaned. "Do we have to stop already?"

"I should get to work. I haven't been to the office yet." Jay laughed apologetically.

"I'll make us coffee." Jen grabbed a sweatshirt, one that didn't fit anymore but that she had yet to let go of, and pulled it over her head. Jay had his socks on and retrieved his shirt from where they'd tossed it in abandon. His pants were at Jen's feet, so she stooped to pick them up. As she did, Jay's pocket vibrated against her forearm.

"Your phone's buzzing," she said and reached into the pocket to retrieve it. Jay practically fell over himself to get to it first. Jen looked at him.

"You don't need to worry about that," he said, reaching for the black smartphone.

"I wasn't worried," Jen said, feeling slightly worried now. What was his problem? "Who is it?"

Jay could've said his secretary, a client, a drinking buddy, his hairdresser, pretty much anyone at all, and Jen wouldn't have

thought anything of it. He got calls all the time. But he hesitated for a fraction of a second and in that miniscule pause, Jen saw the truth.

"You creep. You total creep."

Jay didn't look shocked by Jen's outburst. Instead he put on a smile and started to say something.

Jen cut him off. "So that's why you've been less persistent lately. You have a new slut. You were never faithful to your wife. You can't even be faithful to a mistress! So did you bother to tell this one that there was someone else, or were you planning to let her find out for herself, maybe at an impromptu meeting in a grocery store, like I did?"

"Come on, Jen. Be fair. You and I weren't a couple anymore, and I didn't think I stood a chance of us getting back together. I'll break it off with Deanna."

Jen stared at Jay, then laughed. "Like the way you broke it off with Paige?" She didn't give him a chance to reply. "Get out." She pointed at the door. "Get the hell out."

Jay's voice was velvet. "I thought this was just for fun, for old time's sake, you know? C'mon—don't be mad."

"I'm just another piece of ass, aren't I?" The question wasn't meant for him though.

"Jen . . ." He reached for her. "It's not what you think. She's just a fling. We're just sleeping around."

Jen tugged away. "Of course, she's just a fling. Just sleeping around. That's all anyone is to you."

"That's unfair. You were never just sleeping around for me."

Jen wanted to believe that. She really did. He'd been so

much more than that for her. "Oh really? It's kind of hard to picture yourself as special when you know you're just one woman in a long, long line."

Jay nodded as if finally starting to understand something. "So that's what this is about. You didn't end it because I didn't leave Paige. You left me because you found out you weren't my first affair."

"Yeah, maybe." At this point, Jen figured she might as well be honest. "It kind of killed any attempt I made toward self-deception. You didn't cheat on Paige with me because you were trapped in a bad marriage and happened to meet me, the love of your life. You cheated on Paige with me—and didn't even have the decency to let me know what we were doing—because you're a dog."

Jen's heart ached and her hands shook, as she remembered her initial discovery of Jay and Paige. She'd been doing her weekly grocery shop when she'd spotted a tall, slim blonde with her hand laced possessively through *her* Jay's. Seeing the two stroll casually through the produce section, picking out tomatoes, nattering back and forth about which ones were fully ripe told Jen, more than any words could, that it was no new, fledgling relationship.

Jen fast-forwarded through the memory of her accusations, her childish, "How could you do this to me?" but got stuck on the part where Paige laughed and held up one hand—a wedding-ringed hand—to keep Jay from replying.

"I'm his wife, stupid. He hasn't done anything to *you*." She gave Jen a look of such cool indifference that Jen had shivered

and started to make excuses for Jay in her head. After all, he really did look tortured, standing by a weigh scale, a small bag of Roma tomatoes grasped foolishly in his hand.

A *wife*. Jen was shocked to wordlessness. Jay shrugged and looked miserable. Paige just turned away, as if Jen had ceased to be there. As she did, she said to Jay, "God, where'd you get that one? She's so fat...."

Jen's insides crumpled again, as they had then, as they did every time she remembered that scene. *But you stayed with him for another year. And if it wasn't for that drunk's phone call...*

"You think you're the only one?" the voice had slurred. "Jay's a man, that's what they do, they cheat and screw around and in the end they come panting back. Ask Jay about Stacey, or Robin... or how about Jacinda?" The speaker interrupted her own message with a drooling, teary-sounding laugh, and to Jen's horror, she'd heard Jay's voice, angry but not remorseful.

"What the fuck are you doing, Paige? Who'd you call? Hang up the phone. Hang up!"

"Who is this?" Jen had asked stupidly, once the line was cut off, but she already knew. She *knew*. And it ended her and Jay, slowly and painfully, in about five weeks.

Forcing herself back to the present, back to her bedroom, back to Jay in her bedroom, Jen visualized a trashcan in her mind, threw the memory of Paige and Jay into it, and slammed the lid.

"It doesn't really matter. Maybe I should even thank you. I finally know it's really over."

"But you and I weren't together. If we were, I never would've gotten with Deanna. What was I supposed to do? Sit

around and wait? I missed you."

"You missed me? Oh yeah, that's obvious. You could've waited for a bit. I did. But then again, you weren't just a warm body to me. If you missed me and could just replace me with a Deanna? Well... you prove my point." Jen was suddenly exhausted, like she'd run 10K. Her muscles were fatigued, jellied feeling.

She sank to the couch and pointed limply at the door, all her fighting energy gone. Jay opened his mouth, but shut it again. He didn't speak as he made his way to the door. When he reached it, Jen remembered something. "Don't forget your stuff. I found another couple of CDs and a shirt."

There was a rustle as Jay picked up the bag from where Jen had dropped it in their rush to get to her bed. The door opened and then latched shut again.

Her self-righteousness was spent. Hadn't she just been equally willing to use him to fill some gap she'd already known he wouldn't suffice for? She forced herself to wait until she was sure the elevator was long gone before she let herself cry. What had she been thinking? What?

Jen was still sniffling, prostrate on the couch, when the phone rang an hour later. She pulled the cord of her phone's charger until it and the phone fell off the coffee table and landed with a soft plunk. She picked up the receiver. Her sinuses felt full, like there was a surplus of tears in the cavities under her eyes, above her nose. "Hello?"

She must've sounded awful because Lana's boisterous voice

was unusually quiet when she asked, "Where are you? Are you okay?"

Jen tried to laugh. "Okay is relative."

"You know you missed the meeting?"

"The . . ." Jen looked at the clock. It was almost two. "The meeting with Sport Works!" she exclaimed, remembering. "Shit!"

"No worries, I covered for you. It wasn't a problem but Dave was a bit pissed. I think it's more just stress about the changes than you not showing up. Bring him a makeup coffee and he'll be over it."

Jen was silent. She resolved to never use the phrase "makeup" again.

"Hey, you still there?"

"Yeah."

"It didn't go well, eh?" Lana's tone was sympathetic.

"What?" Jen asked and then remembered that Lana knew she'd gone to have coffee with Jay. She groaned inside. Great. Now she'd actually have to talk about it with someone. Lana would push her until she did, push nicely, but still push. She might as well get it over with. "It went like shit." Jen felt, rather than heard, her voice break again.

"Do you want me to come over?"

Jen surprised herself by saying, "That'd be nice." Lana told her she'd see her in a bit. Jen hung up the phone and buried her head in her arms.

Lana walked in with a six-pack of cola, two kinds of chips, a tub of ice cream and four chocolate bars.

"I love you," croaked Jen. "I don't have an ounce of anything decent to eat in the place."

"See, now, just from looking at you, I knew that." Lana grinned. "The best cure for any ailment is always sweet or salty."

"Amen," Jen exclaimed, but her voice wasn't very loud. She looked at the food displayed on the coffee table, and desire mixed with despair flooded through her. She knew that Lana meant well. She really did. Food was comforting. But it had been killing her . . . and now?

Now what? Do you really feel that much better thin? Personally, I think you were a lot more fun and way more easygoing when you were fat. None of your skinny dreams pan out so what do you care? Look at Lana.

Jen looked at Lana.

She looks great, right? Jen nodded. *So eat already!* Jen ate. Lana joined her.

They were quiet for a while, but halfway through the chips, with the chocolate demolished and a dish of ice cream tucked away, Jen noticed the carb overload had calmed and sedated her. The afternoon's pain felt eons away. She was full and philosophical, ready to talk.

"I just don't get it," Jen started and Lana turned, spoon in hand, to face her. "I walked into Quentin's, sure that it would be my last step in severing myself from Jay. I mean, part of me wanted what we had back, sure . . . but I thought I realized for real this time that what we 'had' was only ever fantasy on my part." Lana nodded, but Jen looked at her and shook her head. "That probably doesn't make any sense at all."

"No, I get it. I think most of us have blurred the line between what's real and what we want a time or two," Lana said. Jen smiled at her.

"Anyway, long story short and all that . . ." Jen proceeded to tell Lana the rest. When she got to the bedroom part, Lana hugged her and caused fresh tears.

"Is that what you really want—to be back with Jay?"

Jen stopped crying. "You think I'm back with Jay? Oh no—see, that's where our rendezvous went to hell."

"That bastard!" Lana exclaimed when Jen got to the part about the phone.

"That's what I said." Jen played with the edge of her fleece blanket. "It's for the best, I guess," she finally murmured. Lana made a sympathetic sound, but didn't agree or disagree. Jen sighed heavily again. "I should be relieved. I don't want to be with him, not really. I mean, I tell myself that all the time. I think it's even true . . . It's just that I loved him—who I thought he was—so much. It's hard to face that it was all a lie."

Lana nodded, like that made perfect sense, and Jen was suddenly happy to have her to talk to. It wasn't the huge, shaming ordeal she'd expected.

Lana got up and started stuffing wrappers and empty chip bags into a grocery bag. "Are you finished with the ice cream?"

Jen grunted yes, and Lana disappeared into the kitchen for a minute. Jen put her feet up. Her bloated, over-full state was familiar again, no longer surprising, she realized. She'd been like this a few times the past weeks. If she didn't watch how she dealt with her life, she'd end up back where she started.

"What?" Lana asked, returning from the kitchen in time to hear Jen's gusty exhale.

"Nothing. Just you probably think I'm pathetic."

Lana looked surprised. "Not at all. Why?"

"Because I slept with Jay again."

"Oh, get real. You think you're the first woman to sleep with a toxic ex?"

Jen knew she didn't need to answer.

Lana continued to putter, while Jen huddled on the couch and watched.

"There is one good thing that's come out of this horrible day," Jen ventured after a while.

"And what's that?"

"I finally got him to take the last of his junk out of my condo." Jen smiled, watery-eyed.

Lana laughed. "You're going to be okay, Jen. You really are."

"I hope you're right. I really do." Jen shrugged and repeated her earlier sentiment. "But okay is relative . . ."

WINTER

B5 – Mainstream; Your Entertainment & Lifestyle Weekly

DEAR FAT GIRL: Hurt But Not Surprised.

> Questions, Dreams, Raves, Rants and Fantasies?
>
> Express them and have them responded to by our experts!
>
> ## ASK MAINSTREAM

Dear Fat Girl,

Your letter a few weeks back to "fat, nice guy" was brutal. You act like overweight males don't know half of what women go through. I've been ridiculed and bullied since I was ten. Why? Because I've always been a head taller and eighty pounds heavier than everyone else, but I've never been tough.

I tried to fight back once (my dad's genius advice) and I had to go to the hospital to have my nose set and get stitches in my face and arm because I fell onto the slide when I got pushed and my own weight punctured my skin on the metal edge.

Did I learn anything from this humiliation? Yes. Shut up and take it. I figured this out upon coming home from the hospital to a message that I was suspended for "bullying." No matter that the seventy-nine-pound jerk regularly pulled my shorts down in gym, kicked me in the balls and twisted my fat "girly boobs" leaving bruises all over them; I was the bully because I was so much bigger.

I've never had a date. Oh wait, I lied. There was a girl in grade nine who I retardedly assumed might like me a little because she smiled at me occasionally and even talked to me a few times in Biology. I made the mistake of inviting her to the Halloween dance. I can't blame her for not showing up or for, a week later, announcing to the crowded hallway, "He's a fat creeper, I just said yes so he'd stop stalking me." In fact, I was almost relieved by the scathing comment because it finally silenced them. The beauty and the beast comments were nothing compared to the jokes about what my fat penis would do to her. I'm sorry to be so graphic but my teen life really *was* hell.

You write a good column and I think you mean well but just so you know, fat is fat on a boy or a girl. Boys suffer too.

Sincerely,
"Fat Faggot"

Dear Hurt, (I won't call you by tag you signed with.)

You have every right to be pissed with me, as do the other male readers who wrote in to complain about how flippant I was.

I didn't mean to minimize or negate the cruelty and abuse that overweight boys/men suffer. Hearing stories about what some of you have gone through brought me to tears, literally.

All I can do is apologize and say that despite how I sounded, I do feel your pain and know firsthand how ongoing public humiliations like that feel.

Sincerely sad that I hurt you,
Fat Girl

12

JEN WALKED INTO THE ROOM above Java Hut. For now, it was pretty much just space. Three huge acrylic paintings in warm oranges, yellows and reds decorated the gleaming white walls, two to her right, one to her left. A giant rubber plant took up a corner, looking like it had lived in the loft its whole life and owned the place. Directly in front of her, giving a fantastic view all the way down to Granville Island, were three six-foot-by-six-foot windows.

"Wow, you were right. This is going to be a fabulous office! It's already fabulous!" With a surge of excitement, Jen bounded over to Dave and planted a big kiss on his cheek. "I'm so pumped."

"No? Really? And here I thought you were just happy to see me." Dave pushed off Jen's hug, spun his chair, and surveyed the room. "Do you think it's *too* white?"

"No, I think it's brilliant. Nice and bright, powerful. Confident but fun. Once we have furniture, I'm sure potential customers will walk in and immediately feel like they're in the right place. And I love the paintings. Where on earth did you get them?"

"My cousin, Corrina. She's a painter, remember?"

"Oh, right. I had no idea she was this good."

Dave smiled. "Yeah, she's awesome. I was thinking.... Would your friend Kyra be interested in hanging some of Corrina's work? Maybe selling it for her? On commission, of course."

Jen tilted her head and studied the closest painting. Something about it made her feel like she was watching flowers dance in ecstasy, but there weren't even flowers in the picture if you just looked at the lines.

"She paints more traditional things too, landscapes, kids in parks—maybe they'd be more Kyra's thing?"

"No, I was just thinking about the picture. Kyra will love them, I'm pretty sure. But whether she'll take them probably depends on a variety of factors."

Dave rummaged in his pocket for his wallet and opened it, flipping through it for a business card.

Jen handed him one of Kyra's instead. "Just call her. She won't mind."

Dave nodded. "Thanks."

"Hey," Jen said, suddenly remembering something, "since when do you slough off hugs?"

Dave turned red. "Well, here's the thing.... I'm trying to establish boundaries. I need a bit of space."

"It's just a hug. We always hug." Jen felt tears behind her eyes. Embarrassed she turned away slightly.

"I'm sorry," he said, touching her shoulder. "It's just that I always put more meaning into our hugs than was there. Every

time you'd hug me, I'd feel 'This is it. She's going to like me.'"

"But I do like you—"

"As a friend, I know. I'm tired of pinning hope on something I can't have."

Jen gaped. "What? How come you've never told me this before?"

"I have. You just always thought I was kidding around."

Jen fumbled for something to say.

"Don't worry about it," Dave repeated. "You don't feel the same way, so you didn't notice. It's okay."

"But Dave . . ."

"Yes?"

"Um, never mind. I just—"

"Seriously, I'm sorry I said anything. I'm fine with us. I like you. I hope we're going to stay good friends and that this isn't going to make it hard to work together."

"No, no, it's fine. *We're* fine—Hey, nice chair," Jen interrupted herself, directing her attention to the antique office chair rolling under Dave.

Equal awkwardness and relief showed in Dave's voice. "Yeah, it's great, hey? You'll never believe where I got it."

Jen laughed a little. At least some things didn't change. "What dumpster did you steal it from?"

"You can hardly call what I do stealing. People have thrown out what I take, remember? I merely *retrieve*. It was outside the University's library garbage. This was there too." He rolled a backless black computer chair into view from under his makeshift desk.

"Well, one's a surprising find. One I'm surprised you took. You're not keeping it here are you?"

"Of course I am. It'll hide under my desk when clients come in . . . and when the office is just us three, you'll be jealous of my oh-so-comfortable ottoman."

"Uh-huh." Jen rolled her eyes.

"Holy shit, does it look great in here or what?" Lana exploded into the room in a burst of black: black flares, black turtleneck and, Jen noticed, new black streaks under the red in her hair. The aroma of coffee came with her, and she handed huge, jungle-print travel mugs to Dave and Jen. "Double, double. Milk, nothing sweet—blech—and me, triple, double!" she announced. "Oh yeah, coffee and new cups on me. One of the best things about this office might be its close proximity to the best beans in town."

"Deep breaths, Lana, deep breaths! I think you've already hit the beans too heavy this morning."

"I'll say," Dave agreed, "but thanks a lot."

Lana waved a heavily ringed hand at them. "Someone in this place has to have some energy, some get up and go—speaking of which, I still think pine's the way to go, especially now that I've seen the paint job in here. Natural wood furniture will look great, warm it up, but still be very contemporary. What do you think?"

"Sure," nodded Dave and Jen.

"Well, chop, chop! Let's go and pick stuff out. Spencer's can ship tomorrow, and their factory's right in the city, so even if they don't have every item in stock, it won't be a problem."

"Gee, how come I have a feeling she may have already looked into this?" Dave asked, making a point of directing the question to Jen.

"Wow, Dave, I can't imagine how you arrived at that conclusion, I really can't." Jen assumed a mock puzzled look, stroking her chin as though she had a beard.

Lana rolled her eyes. "Hurry up!" It was impossible to ignore her command. Laughing, they filed out of their new office together, locking the door behind them.

DECEMBER

13

CHELSEA CONCENTRATED HARD, TRYING TO get her body into the act. *The act.* Her mind laughed at her old-fashioned words, but that's exactly what sex felt like these days, one big fake act—and that was on good nights when she could force herself to go through with it at all.

Ted seemed to read her mind and rolled away from her, ceasing his passionate kissing and fondling as if he could tell he wasn't sparking anything in Chelsea but disgust. She tried to quell the feeling, and almost succeeded, but not before she let out a tiny gagging sound.

Ted whispered in the darkness, "What's wrong, Chels? You're not *you*...." Oh? Who am I then? Who am I, Ted? She'd meant to speak the words aloud, but failed. And now she couldn't be bothered. Besides, it really wasn't Ted's fault. He was a good man. Why put all this on him?

So then, a reasonable, lecturing voice in her head put forth, *it is you, isn't it? You wreck things. You wreck people. You wreck good men.*

"Chelsea?" Ted's voice wavered. "You've got to tell me what's eating you." Chelsea noticed then that tears were pouring down her face onto Ted's arm, which had made its way

around her.

He rubbed his hand over her hip, up her ribcage, and she clasped onto it. Ted's hand. A calloused, rough, hardworking, hard-playing *good* man's hand. Ted's hand! She repeated the words over and over and over in her mind. Ted's hand, good, hardworking, clean man. Ted's hand. My Ted. *Not,* her body twitched, *not Richard's icky smooth-as-baby's-skin, pencil-pushing lawyer hand.* Her mind shoved that line of thought away. *Ted, Ted, good, kind, clean, nice Ted. Why, why do I have to remember all this now? After all these years? Why? Why? Why?*

Chelsea voiced her last "why" out loud, and Ted, clearing his throat once, like he was choked up too, said nothing, just held her while she cried herself to sleep.

⁂

JEN STARED AT HER PHONE. The content of Kyra's message wasn't that surprising. Jimmy/James had broken up with her, but Kyra's dramatic love life was old news. The astonishing part was that there were no heart-rending gulps on the machine. No barely contained sobs. No loud sniffles. No teeth-setting-on edge pleas to come over before she couldn't handle being alone anymore. Instead, Kyra was calm. "James and I broke up. Well, he dumped me actually. I think I need to talk to someone, would you mind? If you have time, call me back. Thanks, Jen. Bye."

Jen was floored. Something in Kyra's flat, matter-of-fact tone was off-kilter. Without hysterics and fanfare, Kyra succeeded in sounding far sadder than Jen had ever heard her. It

was the absolute absence of emotion that Jen recognized. Kyra sounded heartbroken.

She punched in Kyra's number, and her eyes flitted to the clock on her DVR. She hadn't missed Kyra's call by too long. *How much time do people spend waiting for people to answer phones, to return calls?* The phone continued to ring, four times, five times... *Come on Kyra, pick up the phone!*

Kyra's voice interrupted the sixth ring. "If I haven't picked up by now, I'm all tied up. If you leave your number, I promise I'll call."

"You sound like one of those dial-a-porn chicks," Jen said with a small laugh. "Anyway, it's me. I'm home for the night now."

Jen's forehead wrinkled as she hung up. She'd really thought there was something different about this breakup, but here Kyra was already out and about. It was just as well. Like she'd be any help to someone with relationship blues. She shrugged and headed to the kitchen. *What to eat, what to eat?*

B5 – Mainstream; Your Entertainment & Lifestyle Weekly

DEAR FAT GIRL: Itching To Be Fat Again.

> Questions, Dreams, Raves, Rants and Fantasies?
>
> Express them and have them responded to by our experts!
>
> ―――――――――――
> ### ASK MAINSTREAM

Dear Fat Girl,

I've lost 100 pounds. I am now, so my best friend says, on the skinny side of thin. She says it like it's the biggest accomplishment in the world.

And I am happy. I feel really healthy and strong. I weight lift and I can bench-press my own body weight! But I'm scared too. Everyone expects so much from me. Don't they know, I'm the same old me? They all want advice. I feel like they expect me to give them a magic pill.

They're disappointed when I tell them it took two years to lose it and that "all" I did was work out six days a week and cut back my food intake, along with quitting my junk food habit and drinking lots of water. I don't get it. Why do they act like I'm holding out on them? My mother's friend actually used that exact phrase, "Why are you holding out on me?" Can you believe it? Like I'd try to keep her fat?

I'm confused and tired. Some days I just want to eat myself back to normal, to where no one had any expectations of me. Do you have any advice? Sometimes I

daydream about being heavy again. Am I insane?

Sincerely,
Itching to be fat again

Dear Itchy,

You're not insane at all. You said that you feel happy and strong now which suggests that you felt sad or weak before? I think deep down you want to stay fit; you just want (need) better ways to cope with the people in your life.

Everyone wants a magic pill. Ads promise, "Get the body you want in just six weeks!" Have they seen my body? There's no way they mean that for everyone. There's always, in minuscule writing, some disclaimer like, "Results shown here not typical," that every poor fat sucker ignores. They promise, "Eat all you want and lose weight!" Are they on drugs? You know you will be if you fall for their gimmick. And here you are—a massive success story—bursting the "it's as easy as a pill or painting your bedroom purple" myths. Hard work and discipline? Yuck. That's not easy or quick. No wonder they're disappointed. Kudos to you for honesty and not pretending it was anything but hard.

Give advice only once. If it's rejected, just smile and shrug the next time they hound you. Don't hide under fat. Find new ways (your voice!) to protect yourself.

Good luck,
Fat Girl.

P.S. Bench-pressing your own body weight? Egads! I have only one question—for the love of Pete, why????

14

MARIE OPENED THE DOOR, THEN followed Jen upstairs to the dining room. She waited until Jen had a big mug of tea in her hand before she attacked.

"Have you been eating again?"

A voice like a fork clanking against your teeth, Jen thought.

"I never quit eating, Mother," said Jen. *And it's nice to see you too.*

Jen was suddenly aware of her jeans. True, they were tighter now, but she hadn't thought they were *too* tight. Now, her stomach seemed to bulge over the waistband. The denim pinched as she sucked in air, as if a full inhale was more than the stressed fabric could take. Her hair felt lank and dull, and she was positive that her face was shiny, telling the tale of too many takeout meals and bags of potato chips. Could her mother really tell in just a couple of weeks?

Marie's eyes did a head to foot evaluation. "Don't undo all your good work dear. You worked so hard." She came over and, uncharacteristically, gave Jen a squeeze. "You deserve to be happy."

Ahh... Something clicked in Jen's mind. Someone, Diane

probably, had let it slip that her and Jay were officially, *officially*, over.

"Thanks, Mom," she said. Her mom, trying to be supportive. Miracles did still happen. "Do you want me to help with anything?"

"No, no, it's nice of you to come early, but I decided to get dinner catered so we can all just relax. Won't your dad be surprised?"

"Yeah, he really will be," Jen agreed. *Happy Birthday, dear, here's a five hundred dollar bill for your catered family birthday party.*

"I got a great deal on the food," Marie chattered. "My bridge partner Eileen's daughter just started her own catering company. She needs guinea pigs to build references with, so for half price and a raving review, we get prime rib, Yorkshire puddings, stuffed baked potatoes, Brie and mushroom strudel, roasted winter vegetables—and cheesecake for dessert. I feel so fortunate! Your father will get a dinner he loves, which we all know I couldn't cook, and it won't even break the bank. I'm paying for it out of that inheritance from my Aunt Maggie's—I told you about it, didn't I? It wasn't much, but still . . . and your dad will be so surprised. He has no idea what's coming."

Jen sighed. At least her mom tried to be a nice person. Why did Jen have to begrudge and suspect everything she did? She gave Marie a bear hug.

Marie giggled self-consciously. "Gee, I know you like prime rib but really, Jen."

Jen laughed too, and her stomach growled. It wouldn't hurt to have one more night of splurging, but then back on the food

wagon tomorrow. For sure.

"Should I change then?"

"Yes, if you don't mind, dear. Diane and Sam should be arriving any minute. It will be lovely if we're looking our best."

Yes, it sure is important to look our best, Jen's mind responded out of habit. *Oh, quit it,* a smaller part piped.

The food was delicious. Everyone agreed that Eileen's daughter's business would be a hit. As her dad glanced around the table at his children and their families, he looked so happy that Jen misted up.

"It's good to see you all at once. Totally unnecessary, of course, I hope it wasn't any trouble," he said in a gruff voice, his pleasure touchingly transparent.

"Of course we came, old man. It's your big one," Sam said, laughing. "Just consider it your Christmas present too. The roads were terrible."

Jen, lulled by thirds of rare prime rib slathered in horseradish, listened dreamily to the light conversation. She noticed that she was seated with her nieces and nephews. *The kids.* Funny and typical that she, not their parents, was nearest to them. She wondered if it was an unconscious put-down from her mother, her mother's mind separating her from the married-with-kids, the "grown-ups." She decided she was being paranoid.

Apparently she wasn't the only one unhappy with the seating arrangements.

"Why do I always get stuck sitting next to you babies?" Rainey hissed at her brother and two cousins, Sam's boys,

Raymond and Josh. "You're such dorks—and you're too old for Transformers."

Rainey's brother, Elliot, mimicked her, causing Raymond and Josh to flail and hoot in laughter. At ten, Elliot and Raymond obviously *didn't* feel too old for transformers and seven-year-old Josh thought anything his older brother and cousin did was the coolest. The plague of being the youngest, thought Jen. Everyone's always cooler than you.

"You're never too old for transformers," Jen interjected with forced cheer, but she winked at Rainey so she'd know she was on her side, too.

"Ahhh, it speaks!" Sam teased.

"What's that supposed to mean?" Jen was honestly confused.

"You've just been pretty quiet is all," Sam's wife, Beth, said quickly like she was defending Sam. And she usually was.

"Yeah, pretty quietly demolishing every bit of food in sight. There's nothing wrong with leftovers, little sis. Leave some for the Ethiopians and all that."

There was an uneasy silence. Jen wondered why on earth her family felt it was their prerogative to comment on her food intake all the time. Good grief. They didn't hear her badgering them every second with what they didn't eat and should, did they? A hot flush spread up her neck to her cheeks and ears. Great. Now not only was she greedy, she was fire-engine red.

"You put away your fair share. Get off her back, Sam," Diane snapped.

"It's different. I'm a guy." That was Sam's answer for every-

thing weight related. And typical, in Jen's studied opinion, of skinny men who hated fat women, he had the metabolism of a hummingbird. He probably ate his own body weight in food every day, but never gained an ounce.

"And why exactly is that different, Sam?" Diane was apparently on the warpath.

Well, who was Jen to get in the middle? She grabbed another roll, spread it liberally with butter and watched the show.

"The difference is, women don't mind a bit of extra meat on a man, so long as he keeps putting bread on the table and a roof over their heads, while men don't like their women to let themselves go."

Fortunately, I put a roof over my own head, jerk, Jen thought. Her mom tsk-tsked nervously.

"Gee, how 400 BC of you, Sam. I'm surprised you could get the words out without grunting and beating your chest."

"You don't have to get so bitchy, Diane. Bruce, how do you handle this feminist woman of yours?" If Sam's last line was meant to drive Diane around the bend, he hit his mark. She went rigid, and half stood up out of her chair.

Bruce, like Jen, had the sense to stay out of it. *Maybe he should be sitting with me and the kids too,* Jen thought, biting back a laugh that felt way too much like a sob. She tuned into Diane's response. It ought to be good.

"If you won't think about how your imbecilic comments make the poor wife you landed with a club feel, would you please consider the negative impact your idiocy could have on your adolescent niece and your prepubescent sons and on their

ideas on what value and place women have in society!"

"Diane..." Sam's voice took on a conciliatory note. "Have you been watching too much Oprah again?" He really wasn't much different from the thirteen-year-old brother Jen remembered.

"Oh, for fuck's sake!" Diane exploded.

Jen and the kids gaped. Then Jen giggled, and so did Rainey.

Beth used the opportunity to scold her innocent boys. "Just because your auntie talks like a toilet mouth, doesn't mean you can. If I hear words like that out of you—"

"This has gone far enough," Marie interrupted. "Jen, end it, please. Tell Sam you weren't offended. Diane, let Jen fight her own battles."

"*Me* end it? It's not my fault. I never said anything!" *See, I do belong with the kids. I'm here for two hours and I'm thirteen again.*

"That's ridiculous. Jen never speaks up for herself, someone needs to!"

Yep, that's me—the poor, fat mute, Jen thought. Something came back to her from an overeaters' support group she used to belong to: if you don't express anger, it will direct itself inward and you'll never quit eating. *Well, duh-uh.*

"I was only joking, Diane, just wanted to get you going," Sam said, probably under duress. Jen suspected Beth had literally kicked him under the table.

"Don't bother apologizing to me. Apologize to Jen." Diane scowled, but then shook her fist and made a small "grrrr" sound, so that he'd know that while she hadn't forgiven him yet, she would.

Conversation moved on and Jen worked hard just to pay at-

tention. Sam and Beth were planning to have another baby. Jen shuddered and hoped it would be another boy, imagining what it'd be like to be Sam's fat daughter.

Diane was thinking of going back to school. Rainey and Elliot were older now, and she almost had a degree, why not finish it? Nowadays it was important to have those letters behind your name.

Yes, because my degree in nutrition's been put to a lot of use, thought Jen.

Marie agreed that Diane's plan to go back to school made sense, but she thought Sam and Beth should give the baby idea more thought.

"Three's a whole different ball game you know," she warned.

They know, Mom! They know. We all know.

Jen's mind wandered. These visits were exhausting. Why did Diane bother to get so emotionally involved? It was much easier to just let them blather. She noticed suddenly that Rainey was staring at her.

"What's up, Rainey?" she asked, smiling, trying to appear present.

"Are you really going to eat that?"

Jen looked down at the spoon in her hand, at the glob of butter that she'd unconsciously been licking. "Well, hey . . . I've heard Ethiopians don't like butter." Everyone laughed except Diane. Jen chuckled the loudest of all.

"See, it's called a sense of humor, Diane. You should get one," Sam whispered.

"Oh, you two," laughed Marie, as if Sam's incessant banter

was just the cutest thing.

Rainey made a face. "Ick, I can't stand butter."

Jen put the spoon down. "Me neither. I must've totally zoned out there." She raised her eyebrows dramatically and said in an ultra serious voice, "Family dinners, Rainey, they'll do it to a person every time." Rainey snickered and nodded.

"What's that supposed to mean?" asked Marie.

"What's *what* supposed to mean?"

Marie looked hurt and directed her attention to her husband. "Are you having a good time, dear?"

He looked up from the sports pages he'd grabbed about the time Diane called Sam a caveman. "What? Oh, yeah. Of course. Everything's great. I'd love some dessert."

Marie got up to serve, Beth offered to help her, and Josh and Raymond, who'd been wheedling to be excused, suddenly regained interest in the table.

Thank God for food, thought Jen. Without it, no families would survive family get-togethers.

"So Jen . . ." Diane said.

Oh please! Drop the butter thing already, Jen thought, figuring Diane was about to try to put something—like Jen's overeating—delicately, but Jen needn't have worried.

"Have you seen much of Chelsea lately? You two are still close, right?"

"Yeah . . ."

"That's what I thought. Is she okay?"

"Ummmm, I'm not sure what you mean by 'okay.' She—"

Diane cut her off. "Brianne's only a year younger than Lor-

raine. Chelsea and I have worked on a zillion committees together. She's one of those fabulous volunteers. You ask her anything and it's better than done, and everything she touches turns out looking like she hired a design group to tackle it. You should've seen the Halloween dance last year."

Diane must have caught the glazed expression in Jen's eyes. "Anyway, I don't know why I'm putting this in present tense. My whole point is that Chelsea *was* a great volunteer. She's dropped everything and the few times I've bumped into her, it's like she barely recognizes me. I actually had to tell her I was your sister, *Diane*, to remind her who I was, and I've known her forever. She looks like a skeleton."

"Oh come on, Diane, give it a rest."

"I'm not being catty. I'm serious. When was the last time you saw her?"

Jen's brow furrowed. She knew in her heart that Diane's observations were on target. She was worried about Chelsea too, worried and suspicious about how well she was adhering to her promise to not be a maniac. She knew Chelsea was back at the gym—she'd apologized apparently—and was doing a full two hours every morning. At least, she was varying her workout. Sheila had been enthusiastic about how well Chelsea seemed when Jen asked about her. Obviously, Chels could still lay on the charm when she needed to. Jen felt like she'd introduced a junkie to heroin. But before she could elaborate on her thoughts, or confirm that she too had concerns about Chelsea's health, the conversation was put on hold. Dessert had arrived.

The Amaretto cheesecake came in three-inch wide by five-

inch high wedges, extravagant even by Jen's old standards. She waited, salivating, for hers to arrive but her spot remained empty even after her mom and Beth had returned to their seats.

"Ohmigoodness, silly me! I forgot you, Jen," Marie exclaimed at the sight of Jen's disappointed face, then hopped up and ran back to the kitchen. She returned a few minutes later with a coffee and a piece of angel food cake piled high with strawberries. "I remembered you wouldn't want a high calorie dessert and got the caterer to make you up something special."

Jen swallowed the lump that rose in her throat. "Thanks, Mom," she mumbled. What else could she say? She'd only been drilling that into her mom's head for months. Was it Marie's fault that the one time she remembered, Jen wished she'd forgotten?

Marie patted her shoulder. "I'm so proud of you," she chirped. The waistband of Jen's jeans seemed to grow teeth and even unsnapped, it squeezed the breath out of her. *Feel proud while you can, Mom. Feel proud while you can.*

KYRA MEASURED OUT HALF A cup of cooked brown rice into five containers, then added sautéed onions, peppers, and snow peas, three ounces of broiled chicken breast, and two tablespoons of Thai-styled dressing. After snapping on plastic lids, she shook each meal vigorously, then placed each container neatly in the freezer below her fridge.

She did up her dishes, wiped down the counters and washed her hands. Then she picked up the phone. After a few rings, a

machine answered.

"Hi, Dad? Aunt Edna mentioned you were in town. I figured we should get together for coffee or dinner? I've learned to make some really fabulous ethnic dishes. So anyway, call me."

She hung up and sighed. Days off seemed so frivolous. She glanced at the clock. She could go into the store. True, it was bad form to haunt your establishment like you had nothing better to do, but then again, sales were better when she was there. Some customers came in just for her opinion.

That settled it. She'd give him an hour to call back or she'd leave. Him. Did she mean James or her father? Oh, who was she kidding? James would never call again. And her dad? Well, a call from him was about as likely as one from James.

Kyra went into the bathroom and poured a bath. She ran her hands over her body in the mirror. Not bad—only the tiniest bit of sag in her breasts. She squinted at them. You'd only notice the sag if you were *really* looking, she decided. No cellulite . . . good.

Was this what life amounted to? She tested the water with her foot before stepping in and sitting down. Then she closed her eyes and slid down so that her whole body, except for her face, was submerged in the steamy, mango-scented water.

She imagined a cheery, faceless someone whistling as he got dressed in the bedroom, and the pitter-patter of little feet in the hall, then a child's voice calling, "Mommy, where are you?"

Lost in her daydream, Kyra almost answered, "In here, dear." She sat up abruptly, feeling foolish, even though there were no witnesses to her silliness. She lathered her legs and

started to shave.

Funny how only Chelsea managed to make it to the altar and now even she—*now even she what? Wasn't living the fairy tale?* Kyra dwelled on Chelsea for a few minutes. There was something going on in that house, and although it made her feel like a traitor, Kyra would bet her last dollar that whatever it was wasn't Ted's fault.

She resolved to call her friend when she finished soaking. And maybe she'd call James too. She hadn't called him for a week. That wouldn't constitute stalking; she'd just call for old times' sake. She was still deliberating whether being together for three and a half months was long enough to warrant an "old times' sake" call without sounding pathetic when the phone rang. She wanted to let the machine get it, but it might be her dad. She leapt up, almost slipping on the sudsy tub bottom, and grabbed a towel. Loath as she was to drip on her carpeting, she had no choice because she'd forgotten the cordless in the kitchen. She scuttled into her bedroom and caught the phone on its fourth ring.

"Hello," she sang out cheerfully, fighting to not sound breathless.

"Miss Thomas?"

Kyra's heart fell. She'd recognize that crusty old voice anywhere. "Yes?"

"It's Mary Betel, your father's secretary."

"And what can I do for you today, Mary?"

"I'm just calling to let you know that your father regrets it, but he's inundated with appointments this trip and won't be

able to have dinner with you."

Kyra pursed her lips, but remained silent.

"And he said to say that he hopes you're well and that it works out to visit the next time he's in town."

"Well, thank him for me, Mary."

"Will do. Thank you, Miss Thomas."

Kyra trudged back to the tub. It felt lukewarm now, although she knew that realistically she hadn't been gone long enough for the water to cool.

It was pointless. Why'd she even try? It's not like he'd ever given a damn about being a parent. He hadn't come to see the store since she renovated—and it'd been over a year. In fact, here she was already planning another reno. He couldn't even be bothered to call in person to ditch her.

It wasn't fair.

"Well, who said life was fair?" her dad's voice muttered in her head.

Kyra sank beneath the bubbles. She stayed under for thirty seconds, sixty seconds, eighty seconds—and then pushed up through the surface, gasping. Kyra sat in the water until it was cold. Then, blueish and prune-like, she crawled into bed and stayed there.

JEN WALKED PAST THE FULL-LENGTH mirror in her hallway. The glimpse of her reflection out of the corner of her eye gave her pause. Even though they were new, her pants looked like they'd need to be replaced soon—by a bigger size again. She turned

and faced herself, studying the eyes of this stranger before her. She had regained twenty pounds or so, but even that did nothing to alter the unfamiliarity of the body before her or the fact that she continued to be a thin surprise to herself.

In her mind, she was still a snug size twenty-four, and this reflected woman in a tight size twelve, with big eyes and a defined collarbone, remained unnerving. But the twenty-pound gain stuck in her mind. Some of it was on her stomach. Where was the rest? She turned and craned her head... maybe her butt? She couldn't definitively place it. Nonetheless, the facts marched through her head: ninety percent of people who've lost weight regain it all, plus more. Less than ten percent of people who manage to lose significant weight keep it all off.

It seemed unbelievable that one could do all the work required, submit to the rigorous torture of exercise day after day, suffer all that restraint, endure all the hungry hours necessary to lose that much weight just to blow it, to fall back into old patterns and regain it. No, it was unfathomable to her and so, even though her old weight-loss group had occasionally talked about maintenance strategies, Jen hadn't listened very carefully; she was too busy planning her new skinny life. She suspected that others, like her, were sure that they would NEVER be one of the ones who returned to Fatty Land. If only the group had alluded to the fact that fat or slim your actual life remained the same. The same struggles existed, the same personal flaws, the same hard relationships—or lack of relationships.

She scowled at the mirror and admitted that even though she resented that the group hadn't prepared her, there was a

good chance they had tried to and she'd just dismissed the idea. She'd blamed her weight for her dissatisfaction with her life for so long that even now, confronted by the evidence that slimness only made buying clothes easier, she could hardly make herself believe it.

Ninety plus percent of people regain all weight lost. Jen shook her head and crossed her eyes at her reflection. It didn't make her smile. She muttered a chant from her school years, "Fat sow, Jenny Cow," at the eyes staring into hers. "You can't get away from reality, can you?"

Jen walked into her living room and checked her call display. Three callers. The number from the last caller was Chelsea's. Would wonders never cease? She'd given up on hearing from her anytime soon, and that would've sucked because it meant that for the first time ever, the three of them would've gone for a month without seeing each other. The worst part was that Jen didn't even feel too sad about it.

She listened to her messages.

Mom wanted to get her recipe for Aunt Maggie's spinach and artichoke dip. *What's with Mom? Since when is she interested in food?*

Diane wanted to get together. *Could be fun.*

The last message was a surprise. It wasn't Chelsea at all.

Ted's voice was uncertain. "Jen? Ted here. If you could give me a call, preferably at work, I'd really appreciate it. There's something up with Chelsea. I was wondering if you knew what . . . if you could help."

Frowning, Jen replayed the cryptic message and jotted down Ted's work number. She looked at the clock. Ted would

be long gone from whichever jobsite he was currently overseeing. She'd call him first thing Monday.

In the kitchen, Jen poured a big glass of chocolate milk, and grabbed a couple of pieces of cold pizza. She might as well finish up the hoard of junk food she'd accumulated because as of tomorrow, it was back to eating healthy and regular workouts.

Her butler stood mutely on her computer screen, a letter lying on a silver tray. She smiled. She still got a kick out of the variety of e-mail messengers out there. She clicked and as the program opened, she couldn't hold back her hope. "Come on, Greg. Don't disappoint me."

He didn't. There were two e-mails from him. She smiled. The phone rang as she typed her reply, but she didn't answer. There was no one else she wanted to talk to. She wanted to hole up with her computer writing to Greg, and later, maybe, watch some TV. She had lots to munch on. It would be a treat night. After all, she wasn't going to splurge again for a long time.

KYRA SMILED AT RYAN AND pushed herself away from him. She'd given him enough to make him want more, but showed enough restraint to let him know he'd have to work to get it.

"That was nice," she said, unlocking the door and sliding out of the bucket seat.

"I'll call you," Ryan said, leaning over and peering out at her. She bent down and looked into the Porsche.

"Sure," she said. "Whenever." She knew from experience

that pretending not to care was the best hook.

A few minutes later she was in her town house. She kicked off her five-inch heels, and leaned back against her door. Ryan's red, fleshy face appeared behind her closed eyes. Kyra grimaced. He drank too much, laughed too loud, and eyed up the waitress.

Oh, she was sick of it.

Kyra moved from the entranceway into her sunken living room. She hovered between the TV and the stereo, wanting company but not sure which . . . visual or audio?

She wished she could be more like Jen, but knew Jen would laugh at that. Jen would say she was desperate to be in a relationship too. But really, even if Jen couldn't see it, she was fine alone. Kyra thought about this, and nodded, agreeing with herself. Jen really was. Kyra, on the other hand? Not so much.

"A woman who can't keep a man is pathetic," her aunt's voice nagged in her head. The vodka bottle on the sidebar glowed attractively in the dim room.

"You're the one who's pathetic," Kyra murmured and poured a drink. "Cheers, Auntie, to you!" Kyra lifted her clunky highball glass in a mocking salute, then drained it. She stooped and got ice from the tiny hidden bar fridge, poured another drink, and sat down on the couch.

The shrewish voice wasn't done. "I was married for twenty years and if Frank hadn't passed, we'd still be married!"

"He died to get away from you," Kyra said, silencing the voice. She turned the TV on, hit mute, then skimmed the guide. She settled on some old movie with ballroom dancers. She watched the actors swirl and sashay in perfect time to some

unheard song. Every girl had her boy. Every boy had his girl. *The way it's been since the beginning of time,* Kyra thought sarcastically. Still, the dancing was pretty and watching it was soothing, almost hypnotic. Kyra finished her drink and placed the empty glass on a coaster.

Her eyes started to close. She should go to bed. Tomorrow was a long day. She wanted to go in early to do pre-Christmas inventory. She'd go in a minute; she'd just shut her eyes for a few seconds.

As she drifted off on the couch, her last vision on the TV screen was a slowly undulating pink taffeta dress. She couldn't see the dancer's face. She didn't need to. The TV was still muted, but she could hear a gentle voice. "Kyra, Kyra, pretty Kyra. Kyra, Kyra, all the boys like ya. Kyra, Kyra..." Her mother's silly, ever-changing song soothed Kyra into sleep. She was taking curlers out of Kyra's hair, releasing each golden strand into a perfect shining spiral.

Kyra was twelve. Her mom was getting her ready for the grade eight's Christmas dance. Kyra's dress had a black velvet bodice and a shimmery, metallic-pink flared skirt and puffy sleeves in the same material. "You look beautiful, Kyra, just beautiful!" There was a quavering note in her mom's voice that Kyra didn't understand. "Doesn't your little girl look gorgeous?" she asked Kyra's dad as he strode into the kitchen.

"What? Oh. Yeah. Great." He picked up the phone, stretching its long, curling cord carefully over the kitchen table and around the china cabinet, then disappeared into the alcove by the steps to the basement. "Keep it down, okay? I've got a busi-

ness call."

Kyra wasn't fazed. What else was new? Her mom, on the other hand, made a face and mimicked him. Like *she* was twelve, not Kyra. This did surprise her.

"You okay, Mom?"

Her mom hesitated for a second, then laughed. "Oh, I'm great, sweetie. What's not to feel great about?"

Kyra stared at her mom's carefully colored hair. It was the color of honey and she wore it like Greta Garbo, carefully set and perfect, side-parted and gently rolling away from her face, not, in the words of her father, "all permed and crazy-looking like a lot of women these days." It was the only comment about her mom's appearance she'd ever heard her father utter. Her face was smooth and perfectly made up. Her lips glowed a warm, deep plum—"In The Pink," her signature lipstick color. She was wearing a short black pencil skirt with black nylons and a charcoal, ribbed mock turtleneck with no sleeves.

Kyra's friends said she looked like a model. They were right. And she smoked Virginia Slims like a model. Sometimes when she lit up, she even said, "You've come a long way, Baby!" and winked at Kyra.

Kyra couldn't explain why, but as she studied herself in the china cabinet's mirror and took in her mom's pretty reflection, totally absorbed in her task, mouth gently pursed in concentration as she undid the last of Kyra's curlers, an icy finger of worry tickled up Kyra's spine. Later, of course, she realized what the eerie vibe had been.

Kyra jerked awake on the couch. She was cold. On the silent TV, a man waved some kitchen gadget about with too much excitement. A bright red message scrolled along the bottom of the screen, assuring her all this could be hers for just three easy payments. She got up gingerly. Her mind still clouded with the dream.

"Parents split up, people move on. Get over it," her dad's mantra from those days rolled into her head, and pain burned in her chest. Funny, no, *sad*: she used to think he was wise.

Upstairs, Kyra slipped out of her now wrinkled dress. It would need dry-cleaning to restore it, so she let it lie where it fell. She pulled her lilac silk pajamas off the hook on her bedroom door and put them on. Then, her mind still on that fateful dance night, she hesitated by the closet. What the hell, she decided. The night was shot anyway. She opened her closet door and, standing on tiptoes, pulled a pink satin treasure box off the top shelf.

She placed it on her night table, opened it and shifted through a few papers, an old perfume bottle, a broken watch, and a heart-shaped locket. Her hand finally rested on a small square of faded blue paper at the bottom of the box. A small rush of old sadness seeped through Kyra at the sight of it.

After the dance, she'd gone to bed, delirious with fatigue and her very first slow dance, sure that life had changed forever. She'd awoken in the morning to a note—the very note she now held in her hand—and found out she'd been right. Life had changed completely.

Dearest Kyra,

My darling daughter . . . My heart hurts to write such a letter, but I can't (or I will not?) go on like this any longer.

Please know, it's not you. You are perfect, but I need more. Your father is not interested in having a wife and I am not interested in coming in last place in anyone's heart.

Don't worry. We will see each other lots and as soon as I'm settled, you will come to live with me, so don't panic. We will talk this all out soon.

Yours forever, with all my love,
Mom.

Kyra had reread the note so many times the paper had lost its texture and felt like cotton under her hand. The words became part of her as she scoured them for meaning, for a reason, for a code that wasn't there. Even now, twenty years later, the message was printed indelibly on her mind. So much so that she didn't need to unfold the little square she held in her hand, yet she did. Just to see her mother's hand, streaked across the page.

Her mother's promise that Kyra would come to live with her, like most of her promises, never materialized. Her father moved his sister into the house and Kyra, though she didn't quite have the words for it, recognized that her mom was right. Dad seemed just as happy with his sister/ babysitter/ housekeeper as he had with Kyra's mom. Maybe happier. Kyra was never woken by screaming fights anymore.

Her mom visited a lot in the beginning, often bringing Kyra

out to meet yet another "uncle" but the visits became less and less frequent—perhaps she tired of Kyra's constant badgering to let her come live with her? And eventually she remarried and moved to Florida. Kyra hadn't seen her mom for over a year when her aunt told her over breakfast—cold cereal—that her mom had died.

"Took too many sleeping pills," her aunt said bluntly, in answer to Kyra's choked out, "How?"

"Like by accident?" Kyra was already well on her way to being a sophisticated sixteen but it was still mostly an act. Suicide was beyond her comprehension, the stuff of shows like *Dallas* and *The Young and the Restless*, not her life. Her aunt just sniffed and shook her head.

Kyra lay in bed, wide-awake. She hated thinking about this stuff. What good did it do? She'd seen a shrink for a while but he was hopeless. She was a well-functioning, successful adult. "Most people would thank their lucky stars to be in your beautiful shoes," he'd joke. Kyra, knowing he was right, didn't feel particularly helped.

They'd had drinks a few times after she quit seeing him professionally, but she thought he was more screwed up than his patients, so she'd terminated the relationship. Self-help books were more her speed.

She glanced at the clock. In another five minutes it would be three a.m. She wanted to be up at five. It was hardly worth going to sleep.

15

JEN COLLAPSED INTO THE RED leather booth with an exaggerated, "Phew!" She shook her hair and droplets of melting snow flew.

"You ever heard of an umbrella?" Kyra asked with a grin, picking up her paisley print one and shaking it at Jen.

Chelsea smiled wanly and raised a hand in welcome. The chain-link watchstrap on her wrist jangled.

"Hey," Jen said. "How *are* you?"

"I'm—Why?"

"Well, Ted..." Jen's voice trailed off at the sudden icy-hardness in Chelsea's eyes and jaw.

"Ted what?"

Jen attempted to look confused. "Ted? What about Ted?"

"Did Ted call you?"

"Why would Ted call me? Don't be ridiculous! Ted and I don't talk to each other, you know that." Jen prayed she wasn't overdoing it. *Come on, Ted. Tag, you're it. Return my call.* "I was just asking a simple question, sheesh. Why the federal case?"

Chelsea scowled and fiddled with the straw in her water. "Do you guys need to eat or can we just hit the mall?"

Jen and Kyra exchanged a look.

"Well, I can't speak for Jen, but I'm famished. I've been looking forward to one of Mo's infamous bacon-mushroom-cheese burgers for two days."

"Me too. I'm hungry, that is. It's been a long time since lunch," Jen explained and then felt annoyed. She was starting to feel embarrassed about her eating again. It was stupid.

"Well, order then. I've got a lot of shopping to do!" Chelsea motioned at the menus.

Jen ignored Chelsea's rudeness and Kyra did one better, saying cheerily, "Me too, Chels. We'll eat quick. Now what are you having? I know you must be starved. It's Thursday."

Thursdays, Jen suddenly remembered, Ted took the girls out for pizza and a movie. Chelsea always raved that it was her self-care night, facial, footbath—no cooking. Kyra was dead-on. There was no way Chelsea had already eaten.

To Chelsea's credit, she realized her friends remembered and didn't lie. "Okay, okay . . . so I wasn't going to eat. Sue me. I'd like to lose a pound or two before Christmas comes and totally sabotages my diet."

Jen frowned. Chelsea being on a diet was as healthy as a fish taking a break from water.

Kyra appeared empathetic. "Why don't you have the Mexican burger? I love them here—low fat and vegan, taste great. Or how about the vegetarian chili? Lots of protein, low carb." Chelsea acquiesced and ordered a chili.

Jen decided to have the bacon-mushroom-cheeseburger too. Her belly flipped in excitement and her mouth watered. It

was ridiculous. Did other people's bodies respond to the idea of food this way?

"So what's new with everyone?" Jen asked, halfway through their meal, trying to get conversation started again.

Chelsea shrugged. She and Jen looked at Kyra, who also shrugged.

"Come on, guys, we're supposed to be the oldest friends in the world, but sometimes . . ."

"Sometimes what?" Kyra stole a fry from Jen's plate and swirled it in the gravy.

Jen was quiet a moment. Chelsea pushed her bowl away. At least she'd eaten most of it.

"Sometimes?" Chelsea reiterated.

"Oh, I don't know." Jen wished she hadn't opened her big mouth. Why couldn't she just let it be? Who wanted to wreck what they did have over a bit of silliness? Not her. But Kyra and Chelsea wouldn't let it drop.

"It's just that lately our visits kind of feel like work," Jen finally blurted. "We used to count down days, stay out later than planned, arrange another date before we'd hardly gotten a word in. We couldn't stop talking. I don't know. . . . Maybe we get together nowadays because of what *was*, not because of what *is*. Do you know what I'm saying?"

Chelsea scratched the back of her neck, smoothed her hair and looked blasé.

Kyra put her fry down on the edge of her plate, uneaten. "No, I don't know what you're saying. You two are my best friends. I *love* you guys. I've just been preoccupied, that's all.

And I've wanted to call you more than I did the last few months, but I figured you'd be busy with work and your family. Plus, you're always doing stuff with Lana."

I am?

Chelsea shrugged. "Maybe Jen's right."

"Jen is not right. Not this time. You just want to slip away without anyone calling you on not eating again!" Kyra was shaking.

There was a sharp intake of breath. Jen realized it was hers. Chelsea seemed unperturbed. She folded her napkin. "What are you insinuating, Kyra?"

"I'm not *insinuating* anything. I'm flat out stating that if you're not careful, you're going to end up in the hospital again. You're doing exactly what you did when you were a teenager. You're too thin. You exercise too much. You don't eat—"

"Like you don't exercise at least every other day and watch the calories you consume."

"I like to be in shape, yes. I keep track of the food I eat to make sure I eat enough. It's a totally different thing."

"Right." Chelsea's voice could've scratched glass.

"You guys!" Jen's throat was hot and sore. She blinked. "This wasn't what I wanted. I was just trying to see if you were still into meeting monthly or what. I didn't want to find out we all hate each other."

Both Kyra and Chelsea stared at Jen.

"We don't hate each other," they said at the same time.

"So how come this is the third visit in a row that's ended in a fight? We're acting like my parents. They have nothing in common, so they bicker just to have something to say to each

other. Otherwise it would be nada, nothing, no words, zip."

"Wait!" Kyra said. "You said you didn't want to find out we 'all' hate each other. Does that mean you hate us?"

"Yeah." Chelsea swiveled in her seat and glared at Jen. "What exactly did you mean by that?"

"Not that I hated you! Not that at all. I don't know what I meant. I didn't mean anything."

There was an uncomfortable silence.

"Okay," Chelsea said. "We've established that we don't hate each other. That's a good thing."

"Considering we're best friends," Kyra added.

Chelsea grimaced. "Maybe there's a grain of truth in Jen's observation. We haven't been talking much."

Jen was so glad that Chelsea had eaten, she could've kissed her. If only people knew the power of blood sugar! She was almost her old self again.

"I guess, if I'm honest, it's probably not your guys' fault at all. It's probably just me. I've been feeling a bit disconnected lately," Jen said.

The table was silent and awkward again.

"No," Kyra finally broke the quiet. "I haven't been telling you guys anything real about my life for months either. You two always know exactly where you're going and what you want. You make a plan. You make it happen. I'm an idiot. I can't burden you with another pathetic breakup story. I'm supposed to be a grown-up.'"

"Oh, come on," Jen said. "The only romance in my life is vicarious. I need the details. *All* the details." She grinned, then

remembered Greg—and the nightmare with Jay. She had stuff to fess up too.

"You'll find the right man for you eventually," Chelsea added.

"I don't know. I have my doubts when I look at you: the perfect wife, perfect mom with a perfect husband, perfect kids. You're living the dream."

Chelsea looked about as pleased as a wet cat.

"What? What'd I say?" Kyra exclaimed, shocked by Chelsea's expression.

"I am *not* perfect." Chelsea enunciated every word and spoke them as if they stood on their own. "I am a *person,* not just some role—wife, mom, *daughter.* Not everything in my life is perfect. I don't need to be glad every minute of the day, and once in my life, just once, I'd like to be allowed to be shitty. To be grouchy. To be a fucking bitch, thank you very fucking much—to not be *perfect.*"

"Well, you got your wish about the bitch part at least," Jen said dryly, realizing too late that she'd spoken out loud. *Crap.*

There was a brief pause. Then Chelsea started to laugh. "I should've known you of all people would know what to say," Chelsea said, sounding almost hysterical. "You really don't hate me?"

"Of course not. Look, I don't know what's going on with you, but if you're worried that for some reason you can't be your superwoman self and that we won't be able to handle it, don't be."

Jen looked at Kyra, hoping they were on the same page, not

angry with Chelsea but concerned instead. To her relief, Kyra was nodding, a little stunned by the outburst, but not fuming or anything.

"And if you feel pressured by the need to be perfect, well, here's your news flash of the week," Jen took a big breath. "You've never been perfect. Not even close."

Chelsea's eyes widened with surprise that verged on hurt.

Jen hurried on, knitting her eyebrows together and shaking her head in mock sadness. "No, all the way back in grade two, you wore one of my boots home by accident. Then in grade three, you forgot your lunch and ate my favorite cookies. In grade eight, you had a crush on the boy I loved—of course he liked you better than me. In grade nine, you decided that you wanted to be more serious, so you wore plaid pants and white button-up blouses. On *you* they looked great. My mom was so impressed she made me get some and *wear* them. I looked like a gray whale beached on Scotland. That was extremely cruel, not perfect at all."

"And you once told me the wrong answer to an essay question, on purpose!" Kyra chimed in. "And you didn't apologize. You said maybe it would help me learn to study. You actually *like* Brussels sprouts and spinach.... There is such a thing as being so good that it's no longer perfect, it's nauseating."

"And you yelled at me twice."

"And you've yelled at me way more than twice."

"And—"

"Okay, okay, I get your point," Chelsea said.

"No, I'm not sure you do," Jen said. "That we could only

come up with silly things is awful. You really do seem practically perfect. No wonder you feel mental around us, if you feel pressured to keep up some false front." Jen took a deep breath before continuing, "All these years, I just thought you were nauseatingly perfect naturally. You never even appeared to struggle."

"What she said," Kyra said.

Chelsea shook her head. Her eyes were overly bright. "I'm just a little, well . . . maybe sometimes . . ."

"Do you want ice cream?" Jen asked. "It always helps me when I'm floundering."

Chelsea laughed, but actually nodded. "Maybe just a little bit. The not eating thing isn't really helping me."

Jen couldn't believe Chelsea had admitted that out loud. She was wondering how to best broach the subject, now that Chelsea herself had brought it up, when a waitress appeared.

Kyra quickly ordered three house special sundaes, and Jen opened her mouth to ask Chelsea about her eating but the moment was lost. Chelsea changed the subject.

"So, yeah, sorry about that. The last six months have been bad for me. But what about you guys? We can't just talk about me. What have you been up to?" Chelsea's mask was carefully back in place. She was concerned, solicitous Chelsea super-friend again.

How could she have been so blind? Jen berated herself. She'd been Chelsea's friend forever, but until this year she'd never questioned whether Chelsea really was the carefree, ideal woman she presented.

Jen took a large mouthful of Rocky Road without really tasting it, and something else occurred to her. Perhaps she and Kyra weren't entirely to blame, weren't totally terrible friends. Chelsea went out of her way to put her best self forward, starting when? As soon as they got close to some sort of real communication, Chelsea maneuvered away, running and hiding behind her widest-eyed, friendliest gaze and casual questions.

Why hadn't Jen noticed any of this before? Was she so enamored with the idea of Chelsea, *of wanting to be her*, that she didn't even really see her? Funny how she'd always thought it was just being fat that made a person disappear.

Kyra patted her arm, and Jen realized she'd been asked a question.

"What? Sorry—"

"We know. We know. You were off in la-la land. I swear you're worse than when we were kids. Where do you drift off to all the time anyway?"

"I was just thinking about weight." That wasn't totally a lie.

"What are you worrying about? You're as slim as anybody now," Kyra said, but she studied Jen critically, and Jen could almost read her mind. She answered the question before Kyra could ask.

"Yes, I'm gaining weight again. Twenty pounds already." She tried to say it casually.

Kyra just nodded. "I thought something about you was a little different, since you brought it up. I thought you were glowing. I was going to ask you if you had a new guy in your

life?"

"No, the passion dancing in my eyes is my newly resurrected love affair with food. No, seriously, ignore my gut, which is probably sticking out because I'm so full now." Jen was lying about feeling full, but felt she *should* feel full so she said it anyway. "I'm going to the washroom. Watch me leave, and when I come back, tell me if you can notice I'm fatter again."

When she returned, both Kyra and Chelsea were watching her. "So?" she asked.

Kyra shook her head. Chelsea nodded hers.

"Well," Jen demanded. "Which is it?"

"Now you've said it, I can kind of see it, but I don't think it looks like twenty pounds—and I don't think you need to worry at all. You look great. You don't have it in you to be a bone rack," said Kyra.

"You're heavier," Chelsea stated. In her newly adopted, completely devoid of tact manner, Jen thought.

"But," she relented, "you can stop the damage. Kyra's right. It doesn't affect your looks yet."

They had always been thin. They couldn't know what it was like. Every comment, no matter how kindly meant, felt like a slam.

You're being too sensitive, Jen reprimanded herself, and knew it was true. Besides she had asked them their opinion.

"Well," she announced, forcing cheer. "I think it's just my annual hibernation mode. I'll snap out of it, no worries."

Kyra and Chelsea nodded encouragingly, and before they could flounder for words or endure any more excruciating

silences, Kyra said, "Let's shop!"

They paid their bills and headed into the cinnamon-scented, white-light-sprinkled mall.

After a few shops, they stopped at Cleopatra's Closet, lured in by signs announcing "indecent sale prices." As they picked through bins of skimpy undies and fur-trimmed "Mrs. Claus" bras, laughing out loud at some of the more outlandish panties—underwear should not be simultaneously made of velour and vinyl, they all agreed—Jen realized she was still feeling insecure.

"I know I'm probably being annoying, but seriously, do you think I look okay? I worked so hard—I may not have it in me to be a bone rack, but I don't want to go back to being a coat rack."

Kyra looked at her sharply. "I meant that as a compliment, not a failing. You know that, right?"

Jen checked a size tag on a pink push-up bra that was only $9.99 and nodded. "I guess."

"Your weight issues are your own, Jen. Chelsea and I don't even see your body unless you point it out. But until you're happy in your own skin, you'll misconstrue anything anyone says to you." She waved a purple g-string for emphasis.

Jen bit her lip. "I know it's stupid, but it's hard to change my head."

Chelsea, holding a polar fleece pyjama set, had been standing silently beside Kyra's growing stack of barely there choices. She pulled Jen into a hug. "It really is, Jen. But you're doing great. You're *trying*. That's the main thing."

Kyra put her arms around both of them and squeezed.

"Don't leave me out!"

"The staff here is going to think we're nuts," Jen said, laughing and pulling out of the huddle.

"Well, they'd be right."

A cheerful salesgirl rang up their orders. "You're good friends, hey?" she asked.

"The best," Kyra affirmed. Chelsea nodded, and Jen smiled. She recognized the deep truth of the words. Who else could you be completely neurotic around, but old, old friends?

Later though, recalling the night's conversation as she pulled things out of their bags to look at them, Jen remembered something her mother had said long ago.

"Don't be too attached, Jen. People change. They grow. Sometimes bad things happen. I don't want you to be hurt."

Jen wound the tiny music box she'd bought for her mom, and watched the little carousel turn to the tinkling melody of the old children's song, *Animal Fair.* You were wrong, Mom, she thought. Wrong.

16

KYRA LAY IN HER TUB. The tepid water was nice. Numbing. She wondered what the point was. Come to think of it, she wondered what was *what* point? She didn't even really know what point she was searching for. Of her life? Of life in general? Of human existence altogether?

She slid her head and shoulders beneath the water to rinse the conditioner from her hair, and came up shivering but thinking of something more concrete, if just as depressing: Christmas. *Just another day of special family togetherness.* She'd actually called her aunt to suggest maybe sleeping over Christmas Eve, having the night together, opening presents together, and then getting dinner ready together.

Her aunt sounded horrified. "No, no. No sense in that. I only got you one present. It won't take that long. Just come around three o'clock. We'll eat at four. Your father's coming."

Her mind threatened to replay the phone call again. *Don't think,* she implored herself. *Rest.*

She had been chilly, but the feeling was gone now. She lay motionless in the cooling water. Maybe death felt like this. A still, calm inertia. She wished she could turn her mind off and

just enjoy this . . . this what? This just being, not feeling.

Her razor caught her eye, but she didn't dare pick it up—and she didn't let her mind go to the reasons why. Finally realizing the cold bath wasn't working, she was still thinking and thinking and thinking, she got out.

Cold water is good for your skin. It closes your pores, doesn't damage your capillaries the way hot water does. The beauty fact popped into her head and she latched on to it with relief. She analyzed her face in the mirror. Yes, her skin was looking good.

Later, as she made her way to her closet, she noticed that the message button on her phone was flashing. How very rare; she hadn't checked her messages last night.

She pressed Play, and James's slow drawl made her heart jump. "Hey, Kyra . . ."

Returning her call? This was positive. She pressed a button to restart the message from the beginning.

"Hey, Kyra . . . You've got to stop calling. I'm worried about you. Your messages are pretty intense. I think you need someone to talk to. Anyway, it really wasn't you. Like I said, I think underneath it all, you're an interesting person—and you're sexy as—well, you're sexy. But you're just not my type. I'm into having a family and well, you're into shallower, commercial stuff. Sorry. I hope you'll be okay. This will be my last call. I'm getting engaged. My ex and I are back together. You can understand why you can't call anymore." There was dead space, like James had something else to say but then changed his mind. "I'm sorry," he said again. There was a soft click.

"Asshole!" Kyra said to the machine, hating that tears had started. "You're *sorry*? Sorry is nothing!" She sat down on her

bed. Her voice grew quieter. "You should've told me what you wanted. You should've told me . . . I want a family too."

She lay down under her down-filled duvet and felt her naked body slowly get warm. Everything was turning out the opposite of how she'd planned her life.

In her mind, she felt James beside her, and remembered what he did for her, did *to* her. . . . *You're a liar, James, a liar. You were totally into me.* Kyra slid deeper into sadness. Where had she failed?

She was exhausted, but it was hard, so hard to get to that place where her mind turned off and she just slept. *Sleep.* If she could just get there, maybe she could sleep forever. The store could go out of business. People would live just fine without another piece of designer crap. No one would really miss her—well, maybe Jen and Chelsea would, but they'd get over it. No one's life would be greatly affected by her dropping off the face of the planet.

This is not you, a voice a lot like her aunt's screamed in her head. *Some man will not get the best of you. Get up and get moving. You're better than this. Work up a sweat. Stop moping. You'll feel better.*

Although everything in Kyra's body moaned against it, she mentally nodded and got out of bed. With numb fingers, she fumbled into her sports bra and slipped on running shorts and socks. Where the heck were her runners?

Scrounging under her bed, a bitter ghost of a smile touched her lips. *My house is like my life,* she noted and discarded half a dozen items before her searching hands rested on the shoes she wanted. *It looks immaculate, but it's really a complete mess.*

Kyra panted and sweated as half an hour of intense exercise stretched into forty-five minutes and then became an hour.

When she hopped off her elliptical machine, she felt better. More like herself. She was not a quitter. She was not fluff. She would recover from this setback. It was just an age thing, a not-being-quite-where-she-thought-she'd-be-by-now thing. And the remedy for that?

Kyra pulled on her thickest terrycloth bathrobe so she wouldn't be chilled as the sweat, still rolling down her back, dried. She sat down at the small rolltop desk in the corner of her bedroom. Pen in hand, planner open, she mulled. The remedy for that was a plan. Or, in her case, a reevaluation of her plan.

She would call Jen. Take her at her word that she wanted to stay/be close again. It didn't make sense that she'd always hung out with Chelsea more. Chelsea was married. Maybe she and Jen could start clubbing together? They were both single. Or maybe clubs were more for early twenty-somethings. Well, so what? They could join something—maybe volleyball? Chelsea was right. They were still young.

Kyra resolved not to give up her search for a good man just yet. She'd wait till she was forty, past prime childbearing years, before she focused on work exclusively. In the meantime? She stared at a small argillite frog on the corner of her desk.

She did love her store. Even if she had occasional moments where she contemplated whether her boutique did anything even remotely for some airy-fairy greater good, it was not wrong to make a living. She cursed James.

The one thing she'd never doubted, before she met him, was that her business was a good thing. Jerk. He sure never

complained about nice dinners, good wine, or borrowing her car. . . .

Anyway, she wasn't going to just renovate again. She was going to expand. She'd still keep her eyes open for the right man, but, at the same time, take her business to a new level.

And that was something else Jen could help her with. Getting online. Yes, she would begin to edge toward a life centered on business, something she was good at, and she would face the reality that maybe she'd inherited a fail-at-relationships gene from both her parents.

The thought of genes—how far they might determine choices and behaviors—caused a creeping shudder to crawl along her spine. Kyra struggled to reroute that line of thinking.

"There's no DNA code for suicide," she muttered—and desperately hoped she was right. "And since business is good, maybe I could adopt a charity . . . or maybe a family?" she pondered, recalling the city's drive to find volunteers to provide Christmas for entire "needy" families.

Like every family isn't needy, she thought, tasting bitterness like it was something she'd just bit into. *There are all kinds of needs.*

Her mind settled on providing gifts and food for a whole household.

"It could be really fun," she whispered. "Maybe I'll get a family with teenagers."

The alarm clock beside her bed blared. 4:45, already? She left the desk and her jotted notes and turned off the noise. In the bathroom, she set her hair in fat hot rollers to give it bounce and a loose natural wave. While she waited for her curls to set, she did her makeup, throwing a tube of concealer

and a soft pink blusher into her purse when she finished. She didn't have bags yet, but she knew from experience that by about three that afternoon, her sleepless night would show under her eyes unless she had something to cover it up with.

She decided to her wear her vintage smoking jacket over a fitted black tank top and skinny jeans, with her antique amethyst earrings and choker. The sparkly light purple stones in their heavy, ornate settings looked great with the soft rose-fading-to-silver jacket. The effect was both formal and funky. Perhaps a bit dressy for inventory, but 'tis the season, she thought.

She knew countless customers would ask the girls, "Is Kyra in by chance?" And she knew she'd come out on the floor to help them personally select presents for themselves and their loved ones. She couldn't help it; she loved sales. And looking good, being a package—her and her great stuff—all helped. She was sure she'd sell amethysts today.

On silken feet, she padded back to her notepad and wrote down one more thing: "No more wallowing. It's ridiculous."

She felt much better—almost great. The secret really was to keep busy, keep focused. It was pathetic where her mind went when she slowed down.

Kyra hummed a Christmas carol, filling the silence around her with the happy notes of "Winter Wonderland" as she went down the stairs.

Christmas, the busiest shopping season of all, would be her savior this year.

B5 – Mainstream; Your Entertainment & Lifestyle Weekly

DEAR FAT GIRL: People Are Jerks!

> Questions, Dreams, Raves, Rants and Fantasies?
>
> Express them and have them responded to by our experts!
>
> ## ASK MAINSTREAM

Dear Fat Girl,
I guess I'm writing this because I have no one else to vent to.

The other day, I was shopping with my two babies when I ran into a man that I know only from my days working in a donut shop. I greeted him with a big smile (customer service mode dies hard), and I was happy to see him. He'd been a regular, one I thought was okay, sort of grandfatherly, not a total pervert like some of them. He beamed and came over. I thought he'd say something nice about my kids like, "No wonder I haven't seen you for a while," but NO. He eyeballs me up and down and says, "What happened to you? Just because you worked in a donut shop doesn't mean you had to eat all the donuts!" Then he held out his arms to (I guess?) mimic my size, and laughed like this was a clever joke.

I used every bit of willpower I had to not start crying. Why are people such jerks?

I have gained weight (eighty pounds) but why is it his business? After I left, I had all sorts of smart replies but it was too late.

I was a teen, practically a kid, when that old creep

thought I looked so good.

Why on earth do men seem to feel like it's their duty to comment on women's bodies? I know women hit on guys, are suggestive to male servers, etc., but I have yet to meet or hear about ONE woman who would greet a practical stranger with a comment about his size. This man's comment was not the first I've heard.

Sincerely,
Sad & Humiliated Stay-At-Home Mom

Dear Stay-At-Home Mom,

Don't be sad or humiliated. Repeat after me, "The guy's an *idiot,*" and forget him.

I have no idea why so many men seem to feel it's their prerogative to bring up a woman's body. Whether they think it's fat or fine is beside the point. What's it to them? Any men want to enlighten me?

Like you, I've had total strangers say rude things. A blank stare and a "Do I know you?" often gets my point across: You are nothing to me. Why are you even talking?

It's sad but typical that he was comparing you to your teen-self. It's sickening that so many people, including women, think of our teenage bodies, not our mature adult ones, as being the ideal. But that's a rant for another day.

Whatever you do, don't stay home. Keep getting out and enjoying your kids!

Love,
Fat Girl

P.S. I especially loved his "What happened to you?" comment. Gee, uh, do you think she could've just had a baby? Last I heard that does stuff to your waist.

17

JEN RANG LANA'S DOORBELL AND when she saw a shadow move behind the door's side window, she chortled, "Fa la la la la, la la la LA!"

A tall, broad-shouldered man with a shaved head opened the door and looked at her.

Jen turned pink. "Oh sorry. I thought Lana was opening the door. You must be Eddie?"

"Yep. You must be the infamous Jen?"

"I guess—I'm not sure about the infamous part." Jen stepped into the entranceway as Eddie beckoned her in, and a delicious scent of mixed spices, cumin and coriander greeted her. The small ground floor suite was painted a creamy yellow and glowed with candles. A little tree sparkled with white lights in one corner of the living room, nearby a beautiful, shiny cello and gleaming piano.

"I didn't know you played an instrument," Jen greeted Lana as she came out of the washroom.

"She doesn't." Eddie smiled.

"Oh, of course. I knew you were a musician," Jen covered.

"I'm sorry you had to come in. I meant to see you drive up

and meet you in the driveway."

"Why would you do that? I'm happy to see your place. It's fantastic."

Lana smiled a bit and seemed to relax. Eddie offered Jen a drink, which she declined, and then asked if she and Lana would be hanging around long enough to have a samosa. They'd be coming out of the oven soon.

"They're for a Christmas party," he explained, "but I cook every chance I get."

"Ah, that explains the scrumptious smell! I'd love to stay. The mall's open until midnight." Jen looked at Lana. She was picking up serious "I want to get out of here" vibes, and she didn't want to agree to stay if it was going to make Lana upset. Maybe she and Eddie were fighting?

Lana nodded slowly, like she was weighing something over. "Sure, what the heck. We can stay," she finally said.

Laughing around the table, nibbling on the baked samosas—just as tasty but not as greasy as deep fried, Eddie explained—Eddie teased Jen about doing an encore so that Lana wouldn't totally miss out on her Christmas serenade. Jen felt a twinge of jealousy mingle with happiness for her friend. Eddie was really great, openly adoring of Lana. Jen tried not to stare at his lovely mocha skin and stubble-rough chin that begged to be touched.

"Well, we should go," Jen eventually conceded, "but I admit, I'm so happily warm and stuffed that the idea of heading into the blizzard winds and packed mall seems a little less festive than a nap on the couch."

Lana looked concerned. "You don't want to go now?"

"Don't be ridiculous! Of course I want to go. I just shouldn't have eaten three samosas."

Eddie walked them to the door, told Jen it was nice to meet her, and he and Lana exchanged a quick kiss. For some reason, Jen felt a bit embarrassed—or perhaps it was just envy again—by the tenderness between them when Eddie stroked Lana's arm and whispered in her ear, so she went outside first to let them have their "good-bye." Lana came right behind her though.

"So that was Eddie," Lana announced as she slammed Jen's car door and clicked on her seatbelt. "I'm sorry if we kept you longer than you liked."

Jen shoulder checked and pulled out. "What are you talking about? It was great. He's *great*."

"Yeah." Lana sounded like she was going to say something else, but had changed her mind.

"Yeah what?"

"Oh, nothing." Lana changed the subject from Eddie, and chattered about what she was going to purchase, and for whom, and about how the way she always left her shopping until the last minute drove her nuts.

The mall was packed, but after circling through three levels of the parkade, they finally found a spot. They went from shop to shop, talking only sparsely because of the crowds, their conversation consisting of nothing more than quick affirmations of gift choices.

Eventually, Lana let out an exhausted, "Whew, I'm wiped." She was flushed and looked overheated.

Jen remembered days when just shopping and mall walking

felt like a marathon. She shuddered and hoped she wasn't headed back to them.

"Wanna grab a coffee?" Lana asked.

"Sure."

"Do you want to head out of the mall or just stay put?"

Jen checked her watch. "Nah, it's twenty to eleven, a lot of coffee shops nearby will be closed and I don't feel like going downtown. Let's just go to Beans & Bites."

The little mall café was crowded with fellow footsore shoppers. As Jen and Lana walked in, a table of five guys whistled and one called out in a pseudo jolly voice to Jen, "Merry Christmas, ladies—I'm Santa Claus, wanna sit on my knee?"

Jen gave him a withering look and pushed past him as he went on to say something equally endearing about how if she was naughty, he'd treat her good.

"Oh oh, don't let her friend sit on your knee, she'll break your lap," one of Casanova's friends jumped in. He directed his next comment directly to Lana. "You should lay off the Christmas cookies, babe."

Jen's jaw clenched, her face heating up. She continued to scan for an empty table. Poor Lana. She shouldn't have to deal with those kinds of asshole comments. Someone should tell the little idiots where to go. Jen rounded on her heel to blast them, but Lana put a restraining hand on her arm and shook her head, a big cheerful smile on her face. The smile hit Jen in the stomach. The worst part of being a fat girl was this continual denial that people's comments hurt you. Not every big person is happy and jolly. Jen stepped forward, prepared to ignore Lana,

but Lana gave another barely perceptible shake of her head and held fast to Jen's arm. She looked the offensive speaker up and down and smiled at his friend—the "Santa."

Her voice was liquid honey. "I'm not your 'babe.' Your comments offended my friend." She broke off speaking to nod at Jen who blushed. So did the guys. "It's not socially acceptable to make comments like the ones you made to women you don't know—I'm assuming you guys like women, that you want to be with one someday?"

There was an expressionless, embarrassed silence among the once loud crowd. Lana nodded as if to agree with her own words.

"Then you might consider learning how to treat them better."

She grinned again when one of the guys, who hadn't been laughing with the rest, laughed now and whispered, "Ouch—burned!" to his embarrassing friend.

"Have a nice Christmas, guys," Lana said, and headed toward an empty table.

"You too," a couple male voices chorused after her. "Did you see the knockers on her?" Jen heard one of them whisper in awe. She shared his awe, but for different reasons. Shaking her head, she followed Lana. It really didn't seem to bug her. She really seemed as cool as she acted. Jen was stunned.

"Gee, it's such a mystery why some men are single, eh?" said Lana, settling into a chair. "And thanks for carrying all the bags. I kind of saddled you with them. Sorry."

Jen thought of the original comment to Lana, of the group's

come-on to her, of a hundred similar comments and responses she'd endured over the years. It had never mattered that the men were nothing to her, or that they were obviously idiots. Somehow the randomness of attacks, the fact that someone who didn't even know her felt free to be so hurtful, made them almost worse than insults that came from friends or family.

"How on earth did you do that?" she finally said. "Didn't they hurt your feelings?"

Lana raised an eyebrow. "I'd have to care what they thought for them to hurt my feelings. They're just kids trying to figure things out."

Feeling hungry, Jen ordered two appetizers, crab cakes and mushroom caps—they sounded festive—and a banana split that had enticed her. She and Lana could share.

"There," she said to Lana as their server walked away. What she meant by the word suddenly hit her and she blanched. She was her mother—constantly extolling the virtues of thinness but on the other hand, first to the emotional rescue with some calorie-laden anesthetic. But Lana didn't need her bolstering. What was she doing? Lana apparently heard her thoughts and began to talk.

"Half the time, Jen, I don't even realize I'm bigger than other people. I'll be breezing by one of the mirrored walls in a store and I'll catch a glimpse of this big woman—sometimes I'll even think, 'Hey, she looks great!' but even when I think *that*, it's always a shock a second later when I realize the big woman in the mirror is me."

So Lana hadn't always been a fat girl. She had the "who's

that person in the mirror?" thing going on too, just in reverse.

Lana continued, "Sometimes I feel like shaking you. Thin as a stick practically, but you're still insecure and body conscious. Yet, you can be ferocious, absolutely fearless, like nothing will get in your way. I appreciate that you were good to go off on that kid, but I really don't need people to stick up for me."

"Yeah, so I see."

Lana waved her hand dismissively. "People say such stupid things. Don't they ever notice my hair? I've got kick-ass hair."

She did. It was chocolate brown these days, falling in a heavy, shimmering sheet past her shoulders.

"I've got good skin, bright eyes, white teeth. I'm obviously, if anyone would care to notice, healthy. I'm always clean. I dress well, don't show my rolls to the world, but I don't hide in burlap sacks either—maybe that's the problem? Maybe people are affronted because I don't cower and hide like a fat person should? Or maybe they think that I don't know I'm fat and they're doing me a favor by enlightening me? Anyway, it can be exhausting and it can piss me off. I feel like saying, 'If I gross you out, don't look!' but then I always come back to my belief that the rest of society's just victimized by body issues too—like those guys. They don't actually find bigger women unattractive. They just think they do—and big women often act like they're unattractive, so it's a vicious circle."

Jen had always thought that she'd considered weight from every angle, but this one was new to her.

"So yeah... most of the time, I feel good about myself without even really trying. I have a lot of other interests besides

my body, you know? But any self-esteem I have is in spite of our culture, for sure. Even plus size models, give me a break, what are they? Size twelves, maybe fourteens—a very rare sixteen? They're the size of average women yet the companies who use them go on and on about honoring 'plus size' women, and we're supposed to feel all pleased and represented?"

Jen sipped her tea. The server delivered their food, which neither she nor Lana acknowledged.

"I wish I could be like you, Lana, but I don't know how. My whole life has been about losing weight. I try to not let weight issues consume me, and I've come a long way, but ever since I was little, someone was always watching my weight. It was just a natural progression for me to take over the obsession."

Lana grunted to acknowledge that she'd heard Jen's words. "It's really not anything I've done—except what I just said, try to fight feelings of inadequacy with reality. Those guys' comments were completely offensive and inappropriate no matter whom they were made to. They attacked my weight, but even if they hadn't, was it okay for them to make the comment they did to you? Why do they feel entitled to say anything to stranger about her body?"

Jen nodded and Lana railed on. "I'm lucky. I come from family of big proud women. My mom and my aunts are all taller than me and just as heavy—and they're all happily married with husbands who still drool for them. I've always had society telling me one thing, but luckily, my personal life showing something else. Still, I have my own glitches."

"Like what?" Jen asked and picked at a mushroom without

really seeing it, fascinated by what Lana was saying.

"I feel self-conscious about Eddie sometimes, feel that if I go on about how great he is, people will think I'm pathetic and lying. A fat woman get a guy that great? Yeah right. Or conversely, some women might feel sorry for him and make a play for him—'Poor Eddie, what's a gem like him doing stuck with a big thing like her?'"

Jen sensed there was more than fat girl paranoia behind Lana's fear.

"It's happened more than once," Lana confirmed, and Jen winced. "It's just so shitty. It's one thing if some idiot men think fat women aren't dateable, but it's totally another thing when women agree with them."

"But Eddie so obviously and completely loves you."

"Yeah, and I know I don't have to worry about him, but I still do sometimes. He just thinks I'm funny and says things like, 'Really, Lana, paycheck-to-paycheck musicians that work as waiters aren't as attractive as you'd think' which is, of course, blatantly untrue. They're every girl's kryptonite. He just doesn't know it."

Jen laughed.

"And then he says, 'I hate to break it to you, but you're stuck with me forever.'" Lana did an uncanny imitation of Eddie's voice and her eyes sparked with mischief.

Jen smiled and felt wistful. Their affection for each other was tangible. She'd felt it the minute she walked into their home. *That's what people are jealous of. That's why women want Eddie. They're jealous of Lana, not negating her at all.*

Picking up a now cold mushroom cap and then discarding

it, Jen said, "I'm not as pathetically insecure as you think, you know."

Lana looked surprised. "Oh, I know that. You just fight the fat woman's battle. It felt unacceptable to you to like yourself when you were heavy, but secretly, part of you didn't mind your weight—felt like you *should* wear it proudly, even if you couldn't. Now you kind of like being skinny and you think that makes you one of them, one of the fatists. A betrayer of fat girls everywhere."

"How on earth could you have known that? I've never been able to articulate that, even to myself."

"Well, sorry to break it to you, but you're not unique. Every magazine ad, TV commercial, radio blip and billboard cries out against us feeling confident in our own skins. If women ever start to feel okay to just be themselves, our economy will collapse. Unhappy, look-obsessed women are big bucks."

"Yeah . . ." Jen paused, thinking. "You're one of the most confident women I know, but even you admit you're not totally immune to body image issues."

"Wishing to be free does not make one free."

"Well, it almost does."

"True—so *true*." Lana waved her hands, as if her body couldn't contain her passion. "And it really does come down to making a decision. Do I let my happiness be dictated by my size, do I focus on my body and my looks, excluding or forgetting everything else? Or do I focus on the larger picture, on my relationships, on issues that actually affect how I live, on *bigger* things?"

They were quiet for a few minutes, sipping their cooled teas. The waiter popped by, probably to take their plates, and looked at the congealing mass of cold food. "Was there something wrong with the food, ladies?"

Jen and Lana exchanged glances. "No, we just weren't as hungry as we thought. Sorry."

"Should I pack them for you to go?"

"Sure," Lana said. "That'd be great."

"And would you still like the banana split?"

Jen and Lana looked at each other again and grinned. "Yes, please," they said in unison.

JANUARY

B5 – Mainstream; Your Entertainment & Lifestyle Weekly

DEAR FAT GIRL: My Girlfriend's Fat

> Questions, Dreams, Raves, Rants and Fantasies?
>
> Express them and have them responded to by our experts!
>
> **ASK MAINSTREAM**

Fat Girl,

You're fat so I thought maybe you could explain something to me. Why don't fat women do something about it? My old lady's huge. I can't stand it. I try to explain why it doesn't turn me on. I tell her when she's about to fill her face with something that'll keep the pounds there, but she still eats. I've even told her the truth, that I'll leave her if she doesn't do something about her weight but she eats and eats.

What should I do? In some ways, there are a lot of good things about her, but I don't want to be with a fat woman. If she loved me, wouldn't she change?

Sincerely,
Want Her to Lose Weight

Dear Want Her to Lose,

Wow. It's been a long time since I've received such a sensitive letter. You inform her when she's "filling her face" and tell her she doesn't turn you on, yet still can't figure out why she eats? Maybe it's because her boyfriend is a total douche. Maybe it's to get whatever comfort and good

feelings she can from the only warm thing around her—dinner.

What should you do? Well, my first choices aren't printable, so I'll go with suggesting that if you really, honestly, want to be with her (although why she's with you is confusing to me too) start focusing on the ambiguous "good things about her" you alluded to and start telling her about them. Believe it or not, if she ever feels you love her for anything other than her size, she might just be able to stop overeating.

Also, has it ever occurred to you, seeing as you've told her "the truth" that you'll leave if she stays fat, that her weight might be her way of telling you to take a hint and scram already? It's what I'm rooting for.

Very Sincerely,
Fat Girl

18

JEN BOLTED THE DOOR TO her apartment, dropped her purse on the floor, and twirled around the room with her arms out by her sides. It had been a great night.

She and Lana had met for dinner to share their plans for the New Year. After leaving the steak house, they checked out a few January sales, didn't buy anything though, and finished off the evening by driving back to Jen's, parking her car, and going to a neighborhood pub. Lana had just left for home in a cab.

Jen stretched out like a cat on her couch, reaching for the ceiling, and groaning with pleasure at the sensation. I've got to get out more often, she thought.

"Oh no!" Jen sat up abruptly. Greg! She glanced at the time on her phone. Oops. She'd forgotten her online date—well, she hadn't really *forgotten*, just hadn't thought she and Lana would be out until midnight.

On her way to her office, the blinking light on her phone's charging base caught her eye. She almost stopped to listen to her messages, then changed her mind. It was too late to return calls anyway. She grinned. Freed by the stroke of midnight.

She headed for her lone computer (the office still felt empty

with only the one now), and looked at her messenger bar. Rats, he wasn't online. The white sands of Haida Gwaii gleamed from her desktop. She chuckled again at how out of place the animated snowman looked in the corner of the screen. It announced new e-mail by throwing a snowball and making a plopping sound. A pile of snow sat by the snowman's feet.

"Now who'd write me at this hour?" Jen murmured, already knowing full well. Smiling happily, she clicked to open Greg's newest note.

From: InTinyTown
To: jar@yahoo.com
Subject: Where are we?

Dear Jen,

I hung out online for a couple hours, but you were a no-show. Heartbreaker!

No, don't apologize. ☺ Like I've said before, "real" life happens and you shouldn't (we shouldn't) put it on hold to hang out in chat rooms. It's not like you stood me up for an actual date complete with dinner, dancing, a walk under the moonlight... See, doesn't that sound like something you wouldn't want to miss? Hint, hint!

You asked me about New Year's resolutions a few weeks ago and I said that I don't make them, but now I've changed my mind. I missed chatting with you tonight. E-mail is not the same. I like your instant scathing replies and challenges. Am I digressing? An occupational hazard, I apologize. (See, still with the hints and you still haven't guessed!) I'll cut to the chase. My resolution is for us to meet and figure out if we're to be or not to be. (See what happens when you leave me to my own uninter-

rupted pondering? I become one giant cliché.)

We've been talking for over four months. It's time. I feel like I'm falling hard, and that I'm an idiot for it, because I haven't even met you. Anyway, I need to know so I can move on with you or without you. Hopefully, we'll both feel the same.

Greg

P.S. As cheesy as this sounds (and I've been the king of cheese already this letter), even if we meet and decide we're not the stuff romance is made of, I still want to keep in touch, be friends.

P.P.S. You can call the terms for our meeting. I'll even wear bells.

Jen rested her cheek on her fist and re-read the letter. "Oh, fine," she said finally, shaking her head. "At least it was nice while it lasted."

She'd contemplated this for a while, knowing that meeting was inevitable—but that didn't make what she was going to do any easier. She imagined future evenings without conversations with Greg, and already missed them. But he was right. It was time.

Jen clicked "reply," and hit "insert file attachment." She searched through her documents, then selected one with the file name, "believeitornot01" and clicked attach.

From: jar@yahoo.com
To: InTinyTown
Date: 01.23.05
Subject: re: Where are we?

Dear Greg,

Great minds think alike. It is time to meet. Let me know what works for you. I'm sorry to cut this short, but if I don't hit send now, I'll lose my nerve. I know you said a picture is unnecessary, but I disagree.

Talk soon,
Jen

Jen's face wrinkled in regret after she hit send and she sat for a moment, fingers hovering over the keyboard, wishing she could take it back. Maybe she'd made the wrong decision? She wasn't that woman anymore. Why penalize herself? *Because,* her mind warned, *you are totally that woman, and you know it.*

She sighed and reconciled herself to her action.

She played Tetris until she realized what she was doing—waiting to see if Greg would pop back online for a minute. She was six lines away from a new personal record, but she quit her game anyway.

As she got up and made her way to her bedroom, pulling off clothes as she went, her hands came to rest on the small mound of flesh newly reforming around her belly button. It was soft and warm. Comforting *and* hated. At least it was familiar.

"Good-bye, Greg," she whispered.

The alarm clock screeched, and Jen slapped it off. She hadn't slept well. It was a relief to get up. She walked into the kitchen, picking up her trail of clothes. This walking around naked thing was new. It was kind of fun. Maybe she was accepting the idea that she might always live alone? Sipping a glass of orange

juice, Jen deliberated, gym or book? She looked longingly at her latest to-read pile. A novel almost won, but her muscles were crying out to be worked. Wonders never ceased. She pulled on yoga pants and a T-shirt, then rummaged for gym socks.

Grabbing her running shoes from their perch under an end table, she jostled her land phone. Resting it back in its base, she remembered she had messages. "You'll have to wait," she muttered, "When I get an urge to exercise, I have to take advantage of it."

She was back an hour later, slick with sweat. The clock read twenty after nine. She still had time before work. The message indicator on her phone's base was blinking like crazy. She sighed. *Good grief people, it's not even ten. What's so urgent?* It was probably Mom and Diane, fighting again, leaving tirades from equally distorted sides. *Gee, it's too bad I wasn't here to get stuck in the middle last night.*

She punched in her code and as the first message played, she paled. She listened to all six messages, then, without taking time to change her sweaty clothes, she grabbed her keys, shrugged into a jacket, and bolted through her door, slamming and locking it behind her.

19

KYRA ROLLED OVER AND GRUNTED. Her ears were ringing. No. The phone was ringing. She pounced on it, more to make it shut up than out of any desire to talk to anyone. The sudden move made her head pound. The pillow beside her was crushed and with a sickening falling feeling in her stomach, the night came back to her. The phone was still ringing.

"Hello?" she snarled, forsaking the cheerfulness she usually mustered in case it was an employee. She just needed to stop the damn ringing. She listened for signs of life in the bathroom. None. She breathed easier when she saw there were no male clothes strewn on the floor either.

"Hello? Hello? Kyra? It's Jen..." Something in Jen's tone sent an icy spike into Kyra's sleep deprived, hangover-fogged brain. Did Jen know about last night? Kyra felt instantly defensive. Who was Jen to judge her?

"It's me. What's up?" she answered coldly.

"Haven't you checked your messages?"

Messages? Kyra groaned. She was reluctant to say no, then realized it wasn't abnormal. Jen probably wouldn't even ask her why. She was still defending herself in an inner dialogue when

Jen's actual words broke through. Chelsea. Hospital.

Kyra shook her head, trying to clear it. "I'm sorry," she said. "I totally didn't catch what you just said. I had a late night."

"Chelsea's in the hospital. Had some sort of accident. What's not to catch? I'm five minutes from your house. Do you want me to grab you?"

"Oh my God. What happened? Is she okay?"

"Do-you-want-me-to-pick-you-up?"

"Yes, yes, pick me up. Of course."

"Be ready."

"I will be." Kyra hung up, threw on jeans and a sweatshirt, and gathered her hair into a ponytail without looking in a mirror. She ran down her stairs and stood by her door. She ended up waiting for Jen.

The drive to the hospital seemed never-ending.

Jen spoke in a monotone that infuriated Kyra. She felt like she had to pull every answer out of her with a crowbar. From the little Jen knew, you'd think she hadn't even asked questions when she spoke to Ted.

Jen let out a small, squeaky sob suddenly and grabbed at Kyra's hand.

"I didn't check my messages last night or this morning until late. I'm terrible."

"You're not terrible. You couldn't know you needed to," Kyra soothed. "I didn't check mine either."

"She'll be okay. They would've said if she wouldn't be, right?" Jen asked.

"We'll find out more when we get there."

There was nothing else to say. They passed the rest of the trip in uneasy silence.

※

CHELSEA SAT BY THE WINDOW in her room. By some fluke, Jen and Kyra entered the parking lot near her wing and she happened to glance in that direction as they pulled up. She watched them park and studied them as they hurried along the sidewalk, bodies bent against the wind, snakes of snow twisting and writhing before them.

She felt bad, wished they hadn't come. They looked so worried.

She pondered this worry of theirs, and shifted between feelings of annoyance in advance over their concern, and guilt that she'd disrupted their day, made them feel bad.

They burst through her door in a silent rush. Tight, kind smiles sat on their faces, trying to mask their fear but Chelsea, of course, had already seen it.

Kyra was makeup free and dressed like she was going for a hike. Chelsea hadn't seen Kyra like this since they were ten-year-olds, sleeping over at each other's houses. Unpolished, Kyra looked strangely fragile. Her skin was pale and Chelsea noticed small lines that she'd never seen before.

Jen looked great. Full of health. Even though she radiated stress, her color was high, her hair shone and her eyes sparked with energy.

Chelsea felt like she was outside herself looking into the room, and had only a cool sort of curiousness about the three

women she saw: Two overly solicitous, obviously worried friends, and herself, unable to get warm, swaddled in a navy velour robe purchased for her late last night by Ted. Every blanket she'd managed to cajole the nurses into bringing was stuffed around her, filling her wheelchair to overflowing.

It was odd though. She was out of herself and could see the blanketed outline of her body, but she couldn't see her face. Or her hair. Nothing was there. She could only see a color. Just a frozen white haze hovering over her shoulders.

Funny how all she could think about was how they looked to each other. What were they feeling? She couldn't pick that up.

They noticed her wheelchair. This she could feel. Chelsea saw Jen's and Kyra's eyes widen and register shock. Then equally discernibly, they mutually struggled to shove their horror and surprise away.

Jen sounded like she was announcing tea was ready and asking if Chelsea would like milk when she commented, "You're in a wheelchair. Were your legs hurt?"

Obviously Ted was still skirting around just what kind of "accident" she'd had. How unfair. He should've prepared them.

"This is a psych ward, you know." Chelsea saw herself speak the words. She saw the words hanging in heavy, gothic-styled letters in the air between her and her friends. Had she opened her mouth to let them out or had they just appeared?

"We know that, silly." Kyra's words were gentle, overly kind—bright purple curlicues. "We just thought maybe they were full upstairs or you needed quiet . . ."

A cotton candy pink trail of things left unsaid, thought Chelsea. Her next words were black—oily black licorice. It was hard to force them from her mouth, but thinking that they were licorice was kind of funny, so Chelsea laughed and they slid out. "No, not my body. Just my brain. My brain is hurt."

She chuckled again. It really was funny to see words appearing above their heads. Too funny.

Kyra and Jen froze.

Kyra broke the silence first. "But your poor face, your eyes... Did you fall?" Kyra reached out to smooth a piece of Chelsea's hair.

At the sudden movement and the touch of Kyra's hand on her head, Chelsea jumped, then shrieked, "Don't touch me. I said *don't*." She let out a sharp scream.

"I—I wasn't—"

Chelsea screamed louder and louder. She could suddenly see that the people in her room were not her friends. They stepped back. Good. She screamed louder. The blonde one ran from the room. The red-haired one hesitated.

"Get out, you dirty creep, get out!" Chelsea screamed again and again. She screamed until she could see the sound slicing through the air, protecting her like a crimson sword. The red-haired one left too.

See, that's the problem with old Richard, Chelsea thought. *He can be tricky.*

20

TIME PASSED IN A BLUR for Jen. Lana and Dave were great and took care of her clients, like it was their pleasure to do so. Lana even refused to take a portion of Jen's pay for it.

"You need to eat too," she said, dismissing Jen's attempts to share at least a percentage of her cut.

Greg sent three e-mails, all to the gist of "we need to talk," and even though Jen knew what the talk would consist of, and that it probably wouldn't take long, she couldn't deal with it right now.

Out of politeness, she sent a quick response, her first two-liner to him ever. "Sorry. I'm not ignoring you, but my best friend is in the hospital. I'll contact you as soon as I can and we'll talk then."

She thought it was nice that he replied to her blip, expressing concerns and sending prayers for Chelsea. She needs them, Jen thought.

Chelsea and her *accident* (actually a kind of nervous breakdown, although Jen understood everyone's reluctance to use that phrase, in which Chelsea had either passed out and fallen—or, Jen's brain stuttered at the thought, had purposely jumped—

off a bridge she'd been running along. She'd been "lucky"—had struck a concrete abutment. If she'd landed three feet over, she would've hit enough water that she could've drowned.) were the reason for all the hoopla in Jen's life right now. She was helping Ted take care of the kids, and whenever he wasn't at the hospital, Jen or Kyra were, sometimes in shifts, sometimes together. They all desperately wanted someone to be there if, no *when,* Chelsea decided she was ready to see people again.

After the screaming, it shouldn't have come as a surprise, but it did: a gut wrenching, sickeningly painful one. They arrived the next day to find a sign taped to Chelsea's door. "Chelsea Hamilton is not seeing visitors at this time. Please see the nursing station if you have any questions. Thank you for your understanding."

Ted demanded a meeting with Chelsea's doctor and invited Jen and Kyra along.

The doctor was brief and to the point. "Chelsea is lucky to have friends and family that care so much for her and she knows it. However, she feels a heavy burden to please everyone and that's not helping her sort through some of the things that have been on her mind lately. She needs space to sort through her thoughts and feelings without feeling pressure to be a good hostess, to act like she's feeling better, to reassure those she loves. Can you understand that?"

They all said they did, and for Chelsea's sake, they wanted to, but really none of them could. Ted looked like he'd been sucker punched. The blood drained from his face and his shoulders hung. Jen imagined she was seeing him as he'd look in

forty years.

"She doesn't even want to see me?" he asked.

Jen looked away from the pain in Ted's face and pretended she didn't hear the small sound that escaped from him as the doctor said regretfully, "I'm sorry."

"But, it was like she didn't even recognize us yesterday, and her screaming? What if she's lucid today, and—"

The doctor interrupted Kyra. "I'm sorry about how this must feel, and yes, she's lucid, as you put it, and she remembers yesterday although, granted, probably a bit differently than you do. Nonetheless, she was very clear about who she didn't want to see."

"What, like she made a list?" Kyra said. The doctor looked pained. "Well, did she? How do you know who she specifically doesn't want to see?"

The doctor sighed and rubbed his hands together. "I'm sorry," he repeated.

Jen wanted to argue as well. She wanted to return on her own later on, feeling sure that *she* didn't pressure Chelsea. That surely, Chelsea meant to exclude everyone but her, but didn't know how to do that without causing hurt feelings. She was positive that if she came back, and entered the room alone, Chelsea would proclaim gratefully, "Oh thank you Jen, I knew you'd understand what I wanted, even though for obvious reasons, I couldn't just come right out and say it. I really need to talk to you. I'm so glad you're back."

Of course, Jen also knew she was being delusional.

"Look Kyra," Ted's voice was higher than usual and sounded exhausted, "there's no point calling me a billion times a day. I don't know, okay? I don't know!"

Kyra stared at the dead-air phone in her hand. *Idiot. No wonder Chelsea's so unhappy. Ted's incompetent, who knew?*

She stood motionless by her kitchen counter, dinner prep forgotten. She didn't know what to do. She'd never been unable to come up with a game plan before.

Maybe she should go back to work. She'd thought she'd be able to be helpful but no, she just sat at home and got hung up on. She frowned, remembering her and Jen's last conversation. Jen *would* think they should continue to listen to the doctors and give Chelsea space. It'd been almost ten days. *Ten!* What if they were lying about her not wanting to see them? What if they'd screwed up, given Chelsea the wrong meds, turned her into a vegetable? There'd be hell to pay and then some!

Kyra was going over in her head how much capital she could raise to get a team of good lawyers when she realized she was being crazy.

"You're insane," she whispered to herself, then winced at her word choice. "You wish this was something you could just rush in and fix, throw money at and there, ta-da, all better. But you can't fix it. You can't. *Can't.* Maybe nobody can."

Faced with the truth from her own mouth, Kyra sank to the kitchen floor. And there, cheek pressed against the cold tile, body curled in the fetal position, she cried.

CHELSEA LOOKED A LOT BETTER—still in the wheelchair, but smiling now.

"Thanks for coming, old friend," she said.

Jen smiled and sat down in a rose leather armchair. Chelsea motioned her closer, so Jen obliged, pulling the chair in until her knees sat just inches from Chelsea's blanketed form. Chelsea shifted, smoothed the blankets, and then fiddled with an edge of the blue hospital linen that covered her.

"I need to ask you something," Chelsea whispered. "I can only ask you." Jen nodded. "Come closer."

Jen leaned in, so close that her hair brushed against Chelsea's.

In a gentle, fluid motion, Chelsea threw the blankets off her lap and revealed skinless legs—bloodied, thin muscles and stretched looking tendons rippled wetly on glistening ivory bones. The smell of raw flesh filled Jen's nose. Sharp acid bile rose in the back of her throat. Jen tried to shut her eyes against the sight, but Chelsea, with surprising strength, grabbed her arm and shook it.

"Look," Chelsea insisted. "*Look.* And tell me..." A grin spread over her now bony, hollow-eyed face. "Do you think I'm fat?"

Jen shuddered awake. She felt cold, yet a hot current of fear buzzed all over her body and she was sweating. She flicked on a lamp and stared at it until she started to breathe evenly again.

She was tired from dreaming. Every night was variations of

the same. She dreamt of Chelsea's screaming. She dreamt of being at the gym with Chelsea pounding away on the Stairmaster with those blackened eyes and that split open, ugly-stitched lip. In the worst dream, Chelsea's voice was soft and kind as she asked, "Why didn't you help me? You knew I was sick. You knew. You're such a good friend." Jen dreamed so much that she tried not to sleep, and she kept as busy as she could without falling down.

Now, shrugging off memories of recent sleeps, Jen looked over at the table where Brianne and Dina sat doing homework. Being with Chelsea's girls helped. And hurt. If only they knew, she thought. If only they knew it was my fault.

"It's not your fault," the doctor had said, looking at each of them during another brief meeting about five days after Chelsea's incarceration—that's what Kyra called it, and the term was catching. "Yes, if she'd received medical attention earlier, we might've been able to intervene and get enough food and fluids into her that her body wouldn't just fall down in complete exhaustion—but it's a moot point. You didn't see she needed help because she deliberately hid it from you. The physical health issues are just symptomatic of mental ones. She didn't tell you what was going on in her head. She ate enough that you wouldn't know for sure, unless you constantly policed her, that she was, for all intents and purposes, starving herself. In a lot of ways, we're lucky she took a bad fall in a public place. The way she was headed, things would've deteriorated badly otherwise."

"So she's anorexic?" Kyra blurted.

The doctor held up a hand. "She has issues with food, but

calling her an anorexic won't be useful. She has some traits that suggest it wouldn't even be accurate."

"Such as?" asked Ted.

"Well, she knows she is very thin—"

"She does not. She complains about being fat all the time," Kyra said. Jen nodded.

"That may be, but when we talk, and according to discussions our diet psychologist's had with her, she knows she's too thin."

"And you'll be happy, or relieved at least, to know she recognizes people for who they are now, all the time. She hasn't screamed at anyone for forty-eight hours."

"What's that about anyway?" Ted asked. "The poor guy that found her and tried to help her called the other night to see how she was. Said he's been having nightmares."

"Come on, Ted. We've been through this. I'll update you on medical details, but everything else Chelsea wants to share in her own time."

Ted nodded, but Jen noticed his fists clenched and he blinked several times.

"Auntie Jen? Hey, Auntie Jen." A small voice to the right of Jen's shoulder brought her back to the present, away from the doctor's office, back to Chelsea's kitchen counter where she stood cutting up Granny Smith apples and cheddar for her and Brianne and Dina as a snack.

"Do you think you made enough apples?" Dina asked.

Jen looked down at her cutting board. A heaping pile, at least eight peeled and sliced apples, shone up at her. She smiled

ruefully and shook her head.

"Sorry, guys. I guess I'm being a bit of a doofus."

"A *doofus?*" Brianne laughed a little from where she sat with her math book, and she lifted a disdainful eyebrow. "Is that another one of your eighties' words, Auntie Jen?"

"Oh, eighties shsmeighties," Jen said, then thought, *Oh no, I'm talking like my mother.* "Don't tell me you're going to be like Rainey, and start giving me a hard time about the eighties."

"You should bring Rainey over to visit, I haven't seen her since I was like, eight?"

"So you two can gang up on me together and make me feel old? Sure, sounds like fun."

Brianne laughed.

Dina listened to their banter with a contented smile and munched on an apple slice. "You were thinking about Mommy," she said suddenly. "Right? That's why you cut too many apples."

At the mention of their mom, the smile disappeared from Brianne's face and she peered intently into her book. Jen's heart squeezed.

"Yeah, I was thinking about your mom," Jen admitted. "I miss her."

Dina flung her arms around Jen's waist and hugged her hard. "When will she be home?" The words were muffled against Jen's stomach.

"I don't know. Soon? I hope, soon."

Brianne got up with a huff and slammed her book shut. "I can't study with all this noise. I'm going—"

The phone rang, interrupting her.

"I'll get it," she said, abruptly cheerful. "Hello?" Her face changed again, reverting back to glum. "Oh, Dad, it's you. Wha—uh huh . . . okay. Yeah . . . okay. Yeah, it's *great* . . . I said, yeah, didn't I? K . . . *bye.*" Brianne hung up the phone and stood, shoulders limp, looking at something only she could see on the floor.

"What was it?" Jen asked softly. *Dear God, don't let it be bad news, don't let it be bad news, please don't let it be bad news, please help us.*

"Mom's going to let people see her," Brianne said.

"Oh, sweetie, that's great! Hooray!" Jen spun Dina around in a celebratory circle and let her go. Dina giggled, then watched Jen and Brianne carefully.

"Aren't you happy about it?" asked Jen, taking in Brianne's expression.

"Yeah, it's great news," Brianne said, grabbing her book off the table.

"Well, what are you doing now then?" Jen asked.

"I told you. It's too noisy down here. I'm studying." Brianne went upstairs. She hesitated for a second on the third stair. "I'll see you tomorrow, Auntie Jen?"

"You bet," Jen answered softly.

"Good." The word was almost lost as Brianne disappeared into her room.

"OH, OF COURSE, JEN, YOU'RE right. Chelsea and Ted need space to work things out on their own. Thanks for being so genius," Kyra said in an exaggerated, sarcastic way after she hung up the phone. *It's not so easy for everyone,* she mused bitterly. *Some of us need people.* She wasn't good with Chelsea's girls. They made her nervous. She hadn't spent enough time with them when they were little. She'd usually just said hi, and scooted out with Chelsea. After all, she'd been there to take Chelsea out, to give her a break from parenting. It wasn't fair that Jen got along with them so well.

Wait! She finally had an idea. She couldn't believe she hadn't thought of it before. Maybe something from the shop would cheer them up. Brianne was getting to the age that appreciated the funky stuff she sold. And for Dina? Dina . . .

Kyra suddenly remembered a gift her dad had given her when she was around nine: a cherrywood hippo, the size of a small pig. She remembered the way it gleamed in the lamplight and the satin sleekness of its polished surface. It was so cute. She'd loved that thing like it was a real pet. Even now, Piggy-Wig lived in her hallway. She still always smiled when she saw him.

Maybe Dina would like one of the animals she sold. Maybe the giraffe that stood as tall as she did? Maybe a smaller version of Kyra's own hippo? Or the alligator? That was it. The alligator! Kyra was excited. Something inside told her she was dead-on, that Dina would love Allister with his smooth as silk, yet intricately carved and ridged body. He was two feet long. Kyra hoped Dina noticed the friendly twinkle in his eye, like perhaps

he was a friendly vegetarian reptile. She giggled a bit, feeling giddy.

In the car, on the way to the shop, she called ahead and got Annie to buff the alligator with a soft cloth so he'd shine.

Brianne seemed to really like her new gauzy, bright-colored, Pakistani panel curtains and throw pillows, and she nodded her head in agreement when Kyra said something inane about brightening up the place until Chelsea got home. She even gave Kyra a little squeeze, which Kyra returned, feeling inept, but pleased at the same time.

Dina lifted the striped lid that covered Allister's box gently. "It's like there's an animal inside," she said.

"Funny kid. Why would you think that?" Kyra was amazed at Dina's perceptiveness. She'd felt like she was putting a real animal into the box.

Suddenly, Dina let out a blood-curdling shriek and for a split second Kyra thought, What have I done? She thinks it's a monster! Then Dina leapt up and threw her arms around Kyra. Kyra wasn't expecting it, and staggered back until she caught her balance. She twitched with self-conscious pride, then returned the bear hug.

"You'd think I'd given you a real live puppy or something," she said. Dina was already back at the box, beaming. Tenderly, and with utmost care, she lifted the alligator out of his box.

"I love him," she breathed.

"You do know he's made of wood, right?" Brianne asked. For a minute, Kyra was concerned about that too. The gator did look amazingly real. What if that was why Dina was so

excited—she thought it was real?

"Duh." Dina brushed off her sister's comment, and Kyra breathed a sigh of relief. "I've met him at Auntie Kyra's store before, remember? That time when we stopped in, but she wasn't there. What's his name, anyway?" Dina asked.

She even knows he has a name! She will love him. Kyra was overwrought with emotion. Maybe she wasn't totally terrible with the whole kid thing after all? "Allister," she said shyly, almost embarrassed. She'd just remembered that Jen was watching the whole gift-giving thing unfold.

"Allister? That's perfect! Just perfect!" Dina danced around the room, Allister cradled to her chest... or, cradled as much as a two-foot wooden alligator could be cradled, that is.

Watching Dina, feeling goofy with happiness that her presents were so well received, Kyra remembered her hippo again. A vision of her dad's face, how it looked years ago, flashed into her mind. She'd never thought about it this way: all those marvelous, quirky gifts he got her over the years... Maybe they were more than just attempts to assuage his guilt at leaving her so often. Maybe they were actually his way of trying to say that he cared about his daughter, even if he was a complete washout at showing it.

Funny, I bet it's all those gifts over the years, and how much I loved them, that got me into the business. It had never occurred to her before.

Dina was oohing and ahhing over Allister's "little itty bitty soooo cute alligator arms" on her way up the stairs, when Brianne, on her tail, called, "Hey, Auntie Kyra, will you help me put these up?"

"You bet," Kyra answered.

"I'll help too," Jen called, and then added after the kids were out of earshot, "Great presents, Kyra. You have a gift with gifts." She paused, and then started to laugh. "And here I thought, out of all the things you sell, your fetish for wooden animals was bizarre, that you were a bit of a freak, but apparently, it's a unique love, shared by a very few...."

Kyra smacked Jen. "Be careful. I have an ostrich who might just have your name on her."

21

CHELSEA STOOD BY THE DUSTY-ROSE door of her room, surveying the light beige walls and similarly toned bedding. Even the few paintings on her walls were muted rose, sage and blue. Boring, but soothing. It had been her home for what felt like months but was really only three weeks.

She fingered the tender, plum-colored flesh on the back of her hand. Her veins, shrunk from dehydration, had been hard to find. A scattering of blue-purple bruises still marked the frequent failure to find a vein, the collapse of others, and the search for more. She was glad the intravenous was over. She'd actually not minded the last week of food. The first days were hard, but then she started to enjoy the simple food Ted brought in so she wouldn't have to panic over the empty carb, fiber depleted food of the hospital.

Thinking of Ted brought a hard knot, surrounded by butterflies, to Chelsea's stomach. He was trying so hard to be, well... perfect. He still didn't seem to understand. It wasn't him. Was never him.

I'm not going to be able to do this. I won't be able to... Panic moved from Chelsea's stomach to her limbs, but as if psychical-

ly tuned to her, a nurse appeared at the door.

"Bit anxious? Don't worry, perfectly normal. Especially at first, no doubt of that, especially since it's only been a few days since you we took you off the IV sedative. You're going to be fine. The medication that the doctor prescribed will help, and you have the number of his office if you need him."

The repetitive patter of the nurse soothed Chelsea, and reminded her of her therapist's advice just that morning, "It's okay to feel overwhelmed. Just make sure you tell people if they're freaking you out."

Freaking you out. What a funny phrase for a professional to use—but fitting. That's exactly how she felt sometimes. Fear slithered through her, making her sweat. They wouldn't be so understanding at home, she knew. Maybe she could change her mind? Maybe if she started to cry hard enough, she could stay in residence, even for just another weekend? A vision of Brianne and Dina, standing by her bed, wide-eyed, overly polite, never volunteering words or making a peep without being asked to, flitted into Chelsea's head.

"They need me," she whispered, but her tone was obstinate, almost ferocious.

The drive to the house was plodding and the silence bellowed with unspoken emotion. Dina tried to speak a few times, but each time, no matter how quiet her voice, Ted shushed her. Chelsea wanted to tell him to shut up and let Dina talk, but she knew he was just trying to be helpful.

Please don't let it be like this at home, please, Chelsea implored in her head, all the way home.

The house looked beautiful. Jen and Kyra had been meticulous in keeping it cleaned and dusted. A faint citrus scent told Chelsea they'd even polished the wood. The banister and china cabinet gleamed. A cheery bouquet of red, yellow, and blue flowers greeted her from the dining room table.

Chelsea smiled at the sight of them, and Dina caught the look.

"There are two dozen, that's twenty-four, roses by your bed too," Dina said earnestly. "They're from Daddy. These ones are from Auntie Kyra and Auntie Jen. They—"

A sharp look from Ted stopped Dina in the middle of her sentence.

Chelsea put her hand on his arm, and shook her head. "They're beautiful, Dina. They look so happy, hey?" Chelsea looked around for Brianne. She was nowhere to be seen. "Where'd Brianne go?"

Dina shrugged elaborately. "To her room, I bet. She's always in her room."

"Can you get her?" Chelsea asked Ted. He nodded and went to the foot of the stairs. Just before he shouted, Chelsea stepped in front of him. "Actually, maybe I should get her instead."

The eight stairs felt like fifty to Chelsea's wasted leg muscles.

Brianne grunted when Chelsea tapped on her bedroom door. She took it as permission to enter, finding the sound oddly reassuring. At least some things didn't change.

Brianne was lying on her stomach on her bed. Before her, a magazine lay open to a tampon ad. Chelsea smiled sadly. She

would've bet money that Brianne grabbed the magazine when she'd heard her mom tap on the door, that before that she'd been staring into space, worrying.

"How come you ran off so fast, kiddo?"

Brianne scowled. "Whatever. You need quiet and rest from us, right?"

She's furious with me. The realization was a punch in the stomach. Chelsea even felt winded.

"Not from you guys, not from you at all," she said, and extended her hand to pull Brianne up from the bed. "Actually, I want to have a family talk about this right now, before it gets any more uncomfortable."

Seeing that Brianne was intent on ignoring her hand, she dropped it and motioned at the door with her head. "Come on, okay?"

Brianne hesitated for an instant, then pushed herself up off the bed.

"I love your new curtains and pillows. They're very cool."

"Yeah. They're from Auntie Kyra."

They walked out of the bedroom and Brianne said, "If we have to talk, can I at least pee first?"

"No, you have to go in your pants—of course, you can, silly," Chelsea said, trying to laugh. This was a nightmare. The kids weren't happy she was home. Well, maybe Dina was. But Brianne was *not*. Ted was terrified and on edge. She forced herself to breathe and decided to peek into her own room. It looked nice. The roses were gorgeous, and the room was filled with that floral shop scent she'd always loved. He tried so hard.

Chelsea got tears in her eyes.

She left the master bedroom, and decided to glance into Dina's room too. She felt peculiar, like she was seeing a place she'd once known well but was now a visitor to.

She opened Dina's door. Then her heart lurched, and she stifled a scream. There was something under the bed in the shadows—a lizard? It couldn't be. She hunched her shoulders and squinted to see better, ready to bolt if the thing moved. Something flesh-colored hung from its mouth.

"What is that thing?" she shrieked, as Brianne ran to her aid.

"What thing?" Brianne's tone was alarmed until she saw what Chelsea was pointing at. She rolled her eyes. "Oh, him. That's *Allister*. He's from Aunt Kyra too. Don't worry about Barbie. That's Dina's new thing. She feeds all the Barbies to her wooden alligator. She's such a freak."

Chelsea started laughing, relieved. The kids had done okay while she was away. She knew it hadn't been good for them, but they survived. Dina was still such a little kid, doing her strange little kid things. It was so . . . *good*. And Brianne? The amused, 'I'm so mature' scorn in her precious older daughter's voice made her laugh harder.

"Well, it's true, she is a bit freakish, Mom," Brianne added vehemently. "My friends think so too. There's always a Barbie being snacked on, and if not Barbie, then some other poor, unsuspecting doll or stuffed animal." Apparently, Brianne then saw the humor too, because she started to giggle alongside her mom.

"Oh, Brianne, give me a hug. Please. It's so good to be back with you again."

This time Brianne let her mother pull her close, and collapsed against her, hugging back just as tightly as Chelsea hugged her. Chelsea felt tears soak through the tank top she was wearing under her unzipped fleece jacket. She stroked Brianne's dark, silky curls and tried to think of words that would even begin to make up for the last weeks, *months*. She could think of nothing.

"Are you really home, Mom?" Brianne whispered. Chelsea knew that she was being asked about more than being back from the hospital.

"Yes, honey. Yes," she whispered against Brianne's papaya-scented head, willing her to trust her again, to believe her that things were going to be better, that she was going to be better. And she willed herself to believe it too.

SPRING
February

22

IT WAS THEIR FIRST TIME back together, purely socially, since the "accident." They stood looking at each other. Jen wondered if Kyra and Chelsea felt as awkward as she did.

"So . . . ," she said.

"So . . . ," they echoed.

Ted came into the kitchen, painfully, awkwardly boisterous. "So where will you ladies be gallivanting this weekend? Paris? Spain?"

Kyra giggled. Jen shook her head. Chelsea looked pained. "We're just hanging around the city, sleeping at Kyra's," she said.

Ted looked disappointed, like he'd really thought they were going somewhere exotic.

But nonetheless, Jen had to thank him; he'd broken through their speechlessness.

"Where are the girls?" Jen asked, turning toward the mudroom.

"At my mom's, sleeping over. Ted's behind with work. This way he can put in some long hours."

"Oh," Jen said with surprise. She hadn't thought Chelsea

was communicating with her mom. When everyone else's visits were permitted again, Chelsea's mom was still not welcomed. She'd phoned Jen, who was inept and fumbling, for answers that she didn't have to give. "And how's that—"

Chelsea cut her off with a wave, and mouthed, *later*.

Jen nodded.

In the car, Kyra steered the conversation to how they were going to spend their evening. Should they shop, or were they shopped out? Take in a show? Just sit around and gab?

Jen took a deep breath and tried to catch Chelsea's eye in her rearview mirror to smile at her, but Chelsea sat with her legs scrunched under her, staring at the houses whizzing by.

Kyra rambled on about what store they should hit first, and searched through radio stations. She finally stopped at an easy listening station.

"Good grief, we're not in our fifties, Kyra," Chelsea said, but there was a hint of laughter in her voice, and she uncurled her legs and stretched a bit. Jen's stomach relaxed.

As it turned out, they barely left Kyra's place. They got sushi to go, drank wine, talked, and watched movies until three in the morning. On Saturday, they made omelets and drank strong, lovely coffee. Somewhere around two, they ventured out for a walk, but when they got home, they got back into pajamas. All their conversations were light and funny, and they spent the afternoon laughing and chatting about who they remembered from school and escapades from their past.

Jen ached to ask Chelsea how she was coping, to see how her first weeks back at home had gone, but Chelsea didn't seem

to want to talk about it, and Jen didn't know how to go there.

Finally, around seven, they decided that they were wasting their weekend out on the town, and should go dancing. Dinner first though, Jen insisted. After all these years, she still couldn't figure out how Kyra and Chelsea could go for so long without eating. Didn't they have stomachs?

"It'll be great to go dancing. I haven't danced in ages—plus it'll burn off some of the junk we ate," Chelsea said, leaning and resting her arms on the back of the front seat, as Jen pulled out of Kyra's visitor parking lot and onto the main road.

"Junk, what junk?" scoffed Kyra.

"I don't know, eggs, cheese, ham," Chelsea said lightly. "Ten pounds of sushi."

"Whatever, ten pounds of sushi! What'd you eat, maybe eight pieces?"

Jen tried to catch Kyra's attention, to shake her head and mouth "Shhhh," but Kyra was intent on Chelsea.

"So what, you're counting my food now? Calculating my calories? I had ten pieces—"

"So you are consciously keeping a record of how little you eat?"

Chelsea drew in such a sharp breath that Jen touched the brakes, thinking another car was cutting into their lane or something. The vehicle behind her blasted his horn and swerved around them. Its bearded driver flipped his middle finger at her, then was gone.

"Keep it calm, you guys. It's busy tonight," Jen begged, not risking taking her eyes off the street again.

"This is bullshit," Chelsea announced. "I was being facetious, Kyra. I know we weren't eating ten pounds of anything. I wasn't obsessing over food, I was making small talk about dancing."

"Then why even comment? And why all the small talk? You have serious food issues and I think we should deal with them. And you aren't eating enough. What do you think she had for breakfast, Jen?" Jen didn't reply. "Maybe two-hundred calories? Hardly a nibble—"

"We were drinking wine until three in the morning the night before. I'm sorry I don't swill down eggs and ham when I'm hungover."

"And even last night, the wine, you wouldn't have munchies—"

"That's enough. Jen take me home. I don't have to put up with this. FYI, Kyra, FYI—" Chelsea was so angry her voice cut out. She got it back. "I have a perfectly good *doctor*, who actually knows something about my condition, and I don't need Kyra-cop on the job. Sorry, if that ruins your control fantasy. How about you stick to time-slotting and day-planning your own life and leave mine alone?"

"Ouch, you guys. Come on," Jen pleaded. "This was supposed to be a rejuvenating weekend." She got no response. A quick look to her right revealed Kyra staring stonily out the window at the blur of passing lights and storefronts. She checked the rearview mirror again. Chelsea sat, jaw clenched, staring challengingly back at her.

"You guys are being jerks. Both of you."

"Take me home, Jen. I mean it."

"Yeah, take her home. Then she can starve herself in front of other people who love her."

"You are such a bitch!" Chelsea's voice was low with fury.

Jen took her next left and circled through some residential areas until she could get back onto the street they'd just come from, but now in the opposite direction. Kyra and Chelsea could fight all they wanted—at Kyra's.

"This isn't the way to my house," Chelsea stated sullenly.

"Right," Jen replied. It was the last word spoken until Jen pulled into a parking space near Kyra's. She turned off the engine. No one moved. The damp night air fogged the windows and turned the temperature chilly. And still no one moved.

"Get out of the car!" Jen finally exploded. "No one's going anywhere until we talk about what's going on."

"God, you are so controlling," Kyra muttered but it was cold and wet enough that she eventually did get out and storm into her house, Chelsea on her heels. At the door, Kyra snarled at them to take their footwear off on the mat, a comment that made Chelsea give her a disdainful look.

Jen stretched out on the floor, and wondered if she'd been wrong. Maybe she should've driven Chelsea home?

Chelsea sat, stiff and silent, wrapped in a blanket on the couch, her knees tucked up under her chin.

Kyra slammed about upstairs. Eventually, Jen heard the whirr of Kyra's elliptical machine. *It's like we never left our teenage selves behind,* Jen thought, remembering the feuds that used

to pop up every so often between her two perfectionist friends. Once they hadn't spoken to each other for three months. Jen actually lost weight with the stress of being their go-between during the battle. Of course, she'd gained it all back eating fries at Burger Stop after they'd made up.

"Why exactly were you and Kyra even friends with me?" Jen asked suddenly. Chelsea was silent. "Give me a break. I didn't do anything. You should still be talking to me." *Thirteen. I'm perpetually thirteen. With my parents, with my friends...*

More silence. Jen remembered that she'd refused to drive Chelsea home. "I'm sorry I didn't take you home. I just thought you guys would patch it up, work it out like adults—since, of course, that's what we are."

Chelsea threw a pillow at her. Jen ducked, and it hit the wall over her head. The vibration rocked a black porcelain cat, sending it smashing onto the coffee table. The head shattered and its tail broke off.

"Uh oh," Jen said, and although it wasn't funny, she laughed a bit—a sound like a snort which made Chelsea giggle too.

"Oops," she said. A few minutes later, she spoke again. "The reason I like you, dough head, and I assume Kyra likes you for similar reasons, is that you're always honest and upfront. If you think it, you say it. I wished I could be like that, say what I felt. Ask things I wanted to know. I don't know. I guess I just always liked, *like,* that I can trust you to call things as they are." Chelsea fiddled with the fringe on a satin pillow she hadn't thrown. "Why'd you stick with me all these years?"

Part of it was the hope that your gorgeousness would rub off on me, Jen thought, but realized she couldn't say that. And here

Chelsea had just said she liked Jen because she was always honest, always spoke her mind. If only she knew.

"Well, in spite of you stealing Ted, you've always been a good friend."

Chelsea giggled. "I forgot about that!"

"Uh huh," Jen said, teasing, then continued, "and one specific thing? Well, you were always so composed and focused. I always felt my emotions were beyond my control. I wanted your ability to make things how you wanted them to be by just desiring it to be to rub off on me."

Something sad came over Chelsea's face. "See the thing is, it doesn't work. I would've been much better off to just call the shitty things shitty, and get on with it. Instead, I hardly got to enjoy the things that were really good, I was so busy trying to ignore away the bad."

Jen recalled Lana's similar statement about how wishing something was or wasn't didn't make it so. She was just about to ask Chelsea what the shitty things in her life had been—and were—when Kyra tromped down the stairs two at a time.

She stopped at the sight of the broken cat and the telltale pillow. "See? I tell you not to wear your shoes in the house and up you go on your high horse, but I forget to tell you not to throw pillows and look what happens!" Her face was sweaty and pink from the exertion of her workout, but she mimicked her aunt's frosty tone from their childhood visits so perfectly that Chelsea and Jen laughed.

"Miscreants!" Kyra scolded again, still in her aunt's voice, but not quite managing to keep the grin off her face this time.

"I'm sorry. It was me," Chelsea admitted, twisting a strand of her chestnut hair around her finger. "I'll replace it. It *is* replaceable, I hope?"

Kyra waved off the apology and the offer. "The dollar store. Two bucks. No house cat lives forever." She scooped the pillow from the floor, tossed it into Chelsea's lap, and with careful fingers picked up the largest shards of porcelain. When she returned from the garbage, she pulled a mini-vacuum from a hiding place beneath the couch. Within seconds there was no trace of the broken figurine.

"You really are prepared for everything, aren't you?" asked Jen, but it wasn't a question.

Kyra shrugged modestly and a small smile lifted the corners of her mouth. Jen grinned back.

"That's the mind-boggling thing about you," Chelsea said. "You'll spend three hundred dollars on a throw cushion and decorate the same room it sits in with a two-dollar novelty. But somehow, it all works."

"I only get the good quality ceramics from the dollar store. That cat was unflawed, and hand painted. They must've got it from some jewelry store closing down." Kyra paused when she saw Jen shaking her head. "I'm serious—but some of their other stuff though, yikes. Do people really buy that junk?" Kyra stopped babbling midstream, strode over to Chelsea and enveloped her in a hug. "I'm very sorry," she said. "What you eat really is your business, and you're absolutely right, as long as you're eating something, I should shut up. I just really care, you know? And I was really scared for you, but I never got to tell

you that properly. I love you."

Chelsea nodded against Kyra's shoulder, her voice muffled, "I know. I'm just a bit sensitive about food comments. I'm not anorexic."

"I know," Kyra said, releasing her from the hug and settling down on the couch beside her.

Jen took a spot on the floor near them and stretched her legs out in a V-shape in front of her, and leaned over one, then the other. Then she pulled her legs in and sat cross-legged. "A bit stiff from the gym yesterday," she explained to her friends' amused looks. They nodded.

"That's the rumor going around, you know," Chelsea said a moment later.

"What is?" Kyra asked.

"That I'm anorexic." Chelsea's hands locked together, white-knuckled, over the pillow she still held in her lap.

"No, it's not," Jen scoffed.

Chelsea nodded her head vehemently. "No, I know it's true. Dina came home from school the other day, and told me so, right over dinner." Chelsea relayed Dina's full story.

"Irene Feld *really* said that?" Kyra asked.

"Uh huh. Dina said, 'Minnie Feld says her mom says anyone with half a brain could tell that you're nothing but an Ann-Or-Ex-Ick. I told her no way, you were not. But are you, Mommy? What is an Ann-Or-Ex-Ick, anyway?"

"She told her *kid* that? What did you say?" Jen stood up, outraged.

"The truth. I told her that I was not, am not—but I also ad-

mitted that I had some problems in my head that made me think eating wasn't the best thing for me to do." Chelsea pushed her hair behind her ears, then took a deep breath and continued, "I also told her to tell Minnie that if she does meet someone with anorexia, that doesn't mean they're a bad person. It's something they need help with."

"Good for you, but I still would've punched Irene," said Kyra, with clenched fists.

Chelsea's laugh was fragile. "I might have too, but it was Dina I was hearing it from, not Irene. Dina's seen me too angry lately as it is." She rehugged the cushion in her lap. "I also reminded her about our talk when I came home from the hospital, about how I'll try to always eat with them but that they don't have to police me, that I'm the mother, and it's my job to protect them, not the other way around. I'll worry about my food and watch it for myself. And, this was the hard part, if I start skipping meals, they don't need to say anything but they should tell Ted if they're worried."

"Wow," Jen said. "Tough conversation."

Chelsea nodded. "Of course Ted didn't even want me to tell them that. He thought I should've said, 'No, I'm not anorexic,' and left it at that. But after the things I've said and done, to Dina especially, I can't let her think that I was normal about food." A tear escaped from Chelsea's brimming eyes.

"It's okay, it really is." Kyra patted Chelsea's shoulder.

Jen gave an emphatic nod and squeezed Chelsea's knee lightly. "Your girls are going to be fine. They're fantastic kids. You've been great with them. A few rough months, a bad

year . . . That can't undo all the good you and Ted have done, and you're doing the right things again now. Talking it out, telling the truth, even if it's painful. That's got to help them."

Chelsea seemed comforted, but didn't say much more.

Later, after yet another movie, Chelsea and Kyra drifted off to sleep, Chelsea stretched out on the couch, Kyra curled in the loveseat. Jen knew she should try to sleep too. Despite it being their getaway weekend, Chelsea wanted to be home by noon so she'd get to spend time with the girls before the school week started again. If they wanted to squeeze in breakfast together, they'd have to get up reasonably early. But argue with herself as much as she might about why she should sleep, it just wasn't happening.

Kyra's computer monitor blinked seductively from her small dining room. Kyra won't mind, she reasoned, and then, pretending that the only reason she was going online was because she had insomnia, she got up and logged on.

Greg had sent only a minimal reply, "the sooner the better," to her latest promise to get in touch with him for a "real" conversation either by messenger, or by phone.

The sooner the better? It sounded terse to Jen. *Can't wait to dump me, hey?* She wished he'd just stop contacting her, she'd understand the message, and it would be less humiliating. Oh well, at least it would be happening online, he wouldn't be able to see her face flush or, heaven forbid, if she cried.

She was contemplating her pathetic situation, heartbreak over an Internet boyfriend for crying out loud, when a loud ping blasted her ears, and a message box flashed. "InTinyTown

has just logged on." Jen jumped, then pushed the on/off button for the speakers, and looked toward the living room. There was no movement. Apparently, the noise hadn't disturbed them. Jen glanced back at the screen, and moved her cursor to reveal the new message. She smiled wistfully. Why did this have to end? It was so fun. With a huge sigh, she started to type in bold red.

Red-haired: Hey, it's me. Can you believe it?

InTinyTown: Hardly! I was wondering what happened to you, and when we'd be able to talk again.

Red-haired: Well, here I am, having a weekend with the girls actually, but they're crashed now. I'm on Kyra's computer.

InTinyTown: Can you call me?

Jen hesitated and nodded. Then blushed, feeling stupid, and typed, "Yes, will do." She grabbed Kyra's phone from the kitchen counter and slipped upstairs and got settled on Kyra's bed. She wanted to be comfortable and far away from her friends if she started to cry. Her stomach churned as she entered his number. Maybe she shouldn't have sent the picture. No, she did the right thing. It just sucked. Why did things always have to end?

Greg's voice was raspy from not speaking, and as always Jen's belly flipped when she heard it.

"So your friend's going to be okay?"

Jen barely answered before he continued. "I'm really glad. Does that mean we can meet now?"

"You still want to meet?"

"Yeah..."

"We haven't talked for so long. Did you get that e-mail attachment I sent?"

"The picture?"

"Yes."

"I got the picture. I told you that weeks ago."

"And you still want to meet?"

"Where is sharp, witty Jen, and what have you done with her?"

Jen smiled despite the rock of tension sitting in her gut.

"What should I do, just show up at your door? Actually, scratch that. I'm desperate but I'm no stalker—" Greg sighed. "Crimminy! I can see why you don't want to meet me. I say such idiotic things. It's embarrassing."

Jen flopped down on her back, relaxing into the conversation. "I don't know if 'Crimminy' is so much idiotic, as just hopelessly old-fashioned."

"What's wrong with Crimminy? That's strong, manly language where I'm from."

"So you're a trucker. With language like that, you must be."

"Come on, Jen," Greg said. His voice was soft. "No more games. I want to meet. Or to know that we're not going to. I can't keep on like this."

"Well, if you wait until a first date to find out someone's a serial killer, it's too late."

"Not with the serial killer stuff again. I thought we'd already established that neither of us were dangerous. You called my references."

"Yeah, but anyone can bribe someone to be a fake sister or next-door neighbor. The pastor dude was slick though."

"What was slick about him?"

"It was impressive, that's all. I should've seen if I could get a nun or something to be a personal reference for me."

Greg laughed. "So what time should I pick you up Friday? Or do you just want to meet somewhere?"

"Describe me."

"What?"

"You said you got my picture. What do I look like?"

"Well, I'm assuming you have your own picture and therefore know what you look like, but here goes. Gotta say though, describing a picture of someone hardly describes *them*."

"You're stalling."

"You have gorgeous red hair. Hence your online handle. You have a huge, beautiful smile."

"I'm not smiling in that picture."

"Yeah, I know, but I can see that you have a beautiful one all the same. I hear it in your voice, see it in the words you type—"

"Okay, okay."

"You have eyes like a blue-green sea, and I bet they change color depending on your mood. And there's a glint in your eye in the photo that makes me want to know what you were thinking when it was taken."

"I had a glint in my eye?"

"And I like your cleavage. Breasts like that? They make me glad to be a man."

Jen laughed loudly. "I always figured it took nothing but

breasts to make a man glad to be a man."

"Your picture did bring up one question for me though."

Here it comes, thought Jen.

"Do you always wear V-necks? You should."

"Only when I'm wearing clothes."

"Let's meet. I can drive up tomorrow."

"Down boy."

Greg snorted.

"Okay, cut the crap now, seriously."

"What do you mean?"

"I won't be offended. I already know for Pete's sake."

"I'm still not sure what you want." Greg's confusion sounded genuine.

"What's my body like?"

"What on earth does that—"

"Just say it!"

"I'm not sure what you want me to say here? You're fat, Jen? Is that it? I feel like you're setting a trap, that whatever I say or don't say is going to get me in trouble."

"Yes, 'Fat Jen,' that's me."

"Is that what all this has been about? Was that the 'description' you've been waiting for?"

"I weigh 266 in that picture."

"Really? I would've put you at 220 tops."

"Yes, *really*. You still want to meet?" There was an exasperated sigh from the other end of the phone and Jen heard a dull thump, like a fist lightly smacking a book or a table or something.

"*That's* why you kept stalling our meet?"

It was Jen's turn to falter. *You've come this far, just say it all, Jen,* she lectured herself. "I just like you a lot Greg. I couldn't handle the disappointment of thinking you liked me, only to—"

"Yes, I still want to meet you. I said so, right? I really like you too, Jen." The words were everything Jen hoped for, but there was an uncomfortable undercurrent, something he wasn't saying. . . .

"So?" he asked, interrupting her thought.

"Yes, I'd like to meet you too."

"Fine. Good."

Jen studied her nails and chewed the edge of her lip. "You sound angry."

Another heavy sigh. "Not angry. Just confused, maybe a bit irritated. Was your friend really sick, or was this some head/body thing too?"

"No, my friend really was in the hospital. I promise."

"I feel played."

"I'm sorry—"

"Just be straight now. Any other secret tests?"

"Ouch." Jen tried to sound light, but sounded strangled instead. "But I guess that's fair. No, no more tests."

There was a laden pause. The alarm clock by Kyra's bed seemed inordinately loud as it ticked away each second. Finally, Greg broke the silence. "Did we just have our first fight?"

"I guess," Jen said quietly.

"If we did," Greg whispered in return. "I have to tell you . . . we can't have makeup sex on our first date. I'm not that kind of

guy."

Jen smirked. "You don't know what you're missing."

"I have a bit of an idea."

"So we'll meet this Friday?"

"Sounds great."

"I'll pick you up around 7:30?"

"I thought you didn't know your way around?"

"I don't, but you already think I'm an ass, so I better get a map and prove I'm willing to learn new things."

"An ass? I don't think that. Why'd you say that?"

"You and I've been talking, joking, and connecting for half a year, and I've been begging to meet you for months, and you think I'm such a shallow loser that I'd change my mind just because you're a little heavy? If I was that shallow, I wouldn't have hung around after figuring out I wouldn't meet you in the first few weeks."

"Oh yeah, a 'little' heavy."

"I don't like this bash yourself side of you."

"I'm just insanely insecure about my weight sometimes."

"No, really?"

"Admit it though, wouldn't you be happier if I were thin? Wouldn't you like that better?"

Greg didn't respond. Finally Jen broke the silence. "Okay, okay, I'll stop."

"It's late, Jen, and I've got an early morning ahead of me. I'll see you Friday, okay? I look forward to it. What do you like to eat, by the way?"

"Oh, anything. Heck, I thought the picture would've made

that obvious."

For a minute, Jen thought he'd hung up on her. "Hello? Greg? Look, I really am sorry. It's a nervous habit."

"I hate it. If you make jokes about yourself all the time, it will really bug me."

"But, well . . . okay."

"Good. I'll call you before Friday."

"Great! Can't wait—good night . . ."

"Night, Jen." The phone clicked quietly on Greg's end. Jen stared at the silent receiver in her hand.

"Idiot!" she hissed. "You had to go and show your neurotic side, didn't you? If he was looking forward to meeting you, he isn't now." She flopped back against the pillows on the bed in frustration. From downstairs, she heard Chelsea mumble like she was replying. Jen sighed, got off the bed, and slipped downstairs as quietly as she could.

She opened Kyra's fridge and peered into the greenish-lit space, looking for anything munchable. Skim milk. Fat-free, sugar-free yogurt. Soy cheese. Smart carb bread. A lettuce keeper filled with an assortment of dark green lettuces. Was that really it? Boring.

Jen opened the freezer, knowing there wouldn't be ice cream, but hoping for frozen yogurt. It would do in a pinch. There wasn't anything sweet in sight, but she figured out why the fridge was so bare.

"She won't need to make food for a month," Jen said under her breath, staring in semi-awe at the ten rows of rubber lunch containers, stacked six high. Kyra's manically neat, small print

marked each container in indelible black felt. Lunch. Lunch. Lunch. Lunch. Dinner. Dinner. Dinner... Beside each meal title was the calorie count and list of nutrients in equally small, stark letters. It kind of took Jen's appetite away.

I bet she has cereal in her cupboard, and that's it, she guessed, and on cat feet, turned and opened each cupboard. She was almost right. The spice cupboard was well stocked, and the cupboard above it held *two* different kinds of cereal, ooh la la! There was even a small bag of brown rice and some whole grain pasta.

Guess you overbought on your last planned menu shop, Jen thought and smirked, then felt ashamed. It was fine for Kyra to do this—typical actually, now that she thought about it.

"Is there anything you don't plan and organize to the hilt, Kyra?" she whispered.

B5 – Mainstream; Your Entertainment & Lifestyle Weekly

DEAR FAT GIRL: Attract at the Weight I'm at?

> Questions, Dreams, Raves, Rants and Fantasies?
> Express them and have them responded to by our experts!
>
> **ASK MAINSTREAM**

Dear Fat Girl,

You've often said that someone who really loves you won't think less of you because of extra weight and if someone doesn't like you because you're heavy, you shouldn't be with them. I agree with all that in theory, but how does a person live like that in reality?

I want a man who will love me for me, but I don't think I'll be able to attract one that I'd be interested in at the weight that I'm at. The only ones attracted to me are attracted *because* of my weight and that seems just as bad to me.

Sincerely,
Wanna be loved

Dear Wanna be,

Good question. Hard answer.

I've always answered letters about relationships that already existed. It is hard to meet people if you don't fulfill the cultural beauty norm, but have faith, it'll happen,

especially if you value yourself. Confidence is attractive.

You're right in realizing that someone who likes you because you're fat has exactly the same problem as the person who only likes you because you're thin.

And sometimes people have to be okay with being single when they'd rather not be, or making some personal sacrifices to have a relationship.

It's not *bad* to get in shape, you know. Don't stay heavier than is healthy just for the point of not buying into beauty myths. There's nothing wrong with losing weight, so long as you know why you're doing it and don't lose yourself in the process.

Hope you find what you're looking for,
Fat Girl

23

"KYRA? CALL ME BACK RIGHT away!" Jen's voice was frantic, and it sounded like she was tapping her foot in the background. Kyra listened to the pause with a curious half smile. Jen seemed panicked, but there was no reason for her to be. Chelsea was fine. If distant and preoccupied was fine.

"Come on, Kyra, come on. Rats, why aren't you home? I have this date and—"

Kyra picked up. "Hi, Jen."

"You *are* home!"

"Yes, yes. Now speak. What's this about a date?"

Jen came clean.

"Since *fall?* You little sneak," Kyra squealed. "How'd you manage to keep this to yourself? I can never keep a great guy a secret. Why'd you hold out so long?"

"I'm sorry. Just by the time I was sure I was going to meet him, it didn't seem like the best time to bring it up."

Kyra swore Jen sounded embarrassed. She was so funny. "Details, I want details!"

Jen gave details.

"And he's the Internet hottie that Chels and I picked out for

you last fall?"

"Yes, already, *yes—*"

Kyra interrupted her. "Well, see? We know how to pick 'em. So when is this big date and what's the problem?"

Kyra grinned, as Jen rattled off her dilemma. "Ahhhh, so you've come to zee expert for help, dahhling. Well, have no fear, Kyra's here. I'll pop right over."

"Really?"

"Of course. This is your first decent date in a while. You can't go naked. Well, actually—no, no, I'm just joking!" Kyra hung up, promising to be over at Jen's in half an hour, then leapt upstairs to her bedroom to change into something more casual. In her mind, she was already sorting through Jen's closet. Jen still had the tendency to dress like a fat girl, all covered up in baggy clothes. She'd have to fix that for Friday's outing. Good thing Jen lived near a mall. They might have to go and buy something special.

"I'm *not* wearing that." Jen's eyebrows arched in horror. "I want to look sexy, not like I'm meeting some john after we eat."

Kyra laughed. "It's not *that* bad."

"Not that bad? You're holding fishnets. And that top—if you can even call it a top—there's no way I can wear a bra with it, and it's see through!"

Kyra grinned and winked.

"No!"

"All right, all right. I was only half serious, anyway."

"Are you sure there was nothing in my closet that would

work?"

"I'm sure. Your midnight-blue's gorgeous but too formal. Everything else screams, 'I work in an office' or 'I'm a gym rat, computer nerd.'"

"I *am* a gym rat, computer nerd who works in an office."

Kyra just sniffed.

"Well," Jen conceded. "Can we at least look in a different store? I feel like I should be getting ready for a Vegas show dressed in the stuff in here."

Smiling, Kyra took Jen's arm and led her out of Diva. Jen would pretty much let Kyra pick out anything for her now, and still feel like she'd "won" since she'd escaped the flesh-tone with black lace shirt.

They both agreed that they'd found the one, the instant Jen tried it on. The skirt had a ragged hemline, cut on an angle so that one edge flirted just above her left knee and the other edge rested just above her right calf. It was lined with black silk, and made out of a deep rose fabric with a print so dark it was barely perceptible. Metallic thread somehow caught the light and gave the skirt a bit of a shimmer. It had an elastic waistband, the only thing Kyra wasn't sure about.

"What's wrong with an elastic waistband?" Jen asked, adding wryly, "it'll make the skirt last longer at the rate I'm expanding."

"Oh stop that. You're up to a size twelve, so what?"

"Fourteen."

"Loose fourteen, and it looks great. You're a sex pot."

"Who says 'sex pot' anymore? Your aunt?"

"Yeah, me and the aunt. We talk about sex a lot. We're very close." She studied Jen. "Now that shirt, that shirt is wonderful, admit it."

Jen scrutinized her reflection. The shirt had three-quarter-length sleeves and a low scoop neck. Made of some stretchy, soft material, it both clung and skimmed in a way that looked lovely and touchable, but not too small. She smiled at herself.

"Okay, I admit it," she said.

Kyra's appraising green eyes scanned Jen from head to toe, and she clicked her tongue in approval. "He's going to be all over you when he sees you. You're gorgeous."

Jen rolled her eyes.

"You are."

"I don't look fat?"

"No, you don't look *fat*," Kyra said firmly, and then, with a small laugh added, "Besides, after that picture you sent, you wouldn't look fat even if you put on fifty pounds overnight. I can't believe you sent that to him!"

Jen slipped back into the changing room and spoke through the door. "I told you, I plan to screen any potential guy this way."

"Yeah, and I told you, it's ridiculous."

"Why?"

"I don't get the big deal. A lot of guys don't want to be with a fat woman, so what?"

Jen shoved the changing room door open, new clothes over her arm, and strode ahead of Kyra.

"What? Did I say something wrong? You're not fat. You

don't need to worry anymore."

"Don't you get it? I am fat. In my head. I am fat, and if a guy can't handle weight, I don't want him."

"Really?" Kyra asked, baffled.

"Yes, *really*. What am I supposed to do? Spend my whole time in a relationship wondering if he'll dump me if I get heavy again? Forget that."

Kyra's brow furrowed and she squinted at Jen, studying her.

"You're serious?" Kyra finally asked.

"Absolutely."

"You do understand that what you're doing is completely unfair, don't you?"

Jen looked irritated, put her clothes down in front of the salesgirl without greeting her, and looked at Kyra. "What do you mean by that?"

"Why should you be free to eat what you please, gain or lose as you please, and have a relationship without any paranoia about your body? You'll be the only woman in North America to do this!"

The salesgirl laughed.

"See?" Kyra nodded knowingly. "She thinks it's totally unfair too."

Jen shook her head. "Okay, I'll worry a bit, how's that? But still, I do need to know the guy's not a dick—that he'd be okay with it. Just in case." She grabbed her bag, and wished the salesgirl a good night. Halfway out of the store, Jen patted Kyra's shoulder. "Just so you know, I really appreciate this."

"What's *this*? *Shopping*? It's nothing, sweetie. I live to shop,

you know that."

"No, seriously," Jen stopped walking. "This is my first date since Jay—and we didn't really date. It makes me want to throw up. I feel like a moron. Thirty-two and never dated. I'm pathetic."

"You're not pathetic at all," Kyra soothed. "You'll do great. And you never dated anyone besides Jay because you never said yes to anyone else."

"Oh yeah, all four of the guys with fat fetishes who asked."

"So you lied back there."

"When?"

"When you said that you wanted a man who liked fat women."

Jen was quiet until they were almost to the mall exit. "I want a guy who likes *me*. Not me because I'm fat. Not me because I'm not. Just me. I'm never going to be a stick, and I do have the potential to be really heavy again. I like to eat. I like exercising too, which surprises me actually... but I just can't muster up the discipline to live on the verge of starving, and I don't want to." She took a deep breath. "I think I'd die in a relationship where I had to be focused on my weight. I wouldn't be able to enjoy it at all."

Kyra didn't answer right away. At the car though, she hesitated before getting in. "I've never thought of dating from that angle. I've always thought of it along the lines of finding someone who can be what I need them to be and do what I need them to do—and, conversely, how I can mold myself into what they need/want me to be."

"No, you don't, not really," Jen said, sliding into her seat, and shutting her door.

Kyra followed suit. "What do you mean?"

"Maybe that's your initial strategy, but you can never make yourself go through with it."

"I don't understand—"

"If you were so intent on just remodeling yourself to be the epitome of whatever your current guy wanted, you'd have said 'I do' long ago. I think you try to do that, to be super accommodating, but you can't resign yourself to it permanently. Deep down, you want to be yourself too."

"Hmmmmm," Kyra said, and that was it.

DE L'AMOUR WAS ALMOST FULL when Jen walked in at ten after seven. She was kind of glad. The crowd might make it a little hard to hear, but at the same time, the steady buzz of background voices and laughter would make any lags in their conversation less glaring.

She was also glad she'd changed the plan—arranged to meet at the restaurant instead of having him pick her up. This way if it was terrible, she could duck out and leave, and he wouldn't know where she lived.

She wondered if he really looked like his picture. If he did, well... he seemed cute, but it was hard to tell. He was far enough back, with sun shining on his face off the water, that there could be some major surprises. She looked around, but couldn't see anyone sitting alone. She moved closer to the

"Please wait to be seated" sign.

A minute later, a rake thin, artificially busty blonde appeared. "Hello, thank you for coming in tonight. I'm Belle. How many in your party?"

"Uh . . . two. Well, he might be here already."

"Name?" the girl purred. Jen cringed.

She felt like an elephant. She caught a glimpse of herself in the mirror behind the till. *You look nice. Relax.*

"Greg Hart," she said.

Blondie ran a bony finger down a list of names on the reservation list. "There he is. He's on the balcony. If you'll come this way." She flashed a toothy, showgirl smile at Jen, motioning at her to follow.

Did this supermodel know? Had Greg told her he was meeting an Internet date? That would be so humiliating.

Suddenly Jen realized that she'd stopped moving, and the hostess had paused and was waiting for her.

"Sorry," Jen mumbled.

"That's all right," her hostess said brightly. "He's just up there." She pointed to three wide steps leading to a small risen alcove. An ornate silk frame hid the upper tables from view. *No fair,* Jen thought, smiling, her angst over the intimidating waitress forgotten, *he'll get to see me first.* Her heart did a flippy-thing in anticipation. Slowly, taking deep breaths so she wouldn't appear as scattered as she felt, she approached the short, wide staircase.

It wasn't too late to turn around and leave. The big lemon tree on the landing and the privacy screens blocked the stairs

from the balcony's view. But as tempting as fleeing was, Jen's feet moved forward. Too soon, she was at the top. She hesitated by the tree. There were only four tables and they were spaced nicely apart. Two had couples at them, but the other two seated single men. One had dark, curly hair and nice broad shoulders. His head was down so Jen couldn't see his face. She was a sucker for curls and a small current of attraction raced through her, then fizzled. The picture Greg had sent, poorly lit though it was, showed he had blond hair.

She turned toward the guy at the other table. He was bent over a magazine, and there was a soft leather briefcase beside him on the floor. The part of his head she could see was a tousled dirty blond.

Just as she was trying to muster the nerve to approach, the blond man happened to raise his head. Seeing Jen, he stood up and stepped forward.

"The beautiful Jen, I presume?" His voice was like tequila, raspy and smooth at the same time, and Jen smiled but felt a little quivery. Apparently the expression about going weak in the knees was literal.

"Hi," she said. So her response wasn't amazing or memorable. At least she'd managed to speak. He smiled, revealing a cute dimple in his left cheek, and pulled out her chair. As he stood behind her, Jen smelled limes and something else yummy. For some reason, she thought of Kyra. Jen smoothed a napkin over her lap, thanked him, and made a mental note to report his delicious scent when drilled for details.

Greg was just sitting down again when Jen noticed a rather

large book to the left of his place mat, slightly obstructed from her view by a vase of white roses and their water glasses.

"What's that?" she asked. "You thought you'd need a book and a magazine? Boy, you must've really doubted me."

Greg laughed. "No, it's just I promised first thing, right?" He passed Jen the book. It was a large, beat up thing of a bible with a bulletin sticking out of it.

Jen slid the paper out, read it, and looked across the table. "So you're a pastor? That was the big deal?"

Greg's cheeks reddened just a bit and he nodded. "Yes. I'm not ashamed of it or anything. I've just found it puts some people off, so I wanted you to get to know me before you found out."

Jen stared at Greg for a moment. She knew pastors, of course, but Greg was the furthest thing from the ones she knew.

"You can't be a pastor. You love my breasts!" The second the loudly spoken words were out, Jen clapped her hand over her mouth. The dark-haired man at the other table coughed. Her face flamed. "I'm sorry, I mean—"

"No, I'm sorry," Greg interrupted, his skin tone flushing to match hers. "That's fair criticism. It was, well . . . I guess that's what I liked, but also found hard about meeting you online. It was too easy to just say whatever came to me without thinking it through first. That's a novelty for me."

Jen took her napkin from her lap and folded it, then unfolded it, looking at the table. Greg continued. "I should apologize. I know I made more than a few, well, comments of a sexual

nature. I'm sorry."

Jen couldn't help making a face. He sounded so—ugh. Greg was silent too.

"Do you, would you like some water?" he asked eventually.

"I guess, thanks."

A server arrived with menus and Jen resisted the urge to snatch one to hide behind. She endured a slow, meant to be witty, recitation of the evening specials, nodded yes to coffee and wished for gin. Menu finally in hand, she stared at it without seeing the words. She'd wrecked the date before it even started. . . .

Still trying to appear to be deciding on an entrée, she reached for cream without looking too carefully. Greg had done similarly, and his hand grazed hers. Instead of pulling back, however, he rested his fingers on hers for just a moment. They were very warm.

"That was incredibly stupid of me," he said. "What I meant to say, what I wanted to say, was 'Of course I love your breasts. Have you seen them? They're gorgeous.'"

Jen didn't even think, just rolled her eyes and smiled. "I know, I know. The whole 'glad to be a man' thing."

"Exactly." Greg grinned back. And suddenly everything was right. He was Greg. The Greg she knew from their incessant chatting and e-mailing. Her Greg.

APRIL

24

BRIANNE AND DINA WERE AT a "Spring has Sprung" dance at school. Imagine, her babies at a *dance*. But, as Brianne had informed her, "all" schools had dances now, for every grade, not just grade sevens. Chelsea didn't know how she felt about this phenomenon, but for now she was glad. Glad they were out of the house. Gladder still that they weren't coming home, that they were sleeping over at a friend's afterward. So glad they weren't home for this.

She sat at the kitchen table, crying. Ted paced back and forth on the hardwood floor, fists clenched. His face was red and a vein bulged in his neck.

"I don't know what you want, Chelsea. Have I ever? Maybe the doctor's right—I'm just more pressure to you, a burden?"

Chelsea tried to say, no, that wasn't it at all, but the words wouldn't come out. She felt herself cry harder.

"You've got a nice home, good kids. You could work if you wanted, but I'm happy to have you at home, that's what *you* wanted, and we can afford it. I work hard. I don't play around. What else is there? What else can I do? I have always loved you!" Ted stormed while Chelsea sat, mute and motionless.

It was only fair. He had to break sometime. Chelsea knew this. Her counselor said that at some point, Ted, who must be feeling some pretty intense feelings himself, would need to vent. Tears streamed down her face.

Ted's voice took on a high-pitched note. "First it's, 'I'm not happy.' Then it's, 'I'm bored.' Then it's, 'I don't really know what's wrong. I can't talk about it, but it's something serious.'"

He's mimicking me, Chelsea thought, but she wasn't offended. Wetness glistened in the corners of his eyes.

"Then you don't say a thing to me, not a word. For months all you do is sleep, and scream at the kids."

Chelsea winced.

"Then the hospital..." Ted's voice died out on the word hospital, like if he didn't talk about it, he could make it disappear.

We're so alike, thought Chelsea. It wasn't comforting.

"This is Kyra's fault, right? Or Jen's? You see them footloose and fancy-free and you think being single looks pretty damn good? Go. I can't stop you, but I'll be damned if I let you steal my kids. They stay."

Chelsea remained silent.

"Say something, dammit. Say something!" Ted was full out yelling when suddenly he seemed to lose his voice. His next words were so quiet Chelsea almost couldn't hear them. "You have someone else. That's it, isn't? There's someone else."

Chelsea wished that she could just go to sleep, could just avoid this whole thing. She longed to walk into her familiar but new dreamscapes where everything was so much easier. She

wished she could just sleep. And sleep. And sleep. Her mind rested on her dream friend. She felt his arms around her and smiled at the memory of how he listened to the things she said. She loved the way time stopped when they were together. For a minute she even thought she could smell him.

"There's no one else," she finally said. Ted stopped pacing and his hands relaxed. Chelsea had to look away from the naked relief in his face. From somewhere deep within, she heard a voice prompting her, *Try again.*

She resisted it and shuddered—unfortunately at the same time Ted reached tentatively toward her. He stepped back, as if slapped.

Try again. Chelsea took in the defeated slump of Ted's shoulders and saw the tension that rode him, visible in the rigid cords of muscles straining under his crumpled flannel work shirt. He hadn't changed when he got home. She noticed fragile creases beside his eyes—eyes shiny with tears he wouldn't shed. She studied his clenched jaw, his tightened lips. In her memory, she traced the line of his mouth with her finger, willing him to relax, feeling its soft fullness. She watched him as if from far away. This man—this man that she loved. She *loved.*

"Ted?" Her voice was steady. She almost didn't recognize it as her own. "We have to talk. I do have something to tell you."

When it was over, Chelsea couldn't believe that she felt much the same as she had before. And Ted? He didn't seem to think less of her. It really was like her counselor had said. He didn't blame her. He wasn't angry with her for not speaking out be-

fore.

"I'll kill him."

"No!"

"*Yes.*"

"You aren't allowed to say anything. You promised. This is my battle."

"Then you have to—"

"I have to *what?*" There was a glittering sharpness to Chelsea's voice, even though it was quiet.

Words mumbled at the hospital came back to him and Ted faltered. His bravado slipped away. "Nothing. You don't have to do anything. I'm sorry. Whatever you need to do, do. Whatever."

Chelsea saw the wall go up again: the hurt lover railing against what was happening to them shut down by his role of provider and stalwart husband. He wanted to help, but couldn't speak with honesty, fearing his words would unhinge her. Chelsea sighed.

"You can say what you need to say. I won't break," she said. Ted nodded and said he knew that. She could see he was lying. He reached for her.

"So we're good? This was never about you leaving?"

His question held so much pain that it hurt Chelsea to hear him ask it.

"Of course I'm staying. I'm staying . . . ," she said softly, but she couldn't let him hold her. She pretended to not see the wounding in his eyes as she squirmed out of his embrace, saying lightly, "So now we've had it out, do you want to take

advantage of the kids being away and watch a scary movie?"

Ted looked at her for a long moment, and Chelsea wasn't sure what emotions she saw roll through his clouded eyes. They were as dark as water and just as indecipherable. She knew pain was one of them though. She saw it in the lines by his eyes, and in the sag of his shoulders. She reached up and put her hand on his chest, willing him to understand. "I'm going to get through this. I'm going to figure it out."

Ted nodded and placed his hand over hers. She looked into his face. *Please understand, please.* This time, it was Ted who looked away first.

JEN ARRIVED AT WORK EARLY, but was still beat to the office by Dave, Lana and . . . Kyra, of all people.

"What are you doing here?" Jen asked.

Kyra looked up with a grin. "Gee, last I heard, you were part of a web-page design company for businesses and I own a business."

"Yeah, Jen. It's hardly surprising. If you were a better businesswoman, you'd have sucked her in long ago," Dave agreed in a boisterous tone, rolling his chair away from Kyra. Jen looked at them. Something was up.

She shot a glance at Lana who had paused at whatever she was doing to take in the brief exchange. She responded to Jen's raised eyebrows with an exaggerated shrug. "I just work here," she muttered, going back to fiddling with her keyboard and squinting at her monitor.

"So . . ." Jen's voice trailed off.

Kyra and Dave just looked at her.

"Oh, duh!" Kyra finally replied. "I can't believe I forgot to ask. How was the big date?"

"Big date?" asked Dave.

"Oh yes, there's romance in the air, right Jen?"

Jen blushed and smiled. "Well . . . ," she started, then realized Dave and Kyra were sort of turned into each other, looking at some paper on Dave's desk. "You know, you guys look busy. I'll tell all later, Kyra."

"Oh, I'm sorry Jen. I'm just really absorbed in this. I want to hear. I really do."

"You bet, just later, okay? I've got work to do anyway."

Dave nodded, and it annoyed Jen. She ignored him.

"So we'll do coffee soon? I was thinking it was time we all did something again."

"Sure, um, how about tomorrow? *We*. Did you mean Chelsea too? I'll call her."

"Tomorrow? I was thinking tonight would be great. Is it too short of notice for Chelsea, do you think?"

Kyra looked uncomfortable, and her eyes darted in Dave's direction. He kept his head down, overly interested, in Jen's opinion, in the pencil eraser he was tapping on the desk.

"What is it?" Jen finally asked.

"I kind of have a dinner date."

"Silly me. Of course you do. It's Tuesday, always a hot date night." Jen chuckled.

Kyra flushed scarlet, which was crazy. Since when did the

dating diva blush about a date? Suddenly a light went on.

"You mean you're dating *Dave* tonight?" She hadn't meant to sound horrified. She was just surprised. She didn't think it was terrible or anything. Lana had stopped working again, and was shaking her head at Jen.

Jen didn't know what she meant by the headshake. That Kyra and Dave going out was a bad idea? Or that Jen had crossed a line?

"Yes, with *Dave*. And I can't wait," Kyra said, hands on her hips and daggers in her eyes.

Meanwhile, Dave looked wounded. "You don't need to sound so shocked by the possibility of a woman dating me," he said.

Good grief.

"I'm not shocked, exactly. It's just that you're my best friends, and yet this is the first I'm hearing about you dating. Sue me if I'm surprised, okay?"

Lana disappeared into her monitor again, the indignant flush faded from Dave's ruddy face, and Kyra suddenly laughed. "Yeah, it must be a little out of the blue. Sorry. You didn't even know Dave was designing a site for me."

"Remember, you gave me her number so I could call her about my cousin's paintings?"

"They're *amazing*. I knew I could sell them the second I saw them," Kyra finished enthusiastically, "but I need to expand so I'm renting the space beside the store and renovating again. It's ridiculous—but I figure the expansion will pay for itself, especially if I branch out into online sales as well. Remember that

click and drag idea you told me about? I thought it would be totally cool if people could load a picture of the room they wanted to decorate to my website. Then they could cut out their already existing pieces, or not, and see how whatever was catching their fancy would look. I thought I was being a bit over the top—"

"You should've seen her face when I told her that was totally do-able. It was so cute." Dave was as excited as Jen had ever seen him.

Kyra beamed.

Oh no, Jen thought.

Five feet behind the lovebirds' perch, Lana let out an aggravated, "Argh, stupid thing!" and Jen saw her way to escape bizarre-o-love land.

"Problem?" she asked.

"Always," Lana glowered at the screen and entered something on the keyboard with angry jabbing movements.

"Well, I'll just leave you two kids alone. Behave now. And Kyra, so I'll see you tomorrow? Eleven-ish at my place?"

Kyra nodded.

"I'll call Chelsea."

"Sounds great. See you then, Jen," Kyra promised and returned her full attention to Dave.

"So what's wrong?" Jen asked, striding to Lana's desk. Then, she jerked her thumb toward her shoulder in an obvious gesture at Dave and Kyra, but blocked from their view by her body. "How long?" she mouthed.

Lana rolled her eyes. "Oh, this stupid thing feels like it's tak-

en me three weeks."

Jen held up three fingers in front of her stomach with an exaggeratedly shocked expression.

Lana nodded.

"Crazy," Jen said. *It really is*, she thought, and then she winked. "So what exactly is the problem, besides it taking a long time to fix?"

"The stupid 'Contact us' link on the Precious Bones and Stones site keeps looping back—" Lana launched into a convoluted description of the error and Jen listened carefully.

"Yikes, tough one," Jen commiserated. "It's always the seemingly simple ones that end up giving you trouble, hey? But no one ever warns you."

Lana snorted and Jen bit her lip to keep herself from laughing too hard. She hadn't meant that as a dig at Kyra and Dave until Lana laughed. She pulled up a chair and started to look over Lana's code.

JEN SET DOWN A PLATTER of veggies, pita bread triangles and hummus, and shook her head at Kyra and Chelsea. It only made them laugh harder. She retreated to the kitchen for drinks, returning soon with guava and mango punch.

"Are you done yet?"

Kyra shook her head. "You can't be a pastor—"

"You love my breasts!"

"Yes, ha, ha, ha," said Jen.

"A line like that," Kyra added, "should be on a T-shirt."

Jen rolled her eyes. "I'll make him one for Christmas. But now do you believe me that I shouldn't date in public?"

"Oh Jen, that's classic." Chelsea wiped her eyes, still giggling, and passed a glass of juice to Kyra, then reached for her own.

"Seriously, Jen," Kyra said, after taking a sip. "It's great to see you so happy. Maybe I should check out online dating."

"No, you shouldn't. You wouldn't be safe," Chelsea said sternly. Both Kyra and Jen looked at her in surprise.

"But I met—"

"I didn't say you weren't safe, Jen. I said *Kyra* wouldn't be safe. She'll fall for anyone."

"Ouch," said Kyra. She grabbed some vegetables. "And not true either."

"Anyway," Jen said, anger and concern—but not for Kyra—roaring through her. "I thought you were seeing Dave now."

"Yeah, so? Good grief, Jen. I haven't married him or anything yet." Kyra grinned evilly but then, looking at Jen, hurried on. "Would you relax? I'm just joking around. I'm not really interested in Internet hookups." Kyra shook a carrot at Chelsea. "And while I should be insulted by Chelsea's comment, I'm not. I do attract a variety of men. It's good for me to meet them face-to-face, first off, so that I can size up the situation."

"But—"

Kyra held up her hand to silence Jen. "And as for Dave, I don't know why you think I'm going to hurt him." She didn't wait for Jen's obligatory denial. "I know you think I will, and that's nice for him, but what about me? He could hurt *me*, you know. But that's not my point. My point is that you don't have

to worry about me hurting Dave. I'm almost positive he's the one."

There was dead silence from Chelsea and Jen. Jen wished she could make her face blank because if her skepticism was as visible as Chelsea's, then poor Kyra. It really would be insulting.

"Oh, come on you guys." Kyra looked at each of them in turn. "He could be."

"I guess." Jen's reticent affirmation was rewarded with a small smile and satisfied nod—shy though, not smug. Quite unKyra-like.

"Anyway, I'm used to you old bitter doomsayers. I almost gave up on men. Did I tell you that?" Kyra waved a piece of cauliflower at Jen. "I contemplated it anyway. A few months ago. Just before Chelsea . . ."

Jen knew a dubious look was back on her face. She felt it arch an eyebrow and lift the corner of her mouth. Saw it mirrored in Chelsea's expression.

"I'm serious. I really did almost give up. But then what? If there's no love, what? Do I focus solely on business? I could, you know." Kyra's tone hardened. "I make a damn good profit for a store concept supposedly being wiped out by the box store whores. I guess it's in my genes."

She's right, Jen realized. *She is a good businessperson, tough, smart. . . .*

"But how empty is that? My dad is lonely, whether he realizes it or not. Did I tell you that he called the other day and—I almost had a heart attack at this one—he even came by the store when Chelsea was in the hospital? I wasn't there, but Joanne said he'd just wanted to make sure that everything was all right

because I hadn't called in weeks. She explained my absence and he said, 'Oh that's all? Good,' and left. Joanne thought it was the sweetest thing, said that she could drop off the planet and her dad wouldn't notice, that I was really lucky. That, of course, made me laugh my head off."

"Is that when he called, too?" Jen asked.

"No." Kyra shook her head. "I guess he felt pretty sure I was fine, so he didn't bother. He called a few nights ago, to say he was in town and could fit me in, if I wanted."

"Gee, how kind of him," said Chelsea.

"That's what you don't get," Kyra said. "It was kind of him—in a pathetic way. The point is, he must like that I call him all the time, even if he doesn't acknowledge it. On some level, he must value me."

Jen reached out and patted Kyra's arm. "Of course he does."

Kyra looked at Jen with appreciation. "And anyway, that's what I like about Dave. He's very emotionally open. He says what he feels—or, at least, he tries to."

Dave? Open emotionally? What?

"And I don't have to be all perfect and cooing for him. He's seen *me*—give me a good deal, cut the shit me—and he still likes me. I wasn't even wearing makeup because I'd just come from the gym." Kyra smiled broadly. "He made time."

"That's really great, Kyra," Chelsea said, shredding the napkin she was playing with.

Jen hated to be the one who rained on Kyra's parade but she had to. She'd been friends with Dave for too long. "It's not fair to him if this is just another one of your phases. Dave's not your type. You like pretty boys, successful business suits, big partiers,

or big rollers. . . . Dave is none of those things."

Kyra was silent for a minute and Jen thought she'd gone too far. She was all for honesty, and "being real" in their friendship. Heck, she was the one who'd initially brought it up, but she didn't want to hurt her friends either.

Kyra finally spoke. "Has it ever occurred to you, Jen, that I'm not any of those things either? I never have been. Do you know how much time I spend at home, making dinners for one?"

Jen remembered Kyra's fridge and had a pretty good idea, yes.

"Do you know how much time I spend watching old movies and redoing my rooms? My relationships end because I end them—well, except for James—because I'm essentially selfish. I can't handle the idea of pretending to be something I'm not for all of eternity. I just didn't realize until recently that I *was* pretending. It was actually something you said, Jen, when we were shopping that made me see it. Sometimes I'm scared that I'm too much like my mom."

There was a stunned silence. Kyra's mom was the big taboo. Had been ever since that terrible long ago moment in Peggy's café when Kyra, in a tone as smooth and hard as the Formica tabletop her hand rested on, relayed the events of her weekend.

Jen still remembered the flash of Kyra's purple nail polish when she'd held up her hand to stifle her and Chelsea's mewling condolences after they learned her mother was dead: "It's okay. I cried all weekend. I'm almost over it. Never mention her again. And lay off your mothers too. We're practically grown-

ups. We should be able to live without whining about our moms every five minutes."

Jen took a big swallow of her now mostly ice-water punch and studied Kyra. For the rest of their school years, they followed her command and spoke of their mothers in Kyra's presence only when initiated by Kyra. Kyra returned her stare through unreadable green slits of eyes.

"You broke the rules though," she said suddenly, and Jen started. Apparently Kyra had been remembering back too.

"All those notes..." Kyra looked away, focusing on an abstract print on the wall beside the couch. Chelsea looked at Jen, her question showing in the furrow of her brow.

Jen just shrugged and motioned at the half-empty plate of food, knowing even as she did that they were finished with food for the time being. And she *had* broken the rules.

For years, on Kyra's birthday, separate from her regular wishes, and near the anniversary of Kyra's mom's death, Jen sent a card with something little written on it. "It's okay to miss her." "She was beautiful; so are you." "Do you remember when..." followed by a little memory. They both ignored Jen's offerings, but once—Kyra's birthday in grade twelve maybe?—Kyra had slipped up behind Jen in the hallway at school, grabbed her hand and squeezed it hard, then slipped away again. That had been the first and last time either of them ever acknowledged the notes. Until now.

"Did you," the words stuck in Jen's throat, "did you mind too terribly? I couldn't say *nothing*. I had to say something."

"Mind?" Kyra's voice was rain-soaked velvet. "No, Jen. I

didn't *mind*. I think you saved my life. I never thanked you because I couldn't find the words. I still can't find the words."

Chelsea shifted on the floor, and Kyra looked down at her. "And you," she said, making her hand a small gun and pointing it at Chelsea. "*You.*"

"Me what?" Chelsea tilted her chin in question.

"You broke the rules too—all those pictures. That crazy scrapbook. Where did you find all those things? I've worn it out looking at it over the years. I don't know why I couldn't just have said thank you—"

"Shhh," Chelsea said. "We get it—and I didn't break the rules. I didn't bring her up. I gave you pictures. *Anonymously.*"

Kyra actually smiled at that, and hugged Jen's polar fleece throw.

The room was quiet, but there was no discomfort. Jen settled into the cushions of the couch, thinking. Suddenly, unease churned in her belly. She bolted forward.

"You said you worry that you're like your mom—"

"Oh," Kyra said, getting it. "No, not like that," she reassured. "I'd never check out like her. I did think about it a few months back, but it's Chelsea I have to thank again. You, Chels, and your girls. I'm just not the type of person who commits suicide. I finally figured that out, thank God."

"Why do you have me to thank?" Chelsea's voice was quiet, but she broke off each word in the question painfully, like she was spitting out glass. "You think there's a *type* that kills herself? A *type* that goes crazy—and I'm that type?"

"No!" Kyra looked stricken. "That's not what I meant at all."

Chelsea just looked at her, eyes hurt, jaw tight.

"I meant that watching you struggle, even with all that you have, and how you're so determined to do right for your girls, even at your own expense sometimes, made me realize how narrow and selfish my preoccupations were. I might never get married and have kids, but I'd be an idiot to let regrets and "what ifs' wreck what I do have. That's all I meant. I was always afraid that whatever made my mom do it was genetic."

Chelsea let out an explosive sigh and buried her head in arms. "I'm such a jerk—I'm sorry," she said, her words a mumble against her sweater. When she straightened, her face was a deep, remorseful red. "I need to get a grip. I've gone from never allowing myself to feel mad—just feeling kind of "off" some days—to being a raging maniac over nothing. I'm really sorry."

Kyra shrugged, twisting and untwisting the end of the blanket she still held in her lap. "How were you to know? *I* didn't even know. How did we get on to this subject anyway? Talk about a party crasher—"

"Don't apologize. We've needed to have this talk for years," Jen said.

On the floor, Chelsea nodded.

"Uh-huh," said Kyra, her tone dubious. "Well anyway, about Dave—"

Jen rolled her eyes. "Are you kidding me? You want to talk about Dave again?"

Kyra cocked an eyebrow. "Well, du-uh. He's what started this whole depressing conversation. You guys are right. I guess I don't *really* know if he's the one . . . but I'm enjoying getting to

know him. It's unsettling. I'm thirty-three, but I think I'm just starting to figure out who I am."

Jen was startled by Kyra's words. "I know," she agreed.

Chelsea didn't say anything.

25

JEN SLAMMED HER MUG DOWN against the desk. "Men! They're such shallow jerks."

"There's a nice gender stereotype." Dave rolled his heavy oak chair over to her desk. "What's the provocation?"

Jen flushed and closed the screen before he could see what was on it.

"Nothing. It's stupid."

"Problems in love land or tech terrain?"

Jen smiled at Dave's love land reference. It'd been a long time since they'd talked about love. She missed him. That was the problem when someone was part of your everyday landscape. You took him for granted. With Kyra in the picture, she got talked to a lot about Dave, but rarely got to talk *to* him.

Jen sniffed. "Speaking of love land, where's Kyra? I thought she was permanently attached."

"Don't change the subject. Is the preacher man the jerk?"

"The—? Oh, Greg. No. He's great, I guess."

"Then what?"

"Uh . . ." Jen fumbled for something to say. "I was reading the Fat Girl archives at Mainstream.com. Some of the things

the guys write in, 'I really like this chick but she's fat. Should I date her? If I do, what will my friends think?'" Jen lowered her voice and impersonated a gorilla, complete with armpit scratching, a few grunts, and a chest thump.

Dave laughed. "I've never read that one."

Shit. Jen had forgotten that he was a big Fat Girl fan. She smiled remembering some of the laughs they'd had over various letters.

Dave caught the look. "I thought you were pissed. Now you're grinning away. Schizophrenic much?"

Jen rolled her eyes. "I was just thinking that the guy might be the missing link. It made me smile."

"What does preacher man think about your evolutionary references?"

"You're a loser. What's your obsession with Greg anyway?"

"What's *your* obsession with Kyra?" Dave rolled away from Jen, and started flipping through their snail mail inbox. "And about shallowness. You think that's just a guy thing? What about you?"

"What *about* me?"

"Admit it. Part of why you're weirded out by Kyra and me is my weight. I'm a fat guy, a real fat guy. Not just big boned. Not stocky. Definitely not football playerish."

"You're totally off base." Jen jumped out of her chair and moved toward Dave.

He rolled to get out of her way. "Whoa, don't hurt me." He grinned at his own joke, but then went abruptly serious again. "Truth hurts, but that *is* the truth."

"It is not."

"You'd never consider dating a fat guy."

"I would not *not* consider it. Weight wouldn't factor into my decision to date or not date someone at all. Not one bit."

"Yeah, right." Dave looked at her for a minute, then turned toward his desk. "Forget it. I've got work to do."

"Oh no, you don't." Jen grabbed the back of his chair and swiveled him to face her again. "That's not fair. You can't tell me I'm shallow, and then disappear behind the work excuse. What's up with that?"

"What's up is that it sucks that you don't think I'm good enough for Kyra."

"What? Of course, I think you're good enough. That's never been an issue. Too good maybe." *If they parrot back whatever I say to each of them. I'm going to regret that comment.* Jen pushed her hair out of her face. "I've never said you weren't good enough."

"Just too fat."

"You're being stupid. I was fat, remember? Bigger than you've ever been."

Dave appeared to not hear her last comment. "So maybe you don't think it makes me unworthy of her. But it blows you away that she'd be with me when she's so hot, right?"

"Are you losing your mind? If I was surprised that you two are attracted to each other, it's because of how different your personalities are, not your bodies. I meant no offense, I promise."

"Question," Dave stated. "If you consider fat guys dateable, why didn't we ever get together?"

Jen sighed. It looked like she was in for the long haul. She plunked down on Dave's backless office chair.

"Answer: because I was fat."

"What? No!"

"Then what, Jen? You've flirted with me ever since we met seven years ago. You go kind of nutsy whenever I'm lucky enough to find a date—"

"No, I don't."

Dave shrugged off her denial. "You and I like the same things, have the same sense of humor, enjoy the same things.... Hell, we used to be practically inseparable. I like to think it was because you liked me, not just because you needed company since Jay was always with his wife."

Ouch. "Of course I liked you. I loved—*love* you. But we're buddies. You know, comrades, amigos, good friends." She punched Dave on the shoulder.

He just looked at her. "Yeah, but why always just buddies? I totally sent out signals. You never even considered them. Why not then?"

"I don't know, because I'm a relationship dolt? I had zilch experience except for—and that's another thing. I was with Jay."

Dave shook his head. "On again, off again. When you two finally split for good, I thought it was finally our chance. But no." Jen tried to interrupt, but Dave shushed her. "Anyway, it doesn't matter. Just try to be happy for me, all right?"

"I am happy for you. I am," Jen stammered, groaning inside. *This is too awkward. Lana, where are you?* But Lana didn't appear, and Jen went back to her desk. A few minutes later, something

occurred to her. She shook her head. No wonder she and Dave were friends.

She walked back to his desk. He looked up.

"I never dated you, idiot, because you never asked me. You made a million jokes, a hundred sarcastic comments, but you never said what you really felt and I couldn't read your mind. Like what I really said before, not the fat excuse you made up, I honestly had no clue."

Dave blushed and was silent for a long while.

"Okay," he finally said. "Fair enough. But shit, do you mean you would've—"

Jen smiled and shrugged. "Who knows?"

"I really like Kyra, Jen."

"She really likes you too."

He cleared his throat. "So we're good? Still amigos?"

"Yeah, yeah."

26

CHELSEA WAITED IN THE VAN outside the school. She'd told the girls she wasn't coming in to get them anymore. Too many people wanted something the minute she popped her head inside the doors—but she didn't tell the girls that. She just told them they were old enough to get themselves outside to the pickup zone.

Brianne seemed to think it was about time and was happy to have her mom at more of a distance at school. Dina seemed disappointed, but she didn't utter a word of complaint. Chelsea smiled, thinking of Dina's bravely set mouth and resolute look as she'd said it'd be okay. Chelsea figured she'd give it a week, and if Dina still hated it, she'd go back to going into the school for her. It wasn't really fair to penalize a ten-year-old for the nagging tactics of busybodies.

Chelsea watched the stream of children coursing out of the huge double doors. A tall girl with a shock of heavy black hair went bounding past, shrieking gleefully, "I'm the King. I'm the King!" as she headed to the white grid painted on the cement.

Four square. Chelsea remembered four square. She'd loved that game. She watched the squares fill up and a line of chal-

lengers grow. There was something about the tall girl reminiscent of herself. She cracked a window slightly. The players' voices came in, screaming in delight and impatience, "Call the ball, call the ball!" The tall brunette whipped the ball. "Queen's ball, long and tall."

Along with the voices, in came a chill. Chelsea shivered. It had been a cold year, and so far spring wasn't showing any promise of warmer times. But kids were funny; they didn't even seem to feel the weather.

Continuing to watch the kids play and wondering vaguely where Brianne and Dina were, Chelsea felt herself slide back to her own sixth grade year. Her memories of childhood had always been sketchy at best, but recently, since visiting her counselor twice a week, a lot of things were coming back.

A boy in a green toque glared at the tall girl. He had missed her ball, and stomped off the court yelling something Chelsea couldn't quite catch. It made her smile, recalling her own scowling nemesis, Andy Miller. She hadn't thought of him in years.

Chelsea ruled at four square because she was tall and could easily catch almost any ball, regardless of how it bounced. Andy Miller was mad at her because she'd taken his position as King and he hadn't been able to get it back for two whole lunch hours in a row. She was jogging to the blacktop when she heard Andy call out, "Jorge loves Chelsea. Jorge loves Chelsea!" just to bug her. Curious, despite herself, she slowed down to hear Jorge's response.

"I do *not* like Skeletor," he said. "If she gets any bonier, she'll look like a guy."

The comment struck Chelsea almost physically, and she stopped mid-run, aware even as she slowed that the squares would be filled now and she'd have to start by waiting in line until enough people were knocked out of the game. She looked down at the sandwich bag of fudge cookies dangling from her hand. *If she gets any bonier, she'll look like a guy.* The words danced in her head and she sucked in air with relief and delight. *That's it! That's it! Thank you, Jungle-Smell-Jorge!* she exclaimed in her mind and resumed her jog. She ran past the four square grids and pretended to do a layup, sending the cookie bag spiraling into a nearby garbage can just as Jen and Kyra walked up.

"Hey, what are you doing? Were those fudge cookies? I would've eaten those if you didn't want them!"

Chelsea grinned at Jen. "Next time they're yours!" She was happier than she'd been in months. She didn't even mind missing out on four square that much.

Chelsea was still staring out the van's window, lost in time. It was surreal, after years of no recall, to suddenly have memories play through her mind as vividly as if they'd just happened. And something else from the memory clicked in Chelsea's mind. That was it. That was her weight/abuse tie in. Her therapist had told her she might discover a link. That was when she first started controlling her weight in an effort to... to... *C'mon, say it.* In an effort to stave off unwanted attention. *Unwanted attention? That's lame ass and you know it. How about being real for once*—Okay, okay! I thought if I could get thin enough, could be boyish, that fucking pervert might leave me alone. Is that better? *Yes, much better.* Yes. Rage pounded in Chelsea's

brain and released as tears.

Movement caught in her peripheral vision brought Chelsea out of her duo-personality self-talk. Brianne climbed into the passenger seat. "Oh, hi," Chelsea said, still startled.

"Hi," said Brianne.

"Where's Dina?"

"Right here," Dina said. "Didn't you see me? I beat Brianne."

"That's great, hon. You were as quick as a bunny!" Chelsea said. "Hey, do you guys like four square?"

"Yeah, it's great!" Brianne stopped in mid-exclamation and then continued in a bored tone. "Well, except I don't play it that much anymore. It's kind of a baby game." Brianne's attempt to be the cool almost teen didn't quite come off. Her "It's great!" had been too enthusiastic. Chelsea smiled inwardly at her daughter.

"I love it too. I can usually be King for at least half of lunch. . . ." Dina stumbled over her words for a second. "And it's really good exercise, right Mom?"

A serpent of guilt writhed in Chelsea's belly. "Oh, sweetie, it sure is—but it's also just great fun." She fought to make her voice upbeat. "Did I ever tell you I used to be a four square champion?" The tightness in her chest eased as Dina beamed.

"Really, Mom? You?"

Even Brianne seemed impressed. "You don't seem like the four square type, Mom."

"Oh, don't let my old mom look fool you, kiddo. No one, and I mean no one, could catch a Chelsea Reinner, lean and mean, and in betweener."

"Really?" Brianne said skeptically.

"Will you show me, Mom? It could be a Dina Hamilton lean and mean and in betweener!"

"It's a deal. I'll show you when we get home. And, Brianne, if you can catch it, I'll do your dishes tonight."

Brianne squealed. "Deal."

As they rolled away from the schoolyard, Dina began to sing in a happy but painful sounding soprano. "This is the song that never ends, it just goes on and on...."

For once Brianne didn't tell her to shut up and after a few minutes, to Chelsea's huge surprise, she even started singing along.

Ironically, Chelsea felt calmed by the raucous decibels coming from the backseat. Not long ago, the noise would've frayed her nerves raw. Today, the volume was comforting. It's been too long, she thought, since the girls felt free to be loud. The realization made her wistful for a second, but then she shook her head hard, mentally pushing her regret away—again. They were making noise now. That's what she had to focus on.

"Sounds great, Dad. And don't be silly. Of course, I can fit you in next week." Kyra smiled at the phone. "You should know that.... Uh huh—yes, it'll be good to see you too. It *is* about time—yep, bye."

Kyra jogged up the stairs to her room, then hesitated by her night table, on her way to the bathroom. She picked up the picture of her mother, and ran a fingertip down the cheek line

of the unsmiling beauty. "All these years of wanting to be you, but terrified of it too—and here, all along, I've been more like Dad. Oh well. It could be worse." Kyra gave the glass-covered face a light kiss, replaced the photo gently on the table, and headed for a soak.

B5 – Mainstream; Your Entertainment & Lifestyle Weekly

DEAR FAT GIRL: STOP HURTING PEOPLE

> Questions, Dreams, Raves, Rants and Fantasies?
> Express them and have them responded to by our experts!
>
> **ASK MAINSTREAM**

Dear Fat Girl,

I'm concerned that you are grossly ignoring and misrepresenting facts to your readers.

You encourage people to stay fat when our hospitals are full of sick people—sick because of being overweight. Obesity is the precursor to most serious diseases in North America today, including, but not limited to, Type 2 diabetes, heart disease, stroke and a wide array of cancers.

The state of being you endorse will bring disaster and heartbreak to those who take your advice and start feeling good about themselves and stop being motivated to halt their unhealthy eating. What they need is to control their portions and to get up off the couch and start exercising.

All bodies are not equal. Fat people are killing themselves. You should try to stop the damage they inflict, instead of reinforcing it.

Sincerely,
Worried

Dear Worried:

I don't encourage people to stay fat. I tell them, fat or not, they are worthy of respect, of love, of decent treatment. . . .

Maybe all bodies are not equal, but all people are, whether society treats them that way or not. A *body* is not a person. A *person* is a person. Hence, fat or thin, people are people: equal.

Obesity can lead to illness, but your inferred solution (Get your lazy ass off the couch and stop eating crap!) is bunk. Do you really think that smokers smoke because they aren't aware of the risks, or that alcoholics think their binges are good for their relationships? If life were as simple as perfection nazis make it out to be, none of us would have a problem because we'd just decide not to.

Without addressing the reason why a person is abusing food, no "cure" for overeating or undereating will ever stick.

It's hard to be fat. Most people can hide their foibles. Obesity? Not so easy. Black may be slimming, but add fifty pounds or more and trust me, nothing fools the eye.

Your "cure" for fatness has been in vogue for the last fifty years and North America's just getting heavier. Don't you think it's time to give compassion, understanding and treating the person as a whole a try? If you really want to help people who are overweight, not just attack them, stop seeing them as *them*. Each of "them" is an individual, not a statistic, not a number on a scale, not a lazy slob who just doesn't care.

Endorse that.
Fat Girl.

27

"Are you sure you want to do this to yourself?" Jen muttered. "Yes," she told her reflection through gritted teeth. "You've come too far to let go now."

Taking a deep breath, Jen walked out of the mint green washroom, and into the meeting room. Quite a few unfamiliar faces, *chubby faces*, she mused, not unkindly. She turned and was instantly bombarded. "Jen, you're back!" "Holy cow, Jen? I wouldn't have recognized you except for that hair!" "So you've returned to your old haunt at last?" Jen smiled, her cheeks pink.

"Good to see you, Jen." Pat, apparently still the current president, gave Jen a light hug.

"Thanks for calling me, Pat. I'm sorry I ignored your messages. You must've been psychic to know just when I needed to get pulled back on track."

"No problem, chicken."

"Chicken?" Jen groaned, but smiled too. "Your nicknames haven't gotten any better, I see."

"So you're weighing in?"

Jen fidgeted with her keys and her shoulders twitched in not quite a shrug. "I really don't want to have to live my life by a

scale. I don't want focusing on pounds up, pounds down to be my reality forever."

"Maybe it won't be. Give yourself time. You had a lifetime to acquire your old habits. Give yourself more than a couple of months to learn new ones."

"It's been over a year!" Jen didn't mean to snap. She flushed.

"You've been at your goal weight for over a year—or almost at goal anyway—and that's good, but it's the year after your first year that's hard because you start to feel like you've made it, that you're done."

Jen shifted uncomfortably. Pat could tell she'd gained weight.

"But you've been dieting to maintain it, right? Bingeing a bit, then promising to 'be good.' Am I right?"

"You're so pushy. You'd think you were a drill sergeant, not a weight-loss support group leader."

Pat laughed. "I know, I know, but what I can I say? That's the point of the club, isn't it? And I'm right, aren't I?"

Jen studied her feet. Feet she used to not be able to see.

"Anyway, you don't need to diet anymore, Jen. You need to learn to not overeat, but you don't need to diet." Pat let the silence between them grow for a moment, then said, "I'm sorry if I'm pushing too hard."

Jen shook her head. "No, you're right. Absolutely. But it feels like crap, okay?"

Pat laughed again and relief flooded through Jen. She was right to have come back. There was no use pretending she didn't want—or need—to be there.

JEN'S SPEAKERS WERE CRANKED UP because she'd been listening to music while she did crunches earlier, and she'd forgotten to turn them down. So when her instant messenger chimed, she almost fell off her chair.

She half smiled, half winced when she saw the typed message. She turned off her speaker to prevent any more heart-stopping noises and quickly typed, "No, I'm not trying to avoid you, paranoid man. Call me."

She closed the message box without waiting for a response, and ran to the kitchen to get a cup of tea. Happy to see it was steeped dark enough, she added milk and honey.

She'd just made it to the couch and settled in, pulling the chenille throw around her, when the phone rang. "Hey there," she breathed into the mouthpiece. "Fancy, you calling me. What a coincidence." She tucked her legs up under her. "Yeah, I can talk for a while. I finally got that project I was complaining to you about running smoothly, so I'm not going in early tomorrow. I'm even thinking of taking the day off. . . . Mmhm? Yeah, maybe—Oh hey, I'm glad you called. There's something I've been meaning to talk to you about."

"YOU'VE GOT TO BE KIDDING! How could we all be in the same situation?" Kyra's volume caused the people at the next table to look over. When Jen shrugged at them, they smiled and went back to their own conversation.

Chelsea, head propped on the heel of her hand, shook her head. "I'm hardly in that situation," she said, her eyes squinting in amusement.

"Oh come on, even you must think it's odd that both Jen and I would be seeing guys that have convictions about sex outside of committed relationships. I didn't realize there were people in North America, let alone males, who still saw sex as a big deal."

Jen laughed.

Chelsea lifted her chin from her hand, and her amused look became a grin. "It is hard to imagine. Maybe you just went through all the other types?"

"Hey!" Kyra pretended to throw a piece of carrot at Chelsea. "What is with you and Jen ragging me about my taste in men and my sex life these days? Is it open season on Kyra or what? You're lucky I'm so easygoing."

"We really are," Jen agreed. "It hardly matters in my case though. I'm thinking of breaking it off."

"No more Greg? But why not?" Kyra's eyes widened. She sounded personally wounded by Jen's words.

"Surely it's not just the sex thing?" Chelsea asked.

Jen leaned back in her chair. "No, that's just part of it." Her friends didn't smile, and her face fell. She sighed. "No, I actually like that about him, or well, I hate it, but I can live with it. Maybe. I always felt like I'd let myself down with Jay—"

"Well, good grief, Jen. Did you want to be a virgin forever?"

"Shut up, Kyra. Everyone's different—"

"Duh," Kyra said.

"No—" Jen didn't finish that thought. "I don't know.... I just can't help but feel that if I'd lived by my convictions, I would've been spared the car wreck that was Jay."

Kyra put her hand over Jen's, stopping the motion of the spoon she was twirling like a mini baton. "So what is it then? What's changed?"

"I don't know, nothing, everything. He's just so great. He lives so fully by what he believes. I let myself down constantly. I have this way I want to be, and then the reality of how I am."

"Welcome to earth, human," Kyra said.

Chelsea smoothed a finger over her watch and nodded. "Yeah, it sucks."

Jen smiled, but kept fiddling with her spoon and didn't look up. "I do think we're a pretty exceptional match. He really gets me. He's hilarious. Oh, who am I kidding? I love him. When we're together, or talking on the phone, I feel, I don't know, fully me or something. Is that the stupidest, corniest bullshit you've ever heard or what?"

Chelsea's eyes were soft and she shook her head.

"Are you kidding? That's what I'm hoping for, baby," Kyra said.

"But it wouldn't be fair to him. I'm not the kind of woman he needs."

Kyra wrapped her hands around her coffee mug and squinted at Jen. "That makes no sense to me. You believe the same things, you like the same things, you love each other. What else is there?"

"No one ever feels they're good enough for the people they love, Jen. Just be yourself."

Jen studied her friends. "And which self would that be?"

SUMMER
May

28

Jen knocked on Chelsea's vivid red door, admiring it, and shivered. She really needed to start remembering that May, especially May in the morning, wasn't summer. She turned slightly and surveyed the cloudless sky. It was cold now, but it would be warm later. She was still smiling when Chelsea swung the door open.

"Thanks for coming. I know it was short notice and all. I hope you weren't busy?" Chelsea held her sweater tightly against her body and ushered Jen in.

Jen laughed at the apologetic greeting and followed Chelsea into the house. "Yeah, you know me. I'm so busy hanging out by myself, that having a friend call . . . well, it really puts me out." Chelsea immediately fell into the hostess role, scooping Jen's bag and stashing it on a wicker shelf by a wrought iron coat tree, asking if she wanted coffee or tea, or maybe lunch?

Jen shook her head to lunch, but said coffee would be great. Chelsea then proceeded to chatter on about how she was thinking of repainting the living room and what colors did Jen think would go nicely? She was thinking of something more dramatic this time.

"What's up, Chels? You didn't ask me here to talk about paint colors."

"No, but you have a good eye."

Jen looked at her over the rim of her mug. "I'm starting to think it's something serious."

Chelsea sighed and sat down at the table. Her hand traced a circle over a knot mark in the smooth antique oak. "Yeah, maybe it is. Okay, you're right. I might as well just come out and say it. My therapist thought that if I could, if I felt safe enough, it might help me to, well, maybe tell someone close to me what really went on with me."

"You can tell me anything. But only if you want to."

Chelsea nodded but didn't say a word. After a moment, she popped up, dumped her coffee down the sink, and poured herself another.

"That other cupful was stale? What was it, five minutes since you poured it?" Jen bantered, trying to lighten the mood. Chelsea didn't laugh, but she didn't frown either. She just sat down and stirred her black coffee with Jen's spoon. Jen opened her mouth and closed it again. Stupid jokes really weren't appropriate.

The silence stretched. Jen's shoulders ached with tension. Finally Chelsea spoke. "It's hard to know where to start."

"Take your time."

Chelsea looked down at the table, and for a moment, Jen thought she'd changed her mind about sharing. Then Chelsea pushed her mug away and took a deep breath.

"For years, for most of my childhood actually, starting a

year after my mother married Richard, I was sexually abused. I have a hard time calling it that though. In my mind, I try to call it other things, or I try to minimize it. I know a lot of people have endured worse than I—I guess somehow that makes me feel guilty."

Jen tried to control her facial expressions as she listened to Chelsea talk, not wanting the horror she felt to make Chelsea feel like she needed to tone anything down. The most horrible part for her was the realization that on some level she wasn't shocked. It all made an awful kind of sense.

"So there. That's it," Chelsea finished abruptly. "Richard couldn't keep his hands to himself and now? Now I can't seem to keep it together. I used to be able to. How come I can't anymore?" Chelsea was quiet, like she was speaking to herself. "I'm told it's good that it came up now. That the longer it lay buried, the worse it would be for me when it finally came up. But I don't know if I agree. I hate remembering."

There were no words to make this okay. None. Then another thought punctured Jen. A cold knife of guilt slid into her gut and stuck. She'd been Chelsea's best friend, and she hadn't seen anything. She'd never helped. She'd never even guessed.

Chelsea studied Jen's face and seemed to intuit her friend's thoughts. "You couldn't have known. My mom? I tried to tell her all those years ago.... She didn't believe me." A small keening sound, like a young animal's pain, broke loose of Chelsea's control.

Tears came to Jen then, and she patted Chelsea's arm helplessly.

Chelsea shrugged her off, swallowing. "When I was a little girl—I can't believe it—but there it is. I was a little girl. *A little girl....*" Her voice trailed off in some kind of damaged awe and disbelief. "Anyway, *then.* I felt like no one would ever believe me. That you guys would think I was gross for even saying something like that. I thought you'd hate me."

"Never," Jen croaked. "I would've believed you."

Chelsea took a big mouthful of cold coffee and played with it in her mouth, pushing it back and forth between her teeth. "I'm going to confront him."

Jen nodded.

"I need to know that kid, his girlfriend's kid, is safe. I never acknowledged my abuse, but looking back, I can see that I always organized my family life so that he never had access to my girls. I was always happy that he worked locked away in a courtroom and stuffy offices. I always had my mom pop over when he was at work, or that's when I visited her. She never even questioned it."

Jen nodded again.

"That's why my therapist thinks that on some level she knew it was true. Will you come with me?"

"Me? Are you sure?"

"Please?"

"Of course. Absolutely. When?"

"I asked him to meet me around one o'clock at Liberty Park."

"Today?" Jen couldn't keep the surprise from her voice. "Okay."

"You don't have to come out. Just wait in the car so I know I have you there. Ted would do it, but I want you."

"Okay."

They sat for a minute.

"Well, I guess we should get going. It'll take twenty minutes to drive...."

"Yes," Chelsea agreed, but she didn't move. "Jen?"

"Yeah?"

"You know I never did anything to ask for it, don't you?"

"What? Of course I know that. *Of course*. I'm horrified you even need to ask."

"Well, sometimes you and Kyra said I only pretended not to want the guys to like me, that deep down I loved the attention."

Guilt stabbed again. In the chest this time. "Oh, Chels. We were just idiots. Just jealous, rotten friends. *We* would've loved the attention you got from guys. The thing with Richard is totally different. One kind is normal boy/girl stuff. The other is just—not."

"I know, I know. Intellectually, I know." Chelsea nodded as she spoke. "I guess I just wanted to hear it out loud from you."

Jen didn't want to, but she couldn't help it. She lost her grip on her emotions and started to cry. Chelsea came over and stroked her hair.

"I'm so sorry, Chels. I totally failed you . . . when you were a kid, earlier this year when things started to go bad for you. . . . I'm so sorry."

"Not at all," Chelsea soothed. "Not at all. It wasn't your fault. You didn't fail me. You couldn't know. Things are hidden.

You've always been here for me. You *did* help me. You *do* help me. And even with the Richard thing . . . why do you think I practically lived at your house?"

Jen stood up and hugged Chelsea. "I'm still sorry."

Chelsea tightened her grip on her oldest friend.

Eventually Jen let go. She looked into Chelsea's face.

"You're going to be okay. You are. You'll get through this."

"You think so?" Chelsea's eyes were black bottomless pools in her pale face. "I hope so. I really hope so, but—"

"You will. You're strong. And we'll help you. Anything you need, just ask."

Chelsea gripped Jen's hand and squeezed it, so hard it almost hurt. "Thank you."

"No problem." Jen squeezed back. "And I mean it. Anything."

Richard was already there, waiting at a picnic table by a trio of birch trees—silver spears piercing vibrant green bodies of leaves, casting long shadows. His proper gray suit stood out amidst the smattering of early sun-seekers in their premature shorts and tank tops.

Chelsea's lips stretched over her teeth in a grim parody of a smile. The thinness and tension in her face, combined with her suddenly bared teeth, gave her the look of a grinning skull. *Good, he's had to anticipate me for a change,* she thought.

She inhaled the fresh spring air deeply, letting the slight stink of mud and growing things invigorate her. A vision of a comic she'd loved as a teen, *Red Sonja,* flashed in her mind; she

pictured herself wielding a sword, muscles bulging. Her body moved effortlessly in long strides, devouring the ground. Seven steps. Five. Three. She paused just out of arm's reach in front of him.

Richard's long, tapered fingers drummed the varnished surface of the picnic table. The methodical movement caused a feeling of repulsion to crawl slug-like over Chelsea's skin. The first tremor of fear she'd felt since entering the park made her hands shake. She stuffed them, clenched into fists, into the front pockets of her jeans.

She cleared her throat. "Thanks for meeting me here."

"No problem, but I'm a little confused. I'm happy you wanted to get together, but the location—" He motioned nonspecifically at the surrounding grass. "Well, it's a little off-putting."

"Really? A little off-putting, is it?" Chelsea hesitated, deliberating about what to say next, about how to launch herself.

"Do you want to sit down?" Richard gestured at the bench beside him. Chelsea gave a curt shake of her chin. After a second's pause, he joined her standing.

"So what's this about then?"

"How about," Chelsea said, finding her voice, an icy steel rasp coming from low in her belly. "How about we cut the crap, Richard? You knew this day was coming. You had to know it was coming. You know what you are, what you did." A small drip of satisfaction trickled down Chelsea's spine as she watched a small ripple of something—apprehension, maybe?—disturb the smug surface of his face.

"What do you mean?" Richard crossed his arms over his chest, but the fingers of his right hand continued to drum just above his left elbow.

"I mean I'm through pretending, you child-fucking, sick twist of a man. How could you?"

The tapping hand froze. "How could I *what*?" Richard's arms fell to his sides. Chelsea ignored him.

"I was seven, *seven,* when you started."

"When I started what? What do you think I did?"

A wild rage stormed through Chelsea. She wanted to shriek, wanted to scream and scream and scream, but the voice that came out of her was as detached and emotion free as she imagined Red Sonja to be when she brought the blade down and—

"When you jammed your finger up my little baby cunt. When you rubbed my chest like I actually had breasts. When you made me promise not to tell or you'd hurt my mom the way you hurt me, and when you—"

A strangled, wet sound escaped from Richard's mouth. His face went an ashy gray, mottled purple.

"Your skin's starting to coordinate with your suit, Dick," Chelsea said, as he slumped back down into a sitting position on the bench.

"What's wrong?" she asked. "Not feeling well? You know, I've been a little under the weather myself." She laughed, and it sounded like the cracking of a frozen river. "Did you really think you'd get away with it? That I'd never confront you? That I'd never say anything? That you could just live while a part of

me was killed over and over by you?"

"You can't remember—" The words were thin and spider-legged.

"Oh, I remember," Chelsea said with unnatural cheer. "Would you like me to go on?"

"I was drinking then. I was *drinking*. It wasn't my—"

"Oh, it was your fault," said the razor edge of Chelsea's voice. She leaned in so that he would feel her breath on his face. "Remember the parties, *Daddy*? Mom used to always nag, 'Why don't you call Richard "daddy," honey? It would make him *so* happy.' I could never tell her, still can't for fuck's sake, that I wouldn't call you "daddy" because a *daddy* doesn't make his daughter suck his dick." Chelsea strode away violently, punching the air with curses and whining in impersonation, "I used to drink. It wasn't my fault. I didn't *mean* to finger fuck you, it was the alcohol—"

Then she was back in front of Richard, speaking with the cold efficiency of a scalpel separating flesh from bone. "That's bullshit, Richard, *bullshit*. Now where were we? Oh yes, the *parties*. 'How about a special treat, princess?' Your so-called treat nearly peeled the skin off my throat. Is that what you thought? That you could get me drunk and I wouldn't remember?"

Richard made a gagging noise and his gorge rose in a dry retch. Chelsea stared at him dispassionately. "You're not sounding good, Richard. Not good at all." She paced away, then returned to the table. "It's strange," she said. "Whenever I rehearsed this moment, planned what to say, how to say it . . . I

always thought it would take a long time. I think I envisioned you—I don't know? Crying? Being sorry? *Something...*" Chelsea shrugged. "Oh well. Like I said earlier, thanks for the meeting. As you can see, I needed to get a few things out in the air." She turned to leave, then pivoted back. "I'm charging you."

Her words hung and for a moment even the breeze stopped. Richard shifted on the bench, and then slowly got to his feet. He managed to keep his lawyer voice steady, but his face was still blotched, his composure a thin veneer.

"Really, Chelsea, I'm sorry you believe these things happened to you, and it goes without saying, of course, that I'm very unhappy that you've linked me to such atrocious acts in your mind. You've been stressed. That stint in the hospital—"

Chelsea snorted, but let him continue, her eyes narrowing.

"Maybe I was too fond of you, maybe once or twice I patted you in a way that could be perceived as inappropriate, but the rest—"

"Look at me, Richard," Chelsea said, and Richard looked at her. And then he listened. "I will rot in my grave before I let you leave here without pause. My charges may not stand, there may be some statute of limitation that's been exceeded—but I will try, and I will be public enough that your good name will be wrecked. There are no big cities, Richard. Only small towns, big mouths—"

"Is this supposed to be blackmail of some kind? You have no evidence. You're a sick woman with issues that go back to I don't know when. Maybe it's your birth father you're—"

"Richard, do you really think I didn't learn anything from

you? I have the picture you just couldn't resist taking. I went looking for it when I was, I don't know? Eleven? I couldn't bear that it existed." She bit back a sudden, hideous urge to laugh, knowing if she let it out, it would never stop. "I kept it in the lining of my princess jewelry box. Didn't you ever wonder where it went? Didn't you ever think—"

Richard suddenly folded from the waist and threw-up, leaving a fleshy pink, fetid mess on ground. With something akin to pleasure, Chelsea noted he'd sprayed his shoes.

Chelsea watched him struggle to compose himself. Saw him hesitate, observed him haltingly wipe the back of his hand across his mouth.

"Gee, Richard, if I didn't know you better, I'd think you just had a *human* response. That's exactly how I felt a few months ago when memory of that picture surfaced and I went to mom's and re-found it, tucked away in a box with all my other childhood mementos—"

She turned to leave.

"But what about your girls?" Richard called weakly. "They'll be embarrassed—ashamed...."

Chelsea waved her hand. "Don't fret about any little girl's shame, Dick. You never did before."

Walking out of the park, she felt lighter somehow, purged, but at the same time, more connected to the earth than she had been in a long time. Her breath came in ragged, post battle gasps, and she concentrated on it, forcing it to slow down. She envisioned Red Sonja once more, but her sword was sheathed

now, a comforting weight at her side—finished with for a time, ready if needed again.

Jen tried to read, but couldn't focus. She disciplined herself not to stare out the window in an attempt to see Chelsea and Richard. Time seemed to have stopped, so she was surprised when she looked at her watch and realized it was two thirty already. She hadn't thought to ask about the girls. What she should do if Chelsea wasn't back in time to pick them up? But then Chelsea was back, opening the door and sliding into the gray leather passenger seat.

Jen started the car and circled through the parking lot. She waited until she was at the turnout to the main road to ask, "So?"

"So?" Chelsea's voice was weary. She rubbed her temples. "So, I guess I'm going to have to track down the woman's name and phone number."

Jen looked from the road to her friend's face, then quickly back to the road again. Good thing too. She hit the brakes, slowing just in time to avoid hitting a squirrel.

"He denied it?"

"Yes. And no. First he played dumb, pled not guilty by reason of intoxication—then he backpedaled—said I must've misconstrued something totally innocent."

Jen thought about the squirrel she'd almost obliterated. Childhood's like that, she thought. One minute, you're running and playing, and the next something terrible you never saw coming changes it all.

Chelsea's hands were still on her face, cradling it now, pinkies over her nose like a mask. "I'm going to call the woman he's seeing."

"What did he say to that?" Jen asked. They were out of the park now, heading home under the canopy of protective evergreens.

Chelsea leaned her head against the window, uncovering her face for the first time since she'd gotten into Jen's car.

"What could he say? I didn't tell him." She closed her eyes.

THE COFFEE SHOP WAS ALMOST empty, Jen noticed with relief. It would be private. She'd just sat down when Chelsea walked in and joined her at the glass-topped table.

"Just one more of these conversations and then, hopefully, never again." Chelsea smiled, face wan although her eyes were warm. She picked up a spoon, turning it over and over in her hands.

"So did you tell your girls?"

Chelsea averted her eyes and shook her head. "It's too ugly. Maybe some day, when they're older, but not now. They shouldn't have to think about that kind of stuff."

Jen wasn't sure—not that they needed graphic details, of course, but shouldn't abuse be talked about? Still, it wasn't her place to say. Chelsea had said it herself, maybe one day she'd feel differently. And she knew, from other things Chelsea had said now, that she'd been hypervigilant. She'd kept the girls safe.

Kyra entered in a rush of energy, smelling like fresh fruit

and sunshine. "Like it?" she queried, holding out a wrist. "It's called Cantaloupe. I couldn't resist. Really, cantaloupes don't smell like this at all, but it's a great name, and so yummy."

She took in the spoon-twiddling Chelsea and the nervous, foot-tapping Jen. "Yikes, why so glum chums? What's up?" She pulled out a chair, checked the seat's surface for food—she was wearing tight white skinny jeans—and sat down.

Chelsea told a paraphrased version of what Jen already knew. It was hard to see Kyra's response, and to realize how obvious her own emotions must've been, no matter how stoic she'd fought to appear. She could see Kyra trying to keep her face from registering devastation and shock. Her response though, when Chelsea finished, was unfathomable to Jen.

"How does this affect you and Ted? Do you like sex? Have you ever liked it?"

"Kyra!" Jen couldn't believe how insensitive she was.

Chelsea, however, didn't seem offended. "Oddly no, it hasn't affected sex for me at all. I guess for some women, it really does." Still holding tightly to her spoon, Chelsea picked up her coffee and sipped it. "Actually wait—that's not quite true. For a while there, when everything just started coming back, it did. And we ... well, we haven't totally gotten back to normal. Ted's a bit unsure if he should initiate it or not, and sometimes, I'm take it or leave it, so I'm not usually the one who starts it ... but no, I don't have any links between *it* and Ted. Ted is so different from—just so different in every way. Thank God."

"That's really good," was all Kyra said.

"So," Chelsea mumbled. "Now what? This is a bit awkward,

hey?"

"No," Kyra said. "Not awkward at all, just a lot to digest. I feel so bad that I never had a clue, that I couldn't be there for you."

Chelsea shook her head and gave a similar response to the one she'd given Jen but with different reasons for why she felt Kyra *had* helped—her unwavering conviction that good men existed being the foremost one.

"Did you call the woman?" Jen eventually asked over a shared dessert. Chelsea nodded, licking whipping cream from her spoon. Both Kyra and Jen looked at her expectantly. "And?"

"And it was okay. She was sad, but appreciative for the call. She said she'd been abused when she was younger and was always afraid of being attracted to creeps. It was bizarre. After her initial shock, she was really open, and I don't know . . . kind of good to talk to. That's all."

"She's not going to see him anymore?"

Chelsea shuddered. "She never said, but she did say that she was convinced that her daughter was safe. He's never had any opportunity. She's always at a friend's house when he"—Chelsea made a retching sound—"sleeps over."

Jen and Kyra waited.

"I explained my abuse never happened until he'd married my mom and officially moved in. She didn't say much to that. But . . . I spoke up. It's out of my hands now."

"Totally," Kyra said.

"You know, I was really worried about what she might say, that she'd get angry and not believe me, but it was my mom

who went ballistic. She thinks it's disgusting and pointless for me to rehash it because 'if' it happened, it was a long time ago."

Kyra and Jen each took one of Chelsea's cold, white hands. None of them spoke because what could you say to that? Jen marveled at the nearness of Chelsea's bones to her flesh, at the seeming fragility of her. Then she remembered Chelsea's workout the day before and hope stirred in her. Chelsea was a lot stronger than she looked.

Chelsea let out a long, shuddering sigh. "So yeah, it's a big mess—but at least it's an out in the open, able to be dealt with, big mess."

They sat in the coffee shop for a while, not really talking, but not eating either. No one went for the remaining cheesecake. Jen felt tempted, but she knew that no rich treat in the world would quell the emotion flooding through her.

"So, speaking of Dave, okay, so we weren't, but I want to," Kyra finally said.

Chelsea laughed. Jen shook her head.

"We've taken our relationship up a notch."

"Which is?" Jen asked, already knowing.

Kyra winked lewdly.

"Congratulations?" Chelsea said, her voice light and teasing. Kyra giggled.

"I thought you were waiting. True love and all that."

"We did wait. I can't believe how long we waited, and we're truly in love so—"

Jen rolled her eyes.

"Don't roll your eyes at me. You're just jealous because as

long as you're fixated on Greg you won't be getting any."

The corner of Chelsea's lip twitched with a repressed laugh. Jen started to reply snappishly, but then realized Kyra's words were a tad too true. She grunted in reluctant agreement. "Okay, what can I say? You're right. Just be careful with your heart and Dave's too. You guys mean a lot to me."

Kyra fluttered her eyelashes in a parody of innocence. "Oh, don't worry. We'll take good care of each other, *very good* care."

"Ew, no details on this one, ever. Dave's like a brother to me—a brother I like."

"You guys," Chelsea said shaking her head at Jen and Kyra's banter. "What on earth would I have done without you two constants in my life?"

"I always ask myself the same thing," Kyra said, "and I always come to the same conclusion—gone crazy and weighed ten pounds less." She stabbed the remaining piece of cheesecake. Chelsea grinned. Jen rolled her eyes again.

JUNE

B5 – Mainstream; Your Entertainment & Lifestyle Weekly

DEAR FAT GIRL: CHANGE MY LIFE!

> Questions, Dreams, Raves, Rants and Fantasies?
>
> Express them and have them responded to by our experts!
>
> **ASK MAINSTREAM**

Dear Fat Girl,

I should lose weight and I think I know how to do it healthily—thanks in large part to you.

I think I'm afraid though. Right now I can have it all—land a boyfriend with a job, get a better job for myself, have my parents off my back, be prettier and have people like me better—as soon as I lose weight. I use my "when I'm skinny fantasy" to cheer myself up all the time.

That's where the fear comes in. What if I lose the weight and my dreams don't come true? What if I go to all the work to change my weight (I have to lose about ninety pounds and then will just be normal, not super skinny) and nothing else changes? My boyfriend is truly sweet, but also truly lazy. My parents ride my slim sister just as hard as they ride me. As for my job, I'm not really trained at anything special, but I'm working as a receptionist, so maybe that's as good as it gets? (I'm thinking about night school.) And if I have more friends when I'm slim, maybe I'll resent them for being shallow.

What do you think? Any advice? Will losing weight

change my life or should I just keep things the same (my life's not that bad!) and that way I can still have my dream?

Sincerely,
Change my life?

Dear Change,

You reiterated a few times that you're happy enough with your life ("Boyfriend's sweet." "Job's as good as it gets." "Life's not that bad."), but at the same time you repeatedly told me that you fantasize about *everything* being different to help you cope.

Here's what I think: You tell yourself that you're fine with things because you don't want to upset anyone by being honest with them and telling them they're not meeting your needs. You eat to squash down your true feelings, the ones you can't bring yourself to talk about. You hide behind your weight, blaming it for why you "fail."

But here's the good news: you're brilliant. You already know that your fantasy is just that, a fantasy. Losing weight will no more change who you are as a person than changing your hair color or getting contact lenses will, with one exception: by controlling your weight and not letting it control you, you may gain the confidence you need to try to take control of other parts of your life.

Losing weight will not miraculously change your life, but *you* can miraculously change your life. Weight loss might be a part of that. It might not. Either way, look into night school, hug your boyfriend and tell him to get a job or say good-bye, and instruct your parents to back off.

Good luck!
Fat Girl

29

THE SUN WAS HOT AND bright through the meeting room's rows of small, old-fashioned windows, and it created a checkerboard of illuminated squares on the ugly gold and green carpet. Jen studied a beam of light, fascinated by the dust motes swirling about in it. She shifted her gaze, to a space void of sunlight, and saw nothing there; the air seemed invisible. Surreal if you thought about it—all these things that the eye couldn't see until the light got bright enough.

"Are you sure?" Pat's voice, at once both skeptical and concerned, broke into Jen's thoughts.

Jen took in the inspirational posters and jokes covering the walls. She considered the line of women negating their beauty and their talents all because they were "bad" and their weigh-in would be higher than last week's.

"Yeah, I just can't do it anymore. In some way or another, my whole life has been about my ongoing obsession with my weight, hating it, trying to do something about it, trying to maintain it.... Want the truth?"

Pat nodded.

"I don't think my weight is an issue at all, more like a symp-

tom. I have a lot of fear, insecurity, and unmet aspirations. I think I focused on my weight to keep me busy, to keep me from having to do the scary thing of working on myself. It was easier to let myself get sidetracked by the idea that the weight had to go first—and putting all my energy into hating my weight gave me permission to not have to try to expend energy elsewhere."

Pat nodded again. "That's funny. I just read something similar—oh yeah, it was a letter to Fat Girl. Do you read her?"

Jen nodded, and Pat glanced at the clock on the wall.

Jen understood. "Anyway, I should get out of here and let you get ready for the meeting. I just wanted to stop by and explain in person why I came back and why I'm quitting again after just a month and a half. And I wanted to thank you. The group too, but especially you. You really made a difference in my life. I know you tried to tell me what I've finally figured out, so thanks."

Pat's bright blue eyes twinkled. "Come by anytime just to say hi, okay?"

"You bet," said Jen as three women came in to weigh.

"How are you tonight, ladies?" Pat asked cheerfully.

Jen half laughed, half grimaced on her way out the door as she heard one woman's answer. "Bad—so bad, but it tasted so good!"

Jen paused with her hand on the door, her eye caught once more by the sun's brilliant pattern on the carpet. She considered the dust motes again. Then she turned back to Pat. "Actually, Pat..."

Pat turned back. "Yes?"

"Can I come every so often, but not weigh in? I need the encouragement—and maybe I could encourage other people, you know?"

The smile lines by Pat's eyes creased. "That'd be great, Jen. Really great."

"MOM, *GREG.* GREG, *MOM.*" IF Jen's cheeks got any hotter, they'd spontaneously combust. She could practically hear her mother think, *He certainly doesn't look like a minister,* as she gave him her infamous, prolonged once over. And he didn't. In faded jeans and a worn T-shirt, he looked like a total hottie.

Before she could carry those thoughts any further, her mom rushed them to the tables. "Everyone's here. Let's eat."

Three patio tables, eighteen rattan chairs—and a matching hammock swinging gently in a metal frame—decorated the back lawn. The tables' yellow cotton tablecloths were barely discernible beneath a huge assortment of salads, veggie plates, and racks of ribs.

"Wow, Mom. This looks great. You must've been cooking for hours. You shouldn't have."

"Don't be silly, Jen." Marie rubbed the back of her slightly sunburned nose with the back of her hand and tucked a stray silver-blond strand behind her ear. "It was nothing. Do you like the new furniture? I thought I'd use some of Aunt Maggie's departing gift for something the whole family could enjoy. Maybe this way, you'll all come over more."

"It's really nice, Mom." Jen settled into one of the chairs, let

her mom place a napkin across her lap, and took a sip of her lemon water.

Diane barely let Greg's rear hit the chair beside Jen's before she was drilling him. "So is it true that when you originally agreed to meet Jen, you thought she was fat?"

Jen almost spit out her water.

Greg looked to Jen. She shrugged and shot him an "I told you they were like this" look. He nodded almost imperceptibly and turned, smiling, back to Diane's query.

"Yeah, I guess. Why?"

"Well, it's just, well, unusual, that's all...." Diane floundered with the demand for relevance put back on her.

"Have you talked to your sister?"

"Of course," Diane answered, her brow furrowed.

"Well, talking to her is attractive. She's a beautiful, dynamic woman at any weight. I could already tell that. But also, evasive as she was—and defensive as she was about her looks—she'd also let it slip a few times that she was a gym rat. I figured that she'd probably been heavy, been made to feel really bad about it, lost weight and was just testing me, worried about what I'd be like if she ever regained it."

Diane's jaw hung slack with awe. "Wow, that is *so* intuitive."

Jen burst out laughing. "Liar!" she exclaimed. "I completely had to explain the immensely rational reasoning behind my ruse." She directed her next words to Diane. "He didn't have a clue."

"But I should've." Greg grinned. "You gave me a zillion hints."

"It's nice to meet you Greg," Jen's dad said and in the next breath bellowed, "Dinner time!"

The niece and nephews ambled across the lawn, kicking dandelions. Rainey's eyes lit on Greg and on her way to her chair, she whispered in Jen's ear, "Yummy, Auntie Jen."

Good grief she's getting old. She sounds like Kyra, Jen thought and smacked Rainey's butt as it slid past her.

"So, you're a pastor," Sam announced, scooping a huge serving of potatoes onto his plate. "What denomination?"

Here we go. Jen looked at Greg, concerned, but he seemed at ease.

"Actually, my church is a small, non-denominational—"

"You know she was seeing a married man?" Sam blurted.

Jen's cheeks burned. Did he lay awake at night thinking up ways to be a jerk?

"Sam!" Marie said, sounding appalled. *Oh, so son can do no wrong unless he's potentially messing up fat daughter's prospects.*

"Ow," growled Sam. Apparently Beth's foot had found his shin. He rubbed his leg.

Jen bit her lip—then relaxed and took a deep breath. She should have done this long ago. "I've put up with a lot over the years," she said. "And why exactly I'm not sure, but I'm done. You guys feel too free to make belittling comments about things that have nothing to do with you. My weight, my relationships, my life are my business. If you want to ask how I'm doing, great. If you want to criticize me, shut the hell up." She

took a big drink of water. "Pass the ribs. Please."

Greg winked at her. Her family stared as if her head had starting whipping around in circles, spraying vomit.

"It's good to be open in a relationship. I thought the guy should know, that's all," Sam finally mumbled.

Greg added a piece of chicken to his plate of ribs and coleslaw. "It's good you care. Thanks." He sounded so sincere Jen marveled.

Sam busied himself with his ribs. "No one makes ribs like my mom—except Jen. She manages too," he said suddenly.

Well, holy cow and thank you, big brother. That was almost sweet.

"They're amazing," Greg agreed with Sam. "There's nothing in the world like chicken and ribs, Mrs. R."

Marie giggled and answered truthfully. "It's the only dish I cook."

"That's true," Jen's dad said.

Greg looked at Jen and smiled. Jen smiled back, shaking her head.

"You're amazing," she mouthed when the others were absorbed in their plates. He just shrugged and looked cute.

JULY

30

KYRA SMILED AT THE FRESHLY painted walls of her newly expanded shop. The deep brown looked like suede.

"You still like these silly animals, I see," her aunt muttered, stroking a small cherrywood chimpanzee. It grinned up at her cheerily. She scowled as she fingered the tag and let out a disbelieving snort. "People pay that much money for hoo-ha like this?"

Birthday, Kyra noted. *She'll say it's ridiculous, but I'll know differently.*

Her aunt's eyes rested on some Turkish tapestries that Kyra had hung the night before. "Your store is very nice." The words were scratchy, as if they'd stuck in her throat.

"Thank you," Kyra said.

"It was about time you invited me into the city to see what you waste all your time with."

The words *you invited me* weren't lost on Kyra. She plucked them from her aunt's sentence and discarded the rest. "Shall we go for lunch?"

"I guess it's time. Will your father actually show up, do you think?"

"Oh, he'll show. And if not, you and I will have a nice time,

just the two of us."

Kyra's aunt gave another skeptical sounding grunt, but she caught Kyra's hand on the way out of the store and held it for just a moment, then let it go. Kyra stopped in astonishment and looked down at her aunt.

"I missed you at Easter," she said in a grouchy tone. It was a good thing Kyra was looking at her aunt's pinched face and saw her mouth move, or she would've been sure she imagined the words.

"Well, you're welcome to come and visit anytime," Kyra said, surprising herself again by meaning it. "We don't have to wait for special holidays."

Her aunt spoke as if Kyra hadn't. "Can that little twit really run the store while you're not here?" she asked loudly. Kyra had no doubt as to whether or not Annie, the "twit" in question, had heard the comment.

"Annie's great," Kyra replied even louder.

"Her nose is pierced." Her aunt said *pierced* like it was leprosy.

"She has a heart of gold and excellent business sense," Kyra affirmed again, loudly.

"Have a great lunch, you two," Annie called, laughter in her voice.

Kyra's aunt sniffed. "Well, you're the boss."

Yes, I really am. The thought pleased Kyra. She took her aunt gently by the arm, giving the rough wool of her sensible blazer a soft squeeze, and led her out the door. A startled look creased the old woman's face, but she didn't pull away.

"Do you think this was a good idea?" Ted asked, tracing the curve of Chelsea's back with his finger and kissing her shoulder. She rolled to face him, shielding her eyes from the white-yellow heat of July sunlight streaming through the window.

"Not good," she answered with a slow smile, stretching her arms over her head. "*Great*—but I'm sure the girls think they have the sickest parents in the world. Imagine having parents that sneak off for a weekend in a hotel in the same city they live in."

"Yep. We're definitely sex maniacs," Ted added, quoting Brianne.

"And totally mushy and gross," Chelsea finished with Dina's comment. They both laughed.

"Hey, I have something for you." Ted got off the bed and walked over to his jacket that lay strewn over a chair by the door. Chelsea admired his back and smiled at his farmer's tan, although in his case, of course, it was a construction man's tan.

Stepping over Chelsea's red leather boots, he whistled. "By the way, I love those on you. They're really hot. When'd you get them?"

He was back onto the bed before she could answer though, handing her an ivory envelope with an exaggerated flourish.

Chelsea slit the envelope open with a fingernail and pulled out a piece of notepaper. As she stared at the words written in Ted's hand, the blood drained from her face and she was suddenly cold.

Ted lost his smile. "I wanted to do something really great like go on a trip, but we're kind of tight right now.... I just thought you'd like it. I'm an idiot."

"How on earth did you come up with this?"

"Look, we don't have to do it. I haven't even paid yet. I just remembered that when we first got together, you always wanted to learn Spanish. You've been talking about wanting little things in common again.... I thought it'd be fun if we took the class together. I missed the mark obviously. I'm sorry."

"No," Chelsea said so firmly Ted jumped. "I'd love to learn Spanish with you. I can't wait to start in fact."

Ted's face brightened with a shy, pleased expression. As Chelsea looked at him, a wave of understanding washed over her mind, leaving her warm with joy—and surprise. "How could I not have known? It's *you*."

"What's me?" Ted asked with a raised eyebrow, tensing a little.

"Relax, silly. It's nothing. Nothing bad, anyway. Just remember when I was doing all that sleeping, those dreams I told you about?"

Ted nodded.

"Well, I figured it out," Chelsea hesitated. *You're the man of my dreams?* She almost laughed out loud. It was so corny, too ridiculous.

"No, tell me. What?" Ted asked.

"It's really nothing, honey." Chelsea leaned over and pulled Ted into a huge hug. "But I really, really love my present. Thank you."

AUGUST

31

"Your body's like chocolate." The words were a soft groan, almost lost against her neck in the tangle of her hair. Jen's insides melted and came undone. She arched upward as Greg simultaneously thrust forward; her breath caught in her throat and she let out a sharp gasp. God, if only there wasn't denim between them.

"Torturer!" she said.

Greg moaned. "I know, I know, and we need to stop now, or we won't be able to." He straightened up, kneeling between Jen's legs. "I'm sorry," he said, his voice hoarse and low. "I don't want to stop—"

"So don't then!" Jen's tone was sharp, but she sighed and pulled herself into a sitting position, tucking her legs up under her, straightening her shirt and doing up the top buttons. "You started it."

"Damn it!" Greg's face was flushed and he sat as far away from Jen as he could on the couch.

"Damn it? Aren't those pretty strong words coming from a preacher?" Jen laughed a little, then sighed. "Why damn it?"

"I just—ah, forget it."

They sat apart, silent for a few minutes.

"I'm sorry, Jen."

"Me too, Greg, me too." Jen turned pink. "It's like we're kids, but aren't I the one who's supposed to be maintaining my chastity?"

"Very funny," Greg said, but his mouth twitched. "Come a bit closer at least."

"Why, so you can torture me some more?"

"Sadly no. One day, however, I will torture you thoroughly. Count on it."

"Hmmm?" commented Jen. She didn't move her body closer, but she did unfold her legs and rest her feet in his lap. "Do you think you can control yourself with my feet at least?"

Greg ran a finger up and down the sole of her foot. "Probably not."

She shivered, then smiled and closed her eyes. "As penance, you can give me a massage." Greg let out a slightly strangled sound. "Relax, Greg—just my feet."

Greg reached for the remote control, turned on the TV and proceeded to rub Jen's feet vigorously.

"I don't know if cartoons are great massage ambiance," Jen murmured.

"No? I think they're perfect."

Later, after returning to her condo after sushi and a movie, Jen got a quilt and pillow for Greg and threw them on the couch.

"So what are we going to do about us?" she asked, facing away from him and lighting a strawberry-scented candle on the

coffee table.

"I've been thinking about that very question a lot," he said.

Jen turned to find him close behind her. He took her hand, and they stood, fingers entwined, not moving. Then Greg ran his free hand along the curve of Jen's face, down her neck, and traced her clavicle. He moved onto her breasts and cupped one gently. Jen swallowed, her nipples hardening at even that simple touch. His hand slid down until it rested on her waist. And there it stayed. For a long while, the only sound in the room was the soft heat of their breath.

Finally Greg spoke. "This, us . . . *You* . . . You're a huge physical thing for me, Jen, but you're not *just* a physical thing. I've dated other women since my wife died, but no one else . . . I mean, it's never been this hard—"

Jen giggled.

Greg rolled his eyes. "Okay, it's never been this *difficult* for me to refrain. It's your laugh. The way you always have two responses to everything. Your terrible sense of humor . . ." Jen kicked him softly and he grinned. Then his voice deepened and his grip on her hand tightened. "It's how you make fun of yourself, like you don't even know you're special. It's the kind of friend you are and how you try to make the world around you better—even your neurotic side is endearing." Jen's eyes misted, as Greg touched her face. "I love *you*, Jen."

"I—"

"No, let me finish. I'd be lying if I didn't say it's also your body and how you move. It's your sexy mane of mermaid hair."

"Mermaid hair?"

Greg lifted his hand from her waist and put a finger on her lips. "It's how you melt against me, and how you have this core of strength under your softness. It's how badly you want—" Greg's voice hitched, but then he continued, softer still, "I love that you want me as much as I want you."

"What we have is special, Jen. We can pretend that we're going to wait and see. We can pretend that you're not perfect for me." Jen shook her head, smiling, and took hold of Greg's other hand. "But if you will just save us the prolonged agony of pretending, and marry me sooner than later, I will spend my life making you happy."

"Is that a formal proposal?" Jen asked, feigning lightness. She leaned against him, reveling in the long lanky hardness of his chest and stomach.

"Don't joke, Jen." His voice was soft to the point of being imperceptible. "I'll be down on one knee the minute I think I have a chance of getting a yes."

Jen pulled away suddenly and let out a frustrated sigh. She went and plopped herself down on the couch.

"Not quite the response I was hoping for," Greg said, sinking down onto the couch beside her. Jen turned to face him.

"You know I love you," she said.

"But?" Greg had been reaching to put his arm around her, but he let it fall slack to his side and looked down at his feet. "But?" he repeated, his voice sad, resigned.

Jen touched his cheek, then slid closer, and took both his hands in her lap. "I love you, but—"

"But again. Why is there always a but? What is it?"

"Easy boy. The problem is you're a pastor—" The happy look faded from Greg's eyes.

"So what? Marry me, Jen."

Jen traced a scar on one of Greg's knuckles, not looking at his face. "I want to, but . . ." She broke off, struck shy.

"But *what?*"

Jen didn't reply for a long while. Then she said, very quietly, "I'm afraid."

Greg pulled her against his side and rested his cheek on her hair. She could smell popcorn from the theatre and lemon grass soap from her bathroom. "Everyone's afraid, Jen."

She shook her head, but said, "Yeah, maybe. It's just that all my life I've felt like an afterthought. My parents love me, but they'd have been fine without having me. My friends love me, but I always thought they didn't really need me—I'm changing my mind on that. And then there was Jay."

"Jay was an idiot," Greg said.

A half smile creased Jen's mouth before she continued. "You called me special, but I have *never* felt special. I believe in God, but look at me—and when I think about being married to a pastor, the pressure—"

Greg laughed and tilted Jen's head to look in her eyes. "Yeah, look at you, trying to live the best you can. That's all anyone can do. You can't fake it."

"You won't wake up one day down the line and think why on earth did I marry this basket case?"

"Well, no promise there exactly—"

Jen smacked him.

"Joking, joking."

"Yeah, well I'm serious, what if you wake up one day and realize you've changed your mind, you don't want me, you don't need me—" Greg pushed past her gently and got off the couch.

"Where are you going?"

"Nowhere. Stand up."

She complied, looking at him suspiciously.

Greg got down on one knee and reached in his pocket. "I've been keeping this on me for weeks, hoping I'd get lucky and cajole you into a moment of weakness where you say yes."

"But—"

"Shh. It's my turn again. No more buts. I love you, Jen. I was hooked the moment you asked if I was a snake-haired monster. All I do is wonder how I can get to spend the rest of my life with you. I'm not going anywhere, and I'm not asking you to be a 'pastor's wife.' I'm asking you to be *my* wife—"

"Okay," Jen said. Greg took a deep breath, like he was going to continue his speech, then closed his mouth suddenly and raised an eyebrow.

Jen nodded. "Yes, I'm saying *yes.*"

He let out a war whoop and jumped to his feet.

"Shhhh! The neighbors," she said, laughing. As he slid the ring on her finger, she felt like all the air left her lungs. She was suddenly light-headed, yet wonderfully clear at the same time.

Well, that's a relief," she said, heaving an exaggerated sigh.

He laughed. "You're telling me."

"So what do you want to do now?" she asked after a pause.

"Well, you could come over here and kiss me."

"Yeah right. I have a better idea." Jen smirked and got up to sit cross-legged on the couch facing Greg.

"And it is?"

"Well, pastor-man, you can explain to me your thoughts on suffering and a good God."

Greg's jaw dropped and his eyes flew to the clock. "A two-thousand-year-long debate and you want to discuss it at two in the morning?"

Jen gave a wicked little smile and raised her eyebrow. "You're the one who wanted to hang out on the couch again. I thought we agreed that was all about suffering?"

Greg groaned. "Well," he said, warming to the subject. "At least let me rub your feet, and I'll give it a go."

Jen walked into Yum, savoring the smell of fresh garlic. The back of her neck was hot and sweaty. The constant mugginess almost made her look forward to the approaching autumn and the inevitably cooler weather—almost. She wanted a few more trips to the beach first. She shook her hair, liking the breeze, and as she did, caught a glimpse of Kyra waving from a frond-filled corner. She waved back and, looking down the line, decided to go and chat until it thinned out a bit.

"They've changed the décor here," she observed, taking a seat.

Chelsea smiled at her. "Yeah, kind of jungley. But it's been almost a year since we were here last. I guess they're entitled to a change."

"It can't have been a year."

"It has," Chelsea insisted. "The last time we were here, we were celebrating the one year anniversary of your goal weight."

"Yikes, she's right," Kyra realized. "It feels like just yesterday."

"In some ways, maybe," Jen said, "but in others, it feels like years."

"That's for sure," Chelsea half muttered, half groaned.

"How are you doing anyway, Chels? It's been a while, first with me out of town, then with you romancing about with Ted," Kyra said.

"Good, good. For the first time in forever it seems, I'm feeling like I'm really in control of myself and not just fighting to stay that way. And . . ." She stood up and did a self-conscious pirouette, smiling. "I've gained about seven pounds. The doctor says I'm in a healthy weight range again. It's really hard though. I didn't realize how much I use food, or avoid food, I should say, to deal. The minute I'm stressed, I think about what I can eliminate. It's crazy."

Jen crunched an ice cube and swallowed it. "Nah, it's not crazy. I know exactly what you mean. I've been dealing with that too—just the reverse: what food I can eat."

Kyra nodded. "Who wants to look at their real problems when you can concentrate on fixing your thighs instead?"

Jen recognized that Kyra was only speaking half in jest. "Yeah . . . but hey, live and learn, right?"

"Yep," agreed Chelsea. "And how about you, Kyra? Anything new?"

"Like what?" asked Kyra, grinning like the proverbial cat who ate the canary.

"Like anything, anything at all. From the look on your face, you've got *something*. What is it?" Jen asked. "Is it about Dave, or potential honorary nieces and nephews?"

"Or your trip. How was your trip?" Chelsea added.

"Oh yes, *your trip*. I totally want to hear about Morocco, but first let me get some food. I'm starving." Jen hopped up and strode over to the counter. The corn chips called out to her, but so did the picture of a huge salad with devilled eggs, ham, turkey and cheddar. She grabbed a package of chips and asked for the chef's salad with blue cheese dressing on the side and an iced green tea, no sugar.

An auburn-haired elf at the cash register smiled as she took Jen's money. "Yum," she commented on Jen's tray. "Corn chips are the best."

"They really are," Jen said, smiling back.

She was walking back to her table when she overheard a plump woman comment to her friend, "See that? It makes me sick. Some people eat whatever they want and never gain an ounce! If I ate like that, I'd be twice my size the second I was finished the food."

Jen looked around to see the skinny, pigging out person. There was no one else nearby. She looked at her laden tray. She still couldn't believe she was a person people found thin. If only they knew. She grinned at the lady, who blushed, realizing that Jen had heard her. Jen decided to be honest. "I don't eat like this all the time, I promise. And I work out. A lot."

"Yeah, sure," the woman said, but her eyes crinkled in a smile.

———

Jen looked at the couch and her chenille blanket longingly and sighed. If she crashed now, she wouldn't get up again, and then she wouldn't get the work done that she needed to.

Walking into her computer room, she stretched, feeling the light, almost euphoric feeling that heavily stressed muscles release after a workout. She groaned with pleasure. The after effects of exercise were almost as good as sex, she thought. Well, almost.

Greg filled her mind, and she simultaneously smiled and sighed. She opened her e-mail, knowing she was out of luck tonight. They'd already talked.

She quickly skimmed subject lines, and the occasional full e-mail, including one called, "Help, I Can't adjust!"—yep, this week's. Definitely. She opened a new document, stared at the blank page for a few minutes, then finally started to type.

> Dear Can't Adjust:
> I understand what you're going through more than you know. I'm approaching the second anniversary of my own 121-pound weight-loss, and you're right. In a lot of ways, it is harder to be thin than heavy. We've lost our scapegoat.

After a little while, Jen hit save, then, fingers flying over the keyboard, added one more thought. "P.S. To the person who

sent in the rant about fat being a punishment for gluttony, I have to ask, is idiocy the punishment for arrogance? Just checking."

She hit save again, then stretched and yawned. She'd edit tomorrow. She had another day before it was due. She rolled her head slowly to relieve the crick in her neck. As her head tilted back, her eyes rested on her bookshelf. A familiar red-haired girl sitting on driftwood smiled down at her. A matching frame encasing another redhead, this one with a grin and a secret gleaming in her eyes, joined her. She wore slim-fitting flares and sat on the same driftwood as the other girl. White-capped waves swelled in the background and the sky behind the trees was denim blue. The backgrounds of the two pictures were identical. So much so that the new, sizes smaller girl could've been superimposed on the same film. But this woman, Jen knew, was not tired of hearing that she had a pretty face, and if she'd once feared she'd become a shadow person of herself, her grin said those fears were since allayed. Jen reached up and stroked the glass that protected the earlier image, her larger self. Any insightful stranger would know they were the same person.

Ev Bishop lives, plays, and writes in wildly beautiful British Columbia.

A longtime columnist with the *Terrace Standard*, her other nonfiction has been published across North America. Fiction-wise, she writes short stories and novels in a variety of genres, under her own name and the pen name Toni Sheridan.

If you enjoyed *Bigger Things*, please recommend it to your friends and family—and/or review it online. You can visit Ev at www.evbishop.com, follow her on Twitter (@Ev_Bishop), or find her on Facebook. She'd love to hear from you!

Coming soon:

Wedding Bands, Book I in the romance series River's Sigh B & B.

A standalone novel, *What is Seen*.

CPSIA information can be obtained at www.ICGtesting.com
Printed in the USA
LVOW13s1006080814

398059LV00007B/14/P